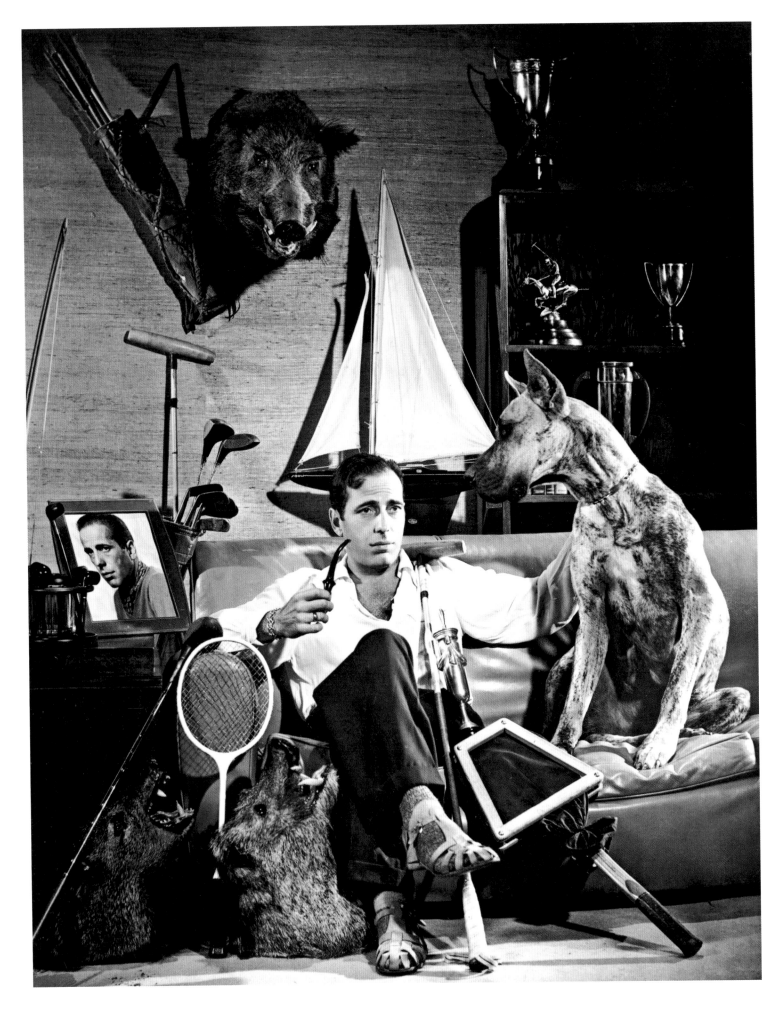

Humphrey Bogart
Warner Brothers, c.1939
Photograph by Scotty Welbourne

Hollywood Unseen

Photographs from the John Kobal Foundation

With a foreword by Joan Collins

Edited by Gareth Abbott
With an essay by Robert Dance

ACC EDITIONS

This wonderful book brought back many memories of my endless hours spent in the studio stills gallery posing for countless photographers in a variety of "turn 'em on" outfits! I spent an entire decade under contract to film studios, starting with J. Arthur Rank in England, moving to Hollywood for 20th Century Fox and also working at Warner Bros and MGM.

Most people nowadays would be amazed that, when doing publicity for *Land of the Pharaohs* at the Warner Bros stills gallery shortly after I arrived in LA, I was instructed: "Bring your best clothes." In contrast to later years, actresses were not dressed, groomed and gowned by an endless entourage of stylists, and it was quite normal for the star to wear either her own clothes or the ones from her current film. Since I possessed few clothes of any merit, I brought my one full-length strapless beaded gown, the pink satin embroidered dress made for my recent twenty-first birthday party, and a white one-piece bathing suit. They were all photographed and often still appear in publications.

Of course, the studio sometimes did supply costumes, particularly for important dates in the public calendar. For the Fourth of July I had to wrap myself in the American flag and look patriotic; for Easter I posed beside a giant egg while little fake chicks played around my feet, and once I had to wear a much-used bunny suit; for Christmas I sat, wrapped in a mink coat, in a sleigh pulled by several "reindeer", with a giant sack balanced on my shoulders from which gifts spilled out, and in another shot I was throwing my arms gaily in the air as gifts fell around me.

But the favourite photos, especially amongst young military men who stuck them on their lockers or above their beds, were the classic "cheesecake" or "pinup girl" shots, with the ubiquitous bathing suit or the tight-sweater-and-shorts look. Many is the middle aged man who told me that a particular pinup picture of me got him through the war (Korean or Vietnam I should add!). I soon wised up to what was needed and bought myself several stylish bathing suits, and was even one of the first to be photographed in the racy "bikini" fashion in England and France.

However, the American studios frowned upon bikinis then, as well as too much cleavage. Even though photographs of Brigitte Bardot in cute *deshabille* eventually flooded the media, it was still forbidden by the censor to reveal that highly erogenous zone: the navel! It was considered "obscene." Some of my early bikini shots made their way into some US magazines but they were craftily edited to cover that supposedly shocking scrap of skin by painting on extra fabric.

Then, as now, publicity was paramount for up-and-coming actors and actresses and for keeping established names in the public eye, and no one harnessed the power of publicity more than Jayne Mansfield. When I was working with her on *The Wayward Bus* she called in sick one day. Later we discovered she had been on the back lot shooting a sexy layout for *Look* magazine.

Photographic stills were a vital part of an actor's life, so we would even have to pose after every scene, holding an awkward "action posture," so that the photographer could capture the moment, not only for prosperity but for the plethora of material churned out for the media, magazines, and the cinemas' front of house displays.

Most of the photographs in this fascinating book of pictures, some of which have never been seen before, are of that sweet and innocent kind, overseen by a protective studio system that by the early 1960s no longer existed. As soon as the contract system was finished, actors fleetingly took charge of their own publicity, but when the paparazzi came on the scene a few years later, there wasn't much chance of that anymore!

Joan Collins
Los Angeles, June 2012

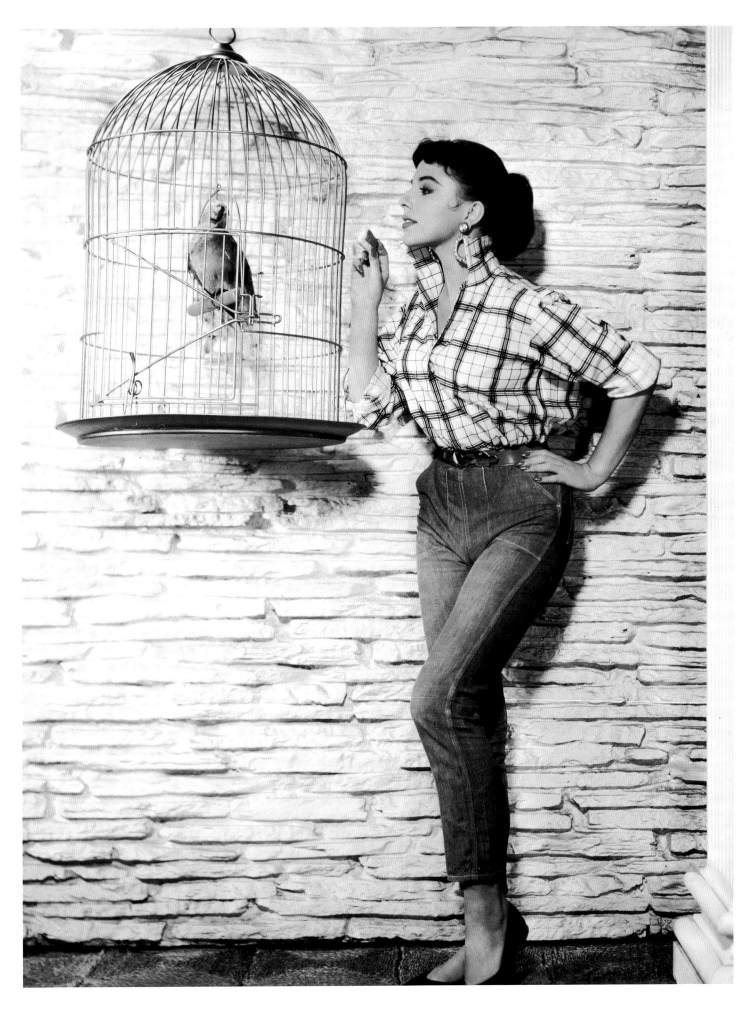

Joan Collins
20th Century Fox, 1955

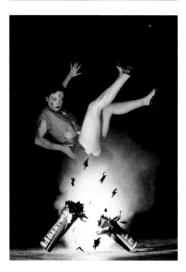

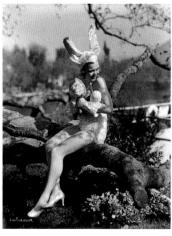

Introduction

Twenty-year-old Greta Garbo, in 1926, spent a clear Los Angeles winter day in the company of photographer Don Gillum. Veteran of a single, not-yet-released American film, the largely untested Swedish ingénue was forced to go through the typical paces that the nascent Hollywood Studio System demanded of attractive young talent. Garbo was not yet the brilliant movie star who would exercise absolute control over selecting her films and co-stars, and managing her publicity. It was probably Gillum who came up with the idea of taking Garbo to the University of Southern California (USC) campus and having her cavort with athletes before his camera. After all, the producers at Metro-Goldwyn-Mayer (MGM), the studio that held exclusive rights to her professional services, had determined that the tall, fit, Nordic young woman must be the athletic sort and ordered a supporting portfolio of photographs. They then used these to supply newspapers and fan magazines with fodder for readers who were anxious to know something about the latest European import. Gillum was a specialist in "action" pictures and worked from a relatively portable 4x5 Graflex camera. He was MGM's photographer of choice for creating publicity shots of aspiring movie stars frolicking in swimsuits on the beach, or in sports clothes playing tennis, or horseback riding, or doing anything else that might capture the spirit of youth and vigor.

Garbo likely got the word from Pete Smith, MGM's publicity chief, late one afternoon that she was to meet Gillum the next morning. She would have stopped by the studio for a quick check of her hair and make-up, and, loaded with a cache of cosmetics for the day, the two would be off. Gillum's instructions from Smith would have been minimal: come back with a good supply of exposed negatives showing off the physical attributes of the attractive leading lady. Gillum knew that the track team would be practicing, and figured that, clad in a borrowed USC track suit, Garbo would make an appealing, and perhaps revealing, subject. In one shot the actress is shown posed poised to start a fictitious race, smiling gamely, and squatting next to the track coach Dean Cromwell who holds a starting pistol in his hand. Garbo looks great and seems to be enjoying herself, conveying, in this and other images taken that day, precisely the attitude demanded by the studio: outdoors girl, at her happiest on the field, on the tennis court or perhaps swimming.

The fantasy of Garbo as the sporty Nordic-American type holds up perfectly in Gillum's photographs. In the end, however, his images never had the chance to define the young actress. By the time her second feature was released, Garbo had registered magnificently on screen in a guise utterly antithetical to anyone's notion of peppy or athletic. It was not outdoors where the Garbo mystique would flourish but in settings nearer the boudoir. After *Flesh and the Devil*, her third film, premiered to great acclaim in January 1927, Garbo took advantage of her position and dictated that she would no longer engage in any sort of superfluous photography. She limited her availability to the strict confines of the movie set and portrait studio, working under the most tightly controlled and private conditions. Unprecedented at the time, and unique in the annals of the Hollywood Studio System which continued until the late 1950s, Garbo was the lone example of a screen performer who could refuse her studio's order to spend an hour, or an afternoon, or a day, with a photographer taking the requisite indispensable publicity shots.

It didn't matter if you were brand new to a Hollywood studio, or an established player, and it didn't matter if you loved having your picture taken, as did Joan Crawford, or hated it like Spencer Tracy, you were contractually bound to be photographed at the whim of your studio's publicity department. Beginning in the early 1920s, a film actor's contract specified these obligations in detail.

Greta Garbo, MGM, 1926

Joan Crawford, MGM, 1927

Jane Wyman, Warner Brothers, 1936

2

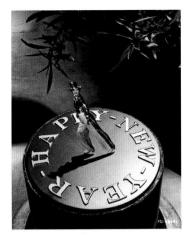

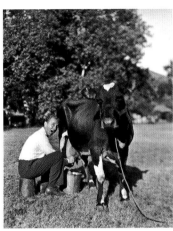

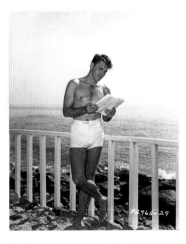

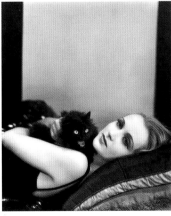

Eleanor Powell, MGM, 1935

Bing Crosby, Columbia, 1936

Burt Lancaster, Paramount, c.1948

Carol Lombard, Paramount, c.1932

One paragraph from Anita Page's MGM contract dated February 13, 1926 was typical:

> *The artist agrees that she will, throughout the term hereof, act, pose, and appear solely and exclusively for and as requested by the producer in such roles and such photoplays as the producers may designate; that as and when requested so to do by the producer she will make personal appearances on the stage in connection with the exhibition of photoplays produced by the producer; that she will promptly and faithfully comply with all reasonable directions, requests, rules and regulations made by the producer in connection herewith; and that she will perform and render her services hereunder conscientiously and to the full limit of her ability and as instructed by the producer, and at all times and whenever required by the producer.*

This sort of language was unwavering until the end of the Studio System in the 1950s. For the better part of forty years, a young hopeful who was fortunate enough to be offered a standard studio contract (typically lasting, with options, from five to seven years) would have virtually no say over choice of films, would be subject to a strict code of moral behavior, and could have the contract canceled at six month intervals at the sole discretion of the producing company. If you were lucky enough to have your option picked up after the first six months, the hard work began.

At the top studios such as Paramount or Warner Brothers, the films we now regard as classics were typically made in four weeks. Contract players might appear in as many as eight films a year. The great Garbo signed a five-year contract with MGM in 1927 and was obligated to make fifteen films. Vacations, sick days, and the like were never mentioned in contracts – if a performer actually got sick and missed work, extra days would be tacked onto the end of the contract for no additional pay.

The primary product of Hollywood was motion pictures – the fifty features released annually by both Paramount and MGM, and in smaller but still plentiful numbers by the lesser studios. Standing alongside this was still photography, which produced millions of images each year for a seemingly insatiable public. Devouring these pictures were the fans and the fan magazines. Beginning in the 1920s, hundreds of thousands of star photographs were sent out each year in response to letters addressed to favorites. Millions of fan magazines bearing names such as *Photoplay*, *Motion Picture*, or *Screenland* were printed each month and were vibrant chronicles of movie-land during the genre's heyday between the late teens and the Second World War. Serious popular journals beginning in the 1930s, such as *Time* and *Life*, focused on news stories but could also be counted on to cover Hollywood, and to regularly feature stars on their covers. A divide supported by all the studios soon became entrenched: formal star portraits went to the fans and fan magazines, the so-called candid publicity photographs were sent everywhere else. From the earliest days of the movies to the current issue of *Vanity Fair*, Hollywood glamour has intoxicated the public.

During the making of a film still, photographers recorded each principal scene in a single shot as soon as it was finished. Actors learned quickly to hold their places until after the still photographer's bulb flashed. Scene-stills, then and now, are potent triggers to the memories we retain of favorite movie moments. Between films, every performer who had a long-term contract was photographed in the portrait studio. Portraits were taken in the hallowed chambers of men such as George Hurrell, Clarence Sinclair Bull, Elmer Fryer or Ernest Bachrach, the aristocrats of their profession. Ruth Harriet Louise, the lone woman to command a portrait studio, worked at MGM in the late 1920s. Stars, particularly women, might spend a full day being photographed, sometimes wearing costumes for a just-completed film. Lesser players would stop by the portrait studios for a few shots to feed the publicity department's endless need for current images to circulate to the worldwide media.

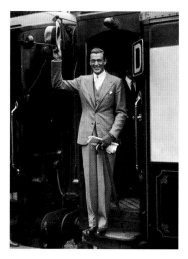

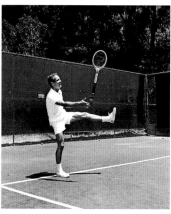

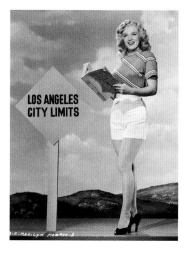

Gary Cooper, Paramount, 1931

Paul Newman, 20th Century Fox, c.1960

Marilyn Monroe, Columbia, 1948

Hollywood Unseen charts the third category of the photography apparatus that was central to marketing films and stars. Not portraits, which always emerged from artfully contrived sessions, and not the scene stills made on the set that prod our nostalgically sheathed memories. Rather, the general publicity photographs depict stars doing anything but working, which is not quite accurate because, in fact, stars and leading players were expected to represent (and represent well) their studios every day whether filming or not. Moreover, nearly every photograph that appears in this book was taken under the pretense of being candid although many are as calculated as a formal portrait, and hairdressers, costumers and make-up artists often hovered nearby, just out of camera range. Nevertheless, publicity photographs were contrived to appear casual, informal and whenever possible natural, and vary from their studio-produced siblings in depicting wide ranging locations. The names of most of the men (and the few women) who worked day and night documenting the lives of Hollywood's royalty have long since been separated from their photographs. Credit was rarely demanded, and most photos were reproduced identifying star, sometimes the film, and possibly the studio, but rarely the person snapping the shutter.

When Gary Cooper stepped on the train at Waterloo Station commencing his long journey back to America after a London sojourn, his departure was recorded by the pop of a camera's flash. Standing still and elegant as a movie star, Cooper smiled in the direction of the photographer; likely the same photographer who welcomed back or said farewell to other stars and movie dignitaries passing through London terminals. But Cooper, the handsome Paramount heartthrob, was a special prize. Like many others of his gender he did not particularly like to be photographed, but understood its critical importance to his career. Cooper spent patient hours before the portrait camera, preferring to pose with his female co-stars, presumably so they would absorb the camera's attention. But to the legion of female film fans it was Cooper who was the object of adoration. Perhaps remembering this simple fact of his success, Cooper grins broadly for the camera and, as an added flourish, doffs his hat acknowledging his admirers.

Stars did not have the option to be tired, or cranky, or even poorly dressed when there was the prospect of an awaiting camera. Cooper was impeccably attired for his trip and the camera dutifully recorded the sharp creases on the pants of his winter-weight hound's-tooth suit. Undoubtedly, he expected to be photographed upon embarking and thus appeared immaculate for the press. Cooper was ready for the cameras and this grab shot, beautifully lighted and composed with an enthusiastic subject, possesses many of the qualities typical of a formal portrait session. Porters, who typically handled luggage discreetly, well outside camera range, here provide the star an enthusiastic audience.

What Cooper and all of his peers learned was that it did not matter when, or where, or even in what circumstances you were photographed, the rule was that you must always look wonderful. Like the movies, publicity photographs were meant to perpetuate Hollywood's illusion as a land of magical perfection. The studios were determined to provide movie-goers – and that meant almost every American adolescent and adult, and a high percentage of Europeans – with a narrow vision of a world of pretty faces, sleek physiques, glamorous attire, and happy endings. Skipping through movie history, the names which propelled us to lay down our admission money at movie box offices included Swanson, Valentino, Dietrich, Gable, Flynn, Davis, either Hepburn, and Paul Newman. The bigger the star, the more screen time allotted. Moreover, the bigger the star, the closer the camera moved in to give us the close-up, film's ultimate tribute to the freakish beauty that leaves audiences spellbound.

The beautiful people with splendid faces were always ready for the intrusion of the camera. Some, such as Joan Crawford and Marilyn Monroe, reveled in the opportunity to pose for photograph after photograph. Crawford had perhaps the greatest career of

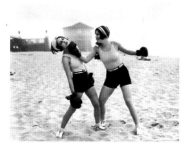

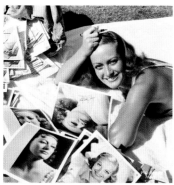

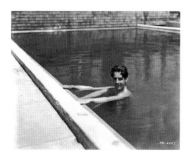

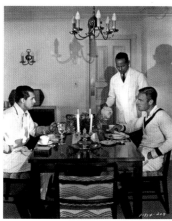

Dorothy Sebastian and Joan Crawford, MGM, 1927

Joan Crawford, MGM, 1930

Ramon Novarro, MGM, 1930

George Bernard Shaw and Clark Gable, MGM, 1933

Cary Grant and Randolph Scott, Paramount, 1935

any Hollywood creation as a star in silents, a bigger star in the talkies, an Oscar winner in the 1940s, a top notch dramatic actress in the 1950s, and culminating with a brilliant star turn in *What Ever Happened to Baby Jane* (1962) alongside Bette Davis. She was hardly glamour material when she made her trek from New York to Los Angeles in the last days of 1924 with an MGM contract that did not seem likely to be renewed after the initial six months. She was like a whole host of girls given a flicker of opportunity, most of whom were sent packing with only fleeting memories of unrealized possibilities and not even an instant of screen time.

Untrained, having only her natural ability as a dancer, with frizzy hair and bad teeth, Crawford figured out precisely what was necessary to ascend the ladder to stardom. She was pretty and she was ambitious, but what separated her from others was a brilliant calculation of the power of the photograph, and understanding this, she made herself available to all the studio's photographers. One day she was romping at the beach with Don Gillum and MGM starlet Dorothy Sebastian. Another day she was modeling fashions. It was through photography that Crawford charted each step on her ascent. Portraits and publicity photographs guided, as well as recorded, her transformation from a pretty dancer in the back row of a New York nightclub chorus line to Hurrell's thrilling beauty. The instant in 1930 when she looked up into the camera lens while seated on the beach, illuminated only with ambient light, reveals her metamorphosis to be complete. A couple of years later, in what must have seemed at the time a humorous candid shot of Crawford lying on the grass of her backyard at home autographing pictures for fans, Clarence Bull captured an image that is the summation of Crawford's stardom. Interrupting her task, Bull asked Crawford to look up to the camera. Revealed is a face as completely made-up as it would be for a movie scene shot on set. Holding her hair back and peering up as she turned toward the photographer, Crawford with the tools and totems of her fame fanned out across the lawn is joyous.

Fans enjoyed "peeking", as it were, over the fence at their favorites, so studios provided a steady supply of images of stars and featured players at home. Sometimes the location was actually the actor's house, but as often as not, it was borrowed for the afternoon. Pools were popular sights for these seemingly impromptu photo sessions, whether tame beefcake shots of Ramon Novarro or John Payne, or gentle cheesecake portraits of lovely lasses such as Myrna Loy, Joan Blondell or Jane Russell enjoying the southern California sunshine. The poses became slightly more daring as the decades passed, although modesty always prevailed, and shoes usually adorned feet even though the sight of high heels on a diving board is curious.

Clark Gable, the world's most popular male star during the 1930s, often welcomed cameras into his home, as did Marion Davies, tinseltown's most ebullient hostess. Davies lived in a Beverly Hills mansion and entertained extravagantly at her Santa Monica beachfront estate. Davies' beach house, rumored to sleep a hundred guests comfortably, was the sight of many costume parties and James Manatt, her favorite MGM photographer, was always on hand to document the outlandishly attired stars. But it was at La Cuesta Encantada, the mountaintop castle Davies shared with publisher William Randolph Hearst at San Simeon, that the Hollywood set's most memorable parties took place. Photographers were almost always invited to record the fun, although a snap of George Bernard Shaw looking down the table at the Hollywood royalty seated nearby suggests intellectuals rather than movie folk might have been Manatt's preferred company.

A curious footnote to the theme of stars at home is a series of photographs taken of Cary Grant and Randolph Scott at the beach house they shared in Santa Monica in the early and mid-1930s. Photographs of two young, handsome, and single leading men depicted without female accompaniment was as rare back then as it is today. These photographs are unique in that they reveal a domestic relationship that was as intimate as any study

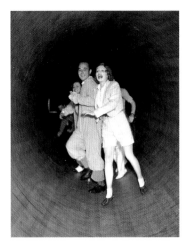

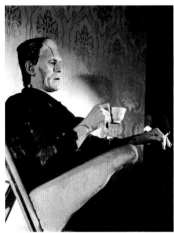

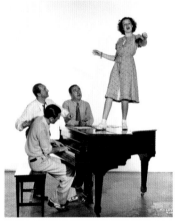

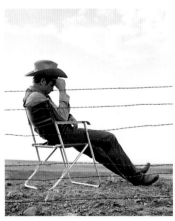

Marlene Dietrich and William Haines, Paramount, 1935

Boris Karloff, Universal, 1935

Judy Garland, MGM, 1937

James Dean, Warner Brothers, 1956

of a married couple at home. Grant and Scott are shown in the kitchen preparing dinner, at the dining table (tended by a servant), playing board games and resting in their sitting room. The camera also followed the pair outside and shots survive of the duo poolside, in the water, and cavorting on the beach. These photographs were coded by the Paramount publicity department and they were sent out to readers who were anxious to know what happened behind the walls of *Bachelor Hall*. No one knows for sure the nature of the relationship between the two oft-married actors, but these photographs continue to appear in nearly every book or article about one or the other, and demonstrate the enormous power that a candid image can have in shaping our notions of the private life of a performer.

Movie stars almost never venture forth into public places, although in the 1920s and '30s it was more common than in the postwar era. On a Sunday afternoon, film actors' one day off from work, in June 1935, Carole Lombard hosted a party at the Venice Amusement Pier, a popular attraction perched over the Pacific Ocean. She invited, if contemporary sources are accurate, more than one hundred guests (mostly drawn from the Paramount star roster) and seems to have taken over the Fun House for her companions' exclusive use. New York society favorite Jerome Zerbe, on one of his regular visits west, was the lone photographer permitted to record the afternoon frolics. Zerbe's photographs, featuring Marlene Dietrich, William Haines, Claudette Colbert, Errol Flynn, Cary Grant and others, are among the seminal images that helped to define the public's perception of 1930s Hollywood as a land of frivolity and pleasure, a notion the studios were anxious to perpetuate. Glamour goddess Dietrich showed up dressed in short pants and ankle socks, and gamely tackled nearly every ride. So too did Cary Grant whose early professional days as an acrobat must have served him well. Everyone is shown having a good time, or is acting the part before Zerbe's camera, and there is no indication of professional competition. Rather, the assembled merrymakers, the film industry's golden youth, share a boisterous, cheerful, brilliant smile-illuminated afternoon.

Movie-goers also enjoyed seeing glimpses of favorites at work. The silver screen might have been home to the great illusions flickering in black and white, but a grab shot of Boris Karloff being prepared for his character as Dr. Frankenstein's monster was almost as tantalizing. Universal Pictures waited almost four years to give horror movie aficionados a sequel to the original *Frankenstein* (1931). In *Bride of Frankenstein* (1935), the monster was given a love interest, and Universal's coffers were given the chance for lightning to strike twice. Karloff was back reprising his terrifying role. Preparing for a day's work, he is seated on what resembles a common barber's chair, as Jack Pierce, Universal's top make-up artist, transforms Karloff into the ferocious monster.

Capitalizing on the popularity of the earlier film, a copious amount of publicity material was prepared and sent out to magazines and newspapers. During the Depression years the major studios released an aggregate of more than two hundred features each week. Unlike current film productions where publicity campaigns, sometimes elaborate, anticipate the release date of practically every new film, in the 1930s only the most important and expensive productions – think *Gone with the Wind* – would be given a substantial launch. Sequels were another matter. Universal had built a reputation as moviedom's horror factory, so it was sensible business to promote vigorously the Frankenstein brand and await the dimes and quarters that would pass over box office counters.

Behind-the-scenes photographs need not have been calculated as promotions for particular films but often were decorative fillers occupying small spots to accompany Hollywood bits and stories. Katharine Hepburn, resting between takes, reminded readers that her no-nonsense Yankee persona was not the publicists' invention. Youthful Judy Garland singing standing atop a piano around the time she filmed *The Wizard of Oz* (1939) underscored her burgeoning reputation as a singing sensation.

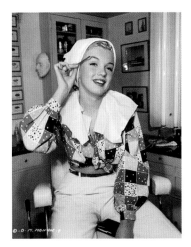

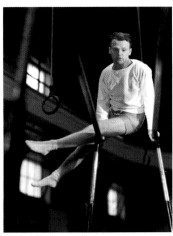

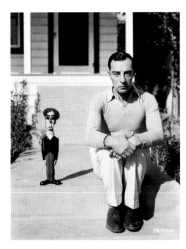

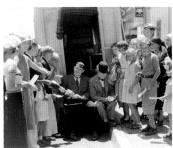

Marilyn Monroe, Columbia, 1948

James Cagney, Warner Brothers, 1933

Buster Keaton, MGM, 1930

Stan Laurel and Oliver Hardy, MGM, 1932

A shot of Jimmy Dean, seated in deep concentration behind a barbed wire fence in a barren landscape, is a perfect summation of the young star's soulful reputation.

Male chauvinism ruled in old Hollywood in spite of the enormous power women wielded at the box office. In recent years female actors have rightfully complained about the paucity of good screen roles for women, the career of Meryl Streep notwithstanding. In the 1920s, '30s and '40s, women had extraordinary opportunities, and this is documented in the careers of Garbo, Crawford, Hepburn, Davis and many others. Still, publicity departments demarcated the sexes in conventional attitudes. Images such as Marilyn Monroe primping with a make-up towel and scarf carefully arranged to prevent accidents are typical. Rita Hayworth, finished with her glamour routine, atomizes the air around her with a favorite perfume. Elizabeth Taylor's deep concentration as she paints her lips is reflected in the mirror. In this sort of photography the camera is the true mirror, and we the fans are basking in the reflected glow of highly polished beauty. It was determined un-manly for any of the guys to be seen in such poses, so make-up, unless it was the theatrical sort that transformed Lon Chaney or Boris Karloff into spectacular characters, was hidden from the public's view.

Men were better exposed in shorts and tee shirts, or sometimes without the tee shirt, exercising at the gym. Fred MacMurray demonstrated that his garage could be a useful location for a workout, although others such as Jimmy Cagney preferred a more formal gymnasium. Cagney, one of Hollywood's archetypal tough-guys was also a graceful song and dance man. Challenging the actor's brand, Warner Brothers relented and let him show off his moves in *Footlight Parade* (1933) and *Yankee Doodle Dandy* (1942). His elegant form is artfully on display as he works out a routine on the parallel bars with no sign of the "public enemy" nearby.

Bing Crosby, on the other hand, appears less at ease seated at a rowing machine and the nearby trainer, whether a prop or not, hardly helps the veracity. Still, shots like these, taken to remind female fans that male stars were all real men – do not worry about it – sometimes approached parody. Whether or not Crosby was an athlete in the gym, he was a well-known and superb golfer, but this was apparently an insufficient demonstration of manliness for Paramount, so he gamely stripped down for his workout. Audiences didn't need reminding of athletic abilities or gender attributes when Johnny Weissmuller and Lupe Velez were cutting-up poolside for the camera. Approaching the startled Velez, known as the Mexican Spitfire, from behind as she stands on edge of the diving board, cinema's Tarzan smiling playfully seems ready to push his real-life wife in to the water. Given the tumultuous relationship between the two during their five year marriage, this set-up would have appealed to editors illustrating the latest chapter in the chronicle of another rocky Hollywood romance.

Comics were among the best subjects for the gag shots that were an entertaining staple of publicity photographs. Buster Keaton must have enjoyed posing in character, for the stone-faced actor was a common subject. He was at his best with props, when seated on the steps in front of his house next to a miniature toy Buster Keaton, for example, both gazing without expression side by side into the photographer's lens. Or, another day the brilliant comic is recorded on the ground in his backyard with a bulldog radiating as much personality as his master. Hanging from a tree branch and supporting his two young sons, one perched on each foot, it is a charming depiction of the idealized family life which was so important to Keaton's new boss at MGM, Louis B. Mayer. Taken in September 1928, as *The Cameraman* was about to be released in theaters, this photo simultaneously shows off Keaton's famous athleticism and underscores his equally awesome powers as a dad (whether true or false).

Some photographs are simply humorous and had little or no didactic sub-text. Groucho Marx seated comfortably atop a fireplug wearing his typically rumpled suit and smoking his trademark cigar is a sight gag looking for a chuckle. So, too, is the

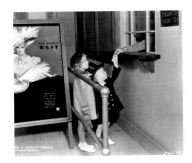

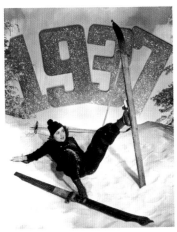

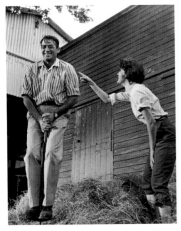

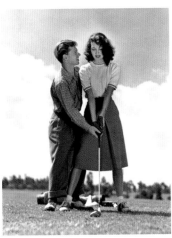

harmonizing of Jimmy Durante at an upright piano, leading a chorus including Laurel and Hardy and Buster Keaton. Durante was new to MGM, and Keaton's star was beginning to diminish when this photo was taken. Laurel and Hardy were the well-beloved comedy team making dozens of popular short subjects at the studio. When Laurel and Hardy were recorded autographing photos for youngsters as their parents watched, was this a record of an actual event? Not likely, rather it was a publicist's invention and even kids were dupes to studio ballyhoo.

Paramount Studios was indulging in a bit of self-promotion when Shirley Temple and Baby LeRoy posed for a humorous shot of the two youngsters purchasing tickets for the bawdy Mae West's adults-only latest feature, *It Ain't No Sin* (re-titled and released as *Belle of the Nineties*, 1934). Six year old Temple had just wrapped up filming the ironically named *Now and Forever* (1934) co-starring Carole Lombard and Gary Cooper. Paramount had let her contract expire, and Twentieth Century Fox signed the little girl who would become the world's number one box office sensation from 1935-1938. Baby LeRoy retired from picture-making the next year at the age of three.

Once in a while, a gag photo would be outrageous. Starlets were usually the subjects and studios could not resist employing comely young ladies in situations that revealed their physical assets. Anita Page is not really riding a miniature rocket amid fireworks exploding all around her. The photograph's point is youthful vitality, shapely legs and a brilliant smile, all of which underscore the MGM marque.

Anita Page on a rocket notwithstanding, there was something of an industry in pre-World War II Hollywood of posing aspiring stars, generally attractive young women, in holiday and seasonal guises. New Year's celebrations annually fostered this sort of imagery and one or more of the fan magazines would publish in January pictures of stars announcing the change to the calendar. Olivia de Havilland was on the cusp of stardom when she was asked to pose flat on her back, as if fallen while skiing, while "1937" appears aurora-like above. One year Eleanor Powell tapped gracefully on a giant New Year's medal projecting upward. Christmas and Easter were the most popular holidays and from the 1920s onwards, it was typical for ingénues to be photographed dressed up as Santa Claus or one of his elves, or as the Easter Bunny. MGM had a bunny suit that was dusted off every couple of years and worn by a succession of lovelies over a decade.

Just whose bright idea it was to ask Bing Crosby to milk a cow is probably lost to history. Crosby gamely mugs for the camera, but it is the cow who steals the moment by looking into the camera's lens with a concentration that rivals the best human portrait subjects. Similarly, it must have seemed a good idea to ask Gregory Peck to try his luck on a pogo stick. Like Crosby, he smiles bravely, but watching the spectacle, it is his co-star in *On the Beach* (1959), Ava Gardner, who gets the last laugh.

Gardner and Peck are having a bit of fun for the camera, but the real point of the photograph, and the thousands like it, is to remind audiences that Hollywood royalty are a privileged class of gorgeous people who are never really like you and me. When a photographer snapped a relaxed Burt Lancaster pausing at a fence along the Pacific Ocean, presumably studying a script, with his legs crossed and attired only in tight fitting shorts, it was a record of nothing other than perfect physicality. In another photograph, Paul Newman, fully but casually dressed and also standing outside in a virtually identical posture, is no less a movie god.

With the women, publicity photos sometimes blur with portraits. Sitting at the edge of a swimming pool and smoking a cigarette, Marlene Dietrich registers as an exquisite Hollywood idol as the sunlight, perhaps augmented by carefully positioned reflectors, sculpts her face and accentuates the famous gams. The composition first suggests a casual grab shot, but the authority of the final picture could stand alongside the official image bank created to sustain the Dietrich myth. Similarly, Carole Lombard posing with a black cat, or Joan Collins inspecting a birdcage, seem cheerful antidotes to the rigid glamour machine, but are

Shirley Temple and Baby LeRoy, Paramount, 1934

Olivia de Havilland for New Year 1937
Warner Brothers, 1936

Gregory Peck and Ava Gardner, Columbia, 1959

Mickey Rooney and Ava Gardner, MGM, 1942

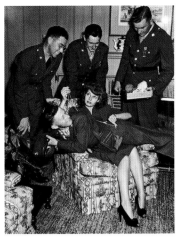

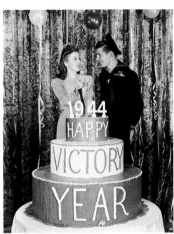

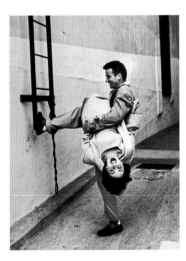

Rita Hayworth, Columbia, 1943

Ida Lupino, Warner Brothers, 1944

Montgomery Clift and Elizabeth Taylor, Paramount, 1950

actually more ammunition in the arsenal of imagery that helped to perpetuate the careers of those actresses. Unlike her Swedish counterpart, Ingrid Bergman is credible enjoying the outdoors, but the photograph of her fishing in shorts and a tee shirt is no more authentic than the depiction of a similarly clad Garbo about to start a race.

Even in the land of make-believe authentic emotions sometimes emerge. Four months after she arrived in Hollywood in the fall of 1941 and took up residence at MGM, Ava Gardner married Mickey Rooney, then the movie industry's top-draw. During a whirlwind courtship they attracted the attention of the studio's publicists who made sure their magic was continually recorded, including one day when Mickey taught Ava how to play golf. Though the marriage lasted little more than a year, for a brief time they seem, in the copious number of photographs that record them together, the paradigm of a romantic young couple.

Although America and Hollywood's initial response was passivity when war broke out in Europe in 1939, from the moment of the bombing of Pearl Harbor the studio's publicity machines raced to match the news press in war coverage. A steady stream of imagery flowed forth showing stars doing their part for the war effort. Most of Hollywood's men of eligible aged enlisted, some even seeing action in Europe or the Pacific. Hollywood and its stars took a lead role in the extremely successful effort of selling war bonds. Actresses entertained the soldiers at home between deployments in canteens from Los Angeles to New York. Studio publicity during the war years was both potent and poignant. Stars visited hospitals, Dietrich entertained troops near the front lines in Europe, and Carole Lombard died in a tragic plane crash on a cross-country war bond tour. Hollywood boosted American and Allied morale during the grim war years, and the studio publicity photographs provide a vivid record of what went on back home.

The 1950s provided glamour and the movies with a spectacular final chapter before the major studios closed, long-term contracts vanished, and stars were forced to manage their own publicity. Elizabeth Taylor and Montgomery Clift, two of that decade's most photographed faces, not only co-starred three times – *A Place in the Sun* (1951), *Raintree County* (1957) and *Suddenly Last Summer* (1959) – but were friends as well as colleagues. Their easy rapport is evident in abundant publicity material that pairs them, particularly before the 1956 accident that ruined Clift's matinee-idol face. The future holds promise in the images taken by *Life* photographer Peter Stackpole when he had a long session with the youthful on-screen lovers during filming of *A Place in the Sun* at Paramount in the spring of 1951. Typical portraits of the radiant pair were taken inside the studio, but invention ruled outside when the twosome cut loose. Rarely has youthful abandon been better captured than by the images of Clift swinging a laughing Taylor around in circles by her waist. Taken on the verge of her film stardom, these photographs never appeared in *Life* although Taylor would become the magazine's number one cover girl, scoring fourteen appearances over the span of fifty years.

Four decades of publicity photographs are presented in *Hollywood Unseen*. These pictures have not been arranged by date, or star, or studio, or even by the sort of situations depicted. Photographs from the 1920s have been juxtaposed with their counterparts taken thirty years later, and cameras across those decades share the goal of ensuring that the ladies and gentlemen anointed movie stars never really cease to resemble the gods and goddesses who appear on the screen. Something changed around 1960, and suddenly the *paparazzi* overwhelmed the studio's tightly-controlled publicity enterprise and transmogrified our view of celebrity forever. Humphrey Bogart confidently riding a bicycle on a studio back lot might appear to be the work of a lurking *paparazzo* awaiting prey, but we know it isn't. The shot of Bogart is perfectly composed and lighted; he sits straight and dignified, and his face is recognizable as Sam Spade or *Casablanca*'s Rick. This is how we want to remember our screen heroes – something like us, but not quite.

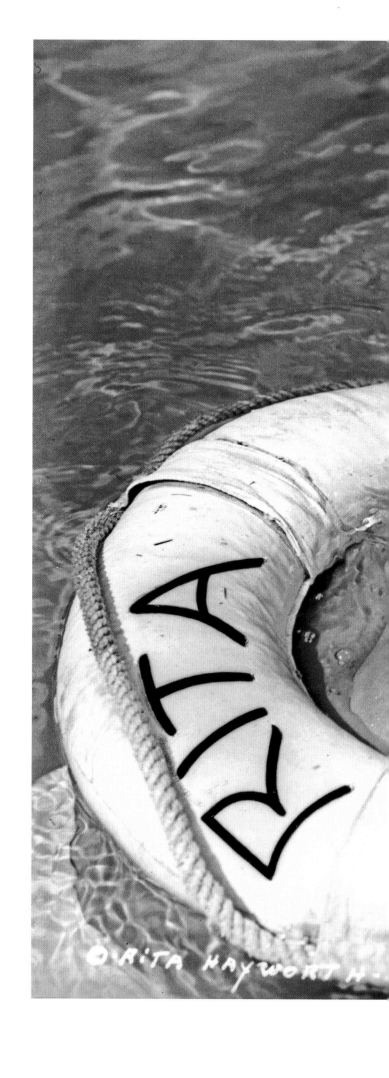

Rita Hayworth
Columbia, 1944
Photograph by Robert Coburn Snr

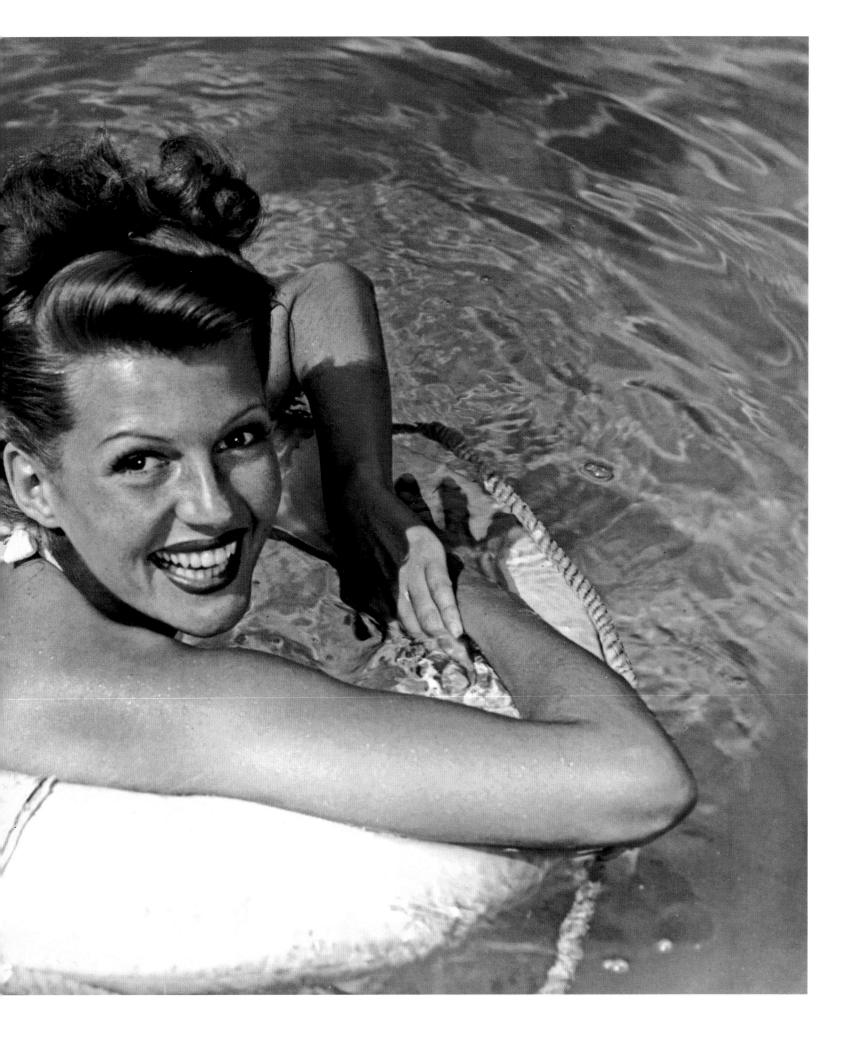

MG-18053
MGM

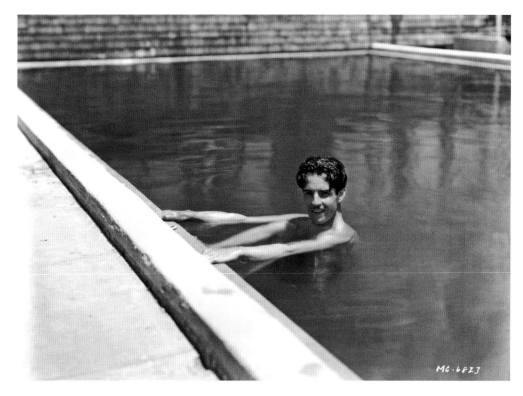

Buster Keaton at MGM Studios,
Los Angeles
MGM, c.1930
Photograph by George Hurrell

Myrna Loy
MGM, 1933
Photograph by Clarence Sinclair Bull

Ramon Novarro
MGM, 1930
Photograph by Russell Ball

13

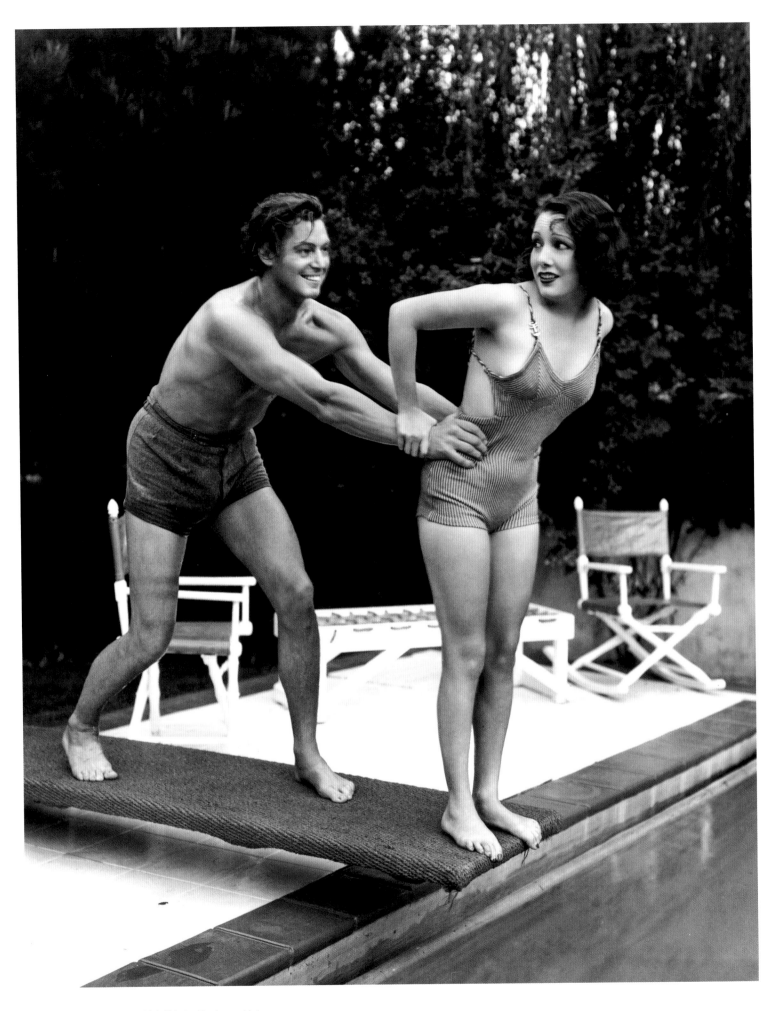

Johnny Weissmuller and his third wife, Lupe Velez
MGM, 1933

MG-16253

Stan Laurel and Oliver Hardy on set
MGM, 1931

Ginger Rogers
RKO, c.1936

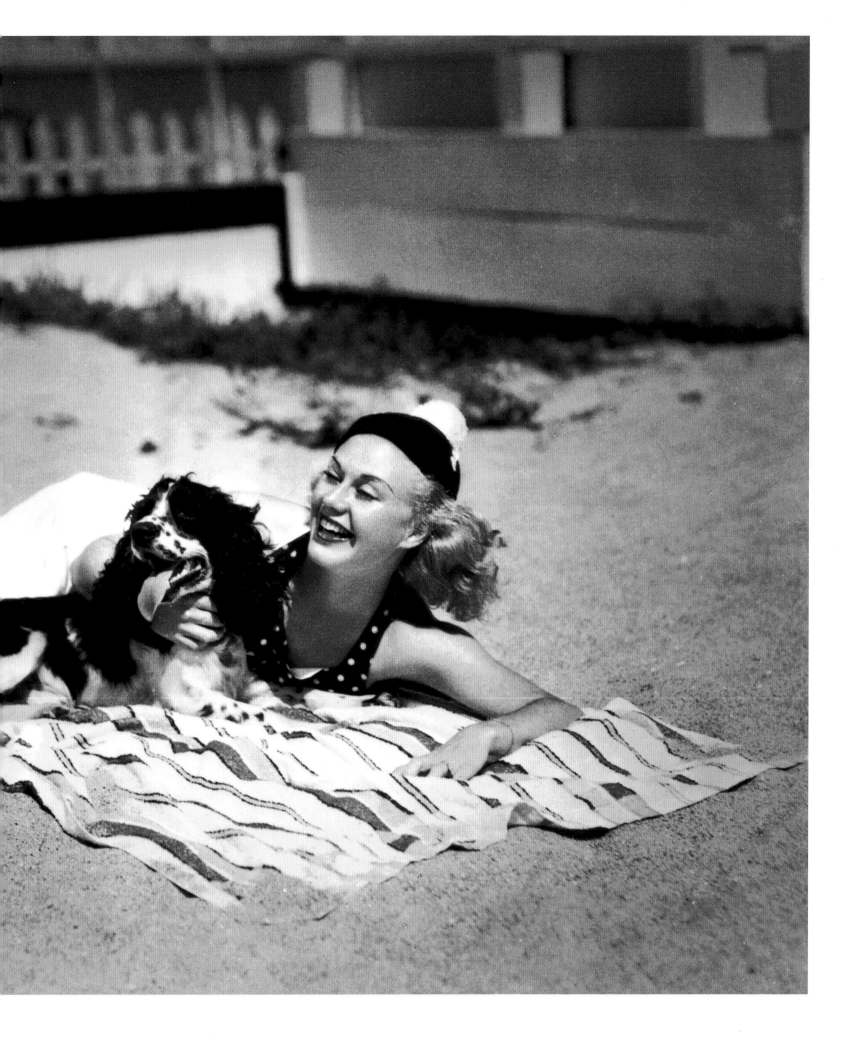

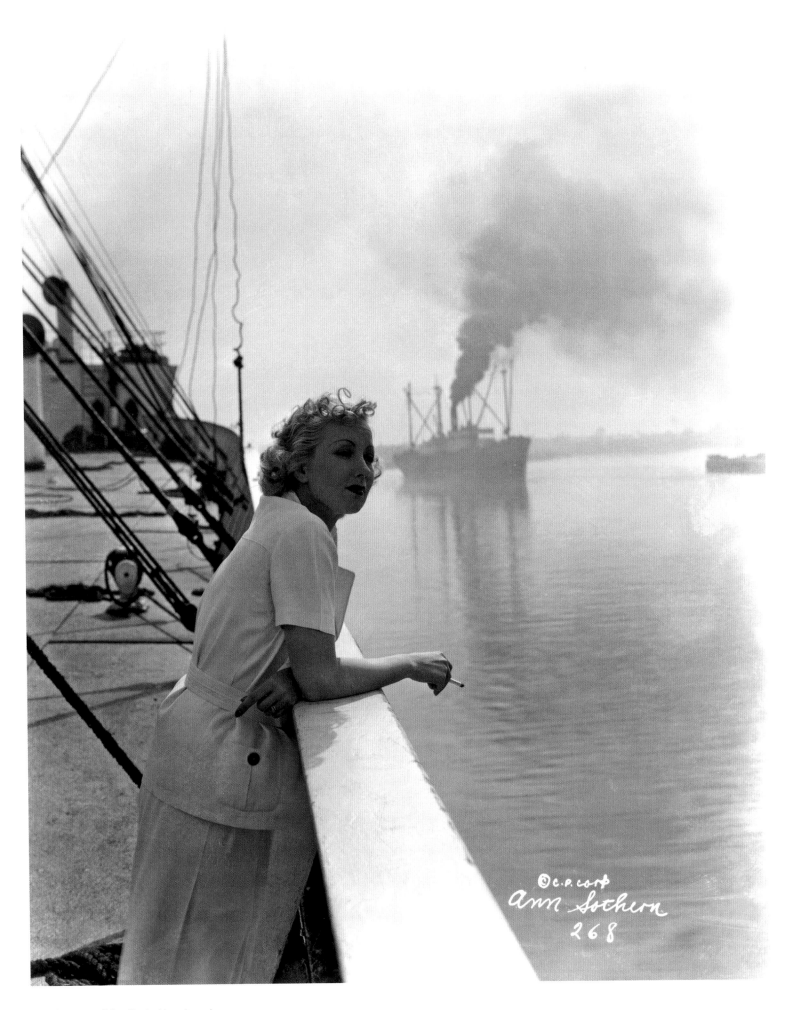

Ann Sothern at the Port of Los Angeles,
Long Beach, California
Columbia, c.1936

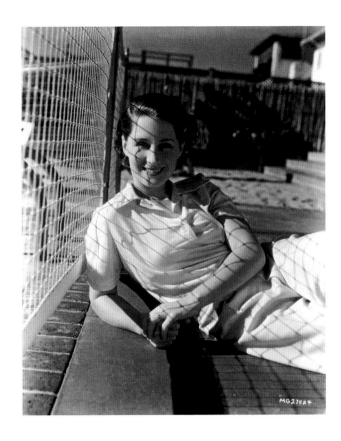

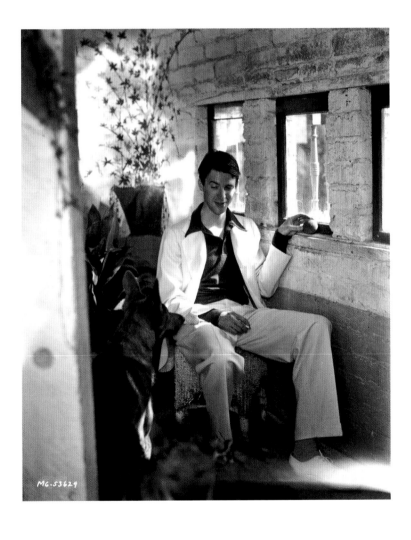

James Stewart playing with his dogs
MGM, 1936
Photograph by Ted Allan

Norma Shearer
MGM, 1932
Photograph by George Hurrell

19

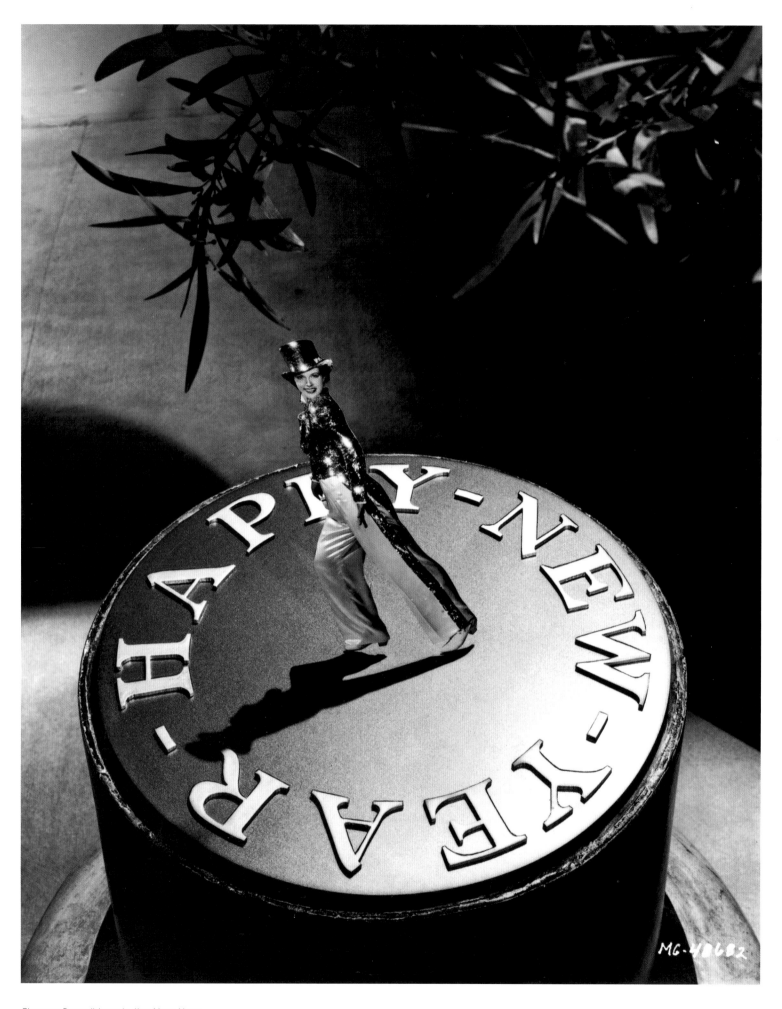

Eleanor Powell taps in the New Year
MGM, 1935
Photograph by Clarence Sinclair Bull

Annual events – including New Year, Easter, the Fourth of July (US Independence Day), Thanksgiving and Christmas – were perfect excuses for Studio publicists to promote their up-and-coming, young, pretty actresses. Young actors, however pretty, were rarely used for these festive shots

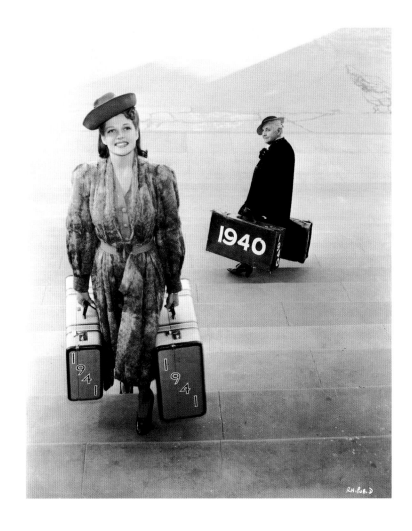

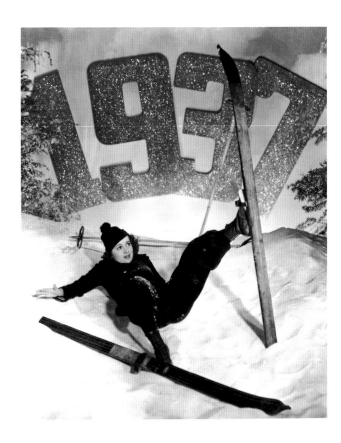

Olivia de Havilland for New Year 1937
Warner Brothers, 1936

Rita Hayworth brings in the New Year
Columbia, 1941

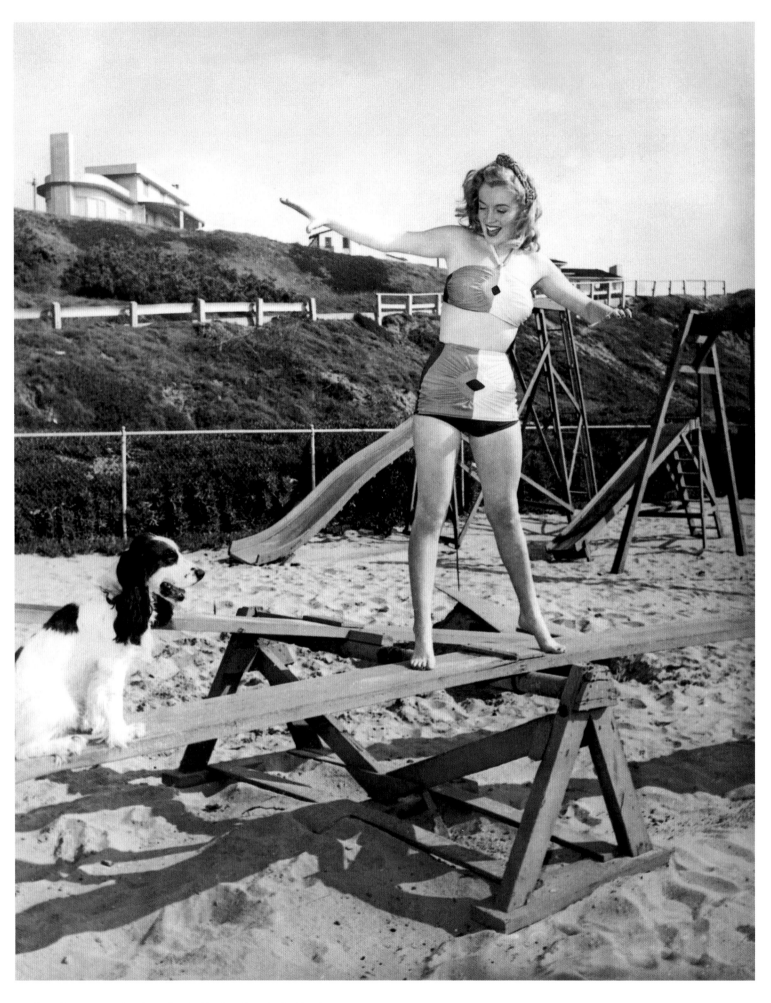

Marilyn Monroe keeping fit on Santa Monica Beach, California
Columbia, c.1948

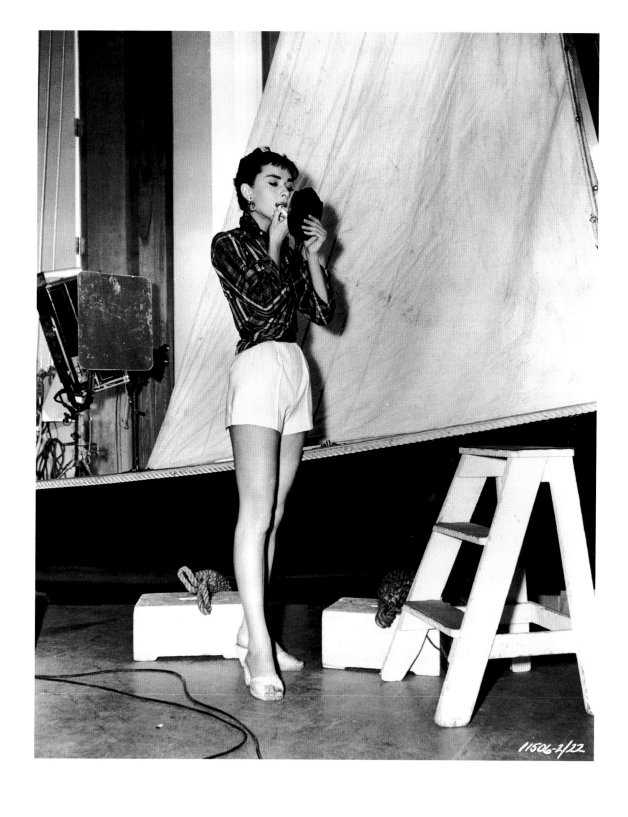

Audrey Hepburn adjusts her make-up off set, Billy Wilder's *Sabrina*
Paramount Pictures, 1954

Stan Laurel and Oliver Hardy during the filming
of the silent short *The Finishing Touch*
MGM, 1927

MGM-14580

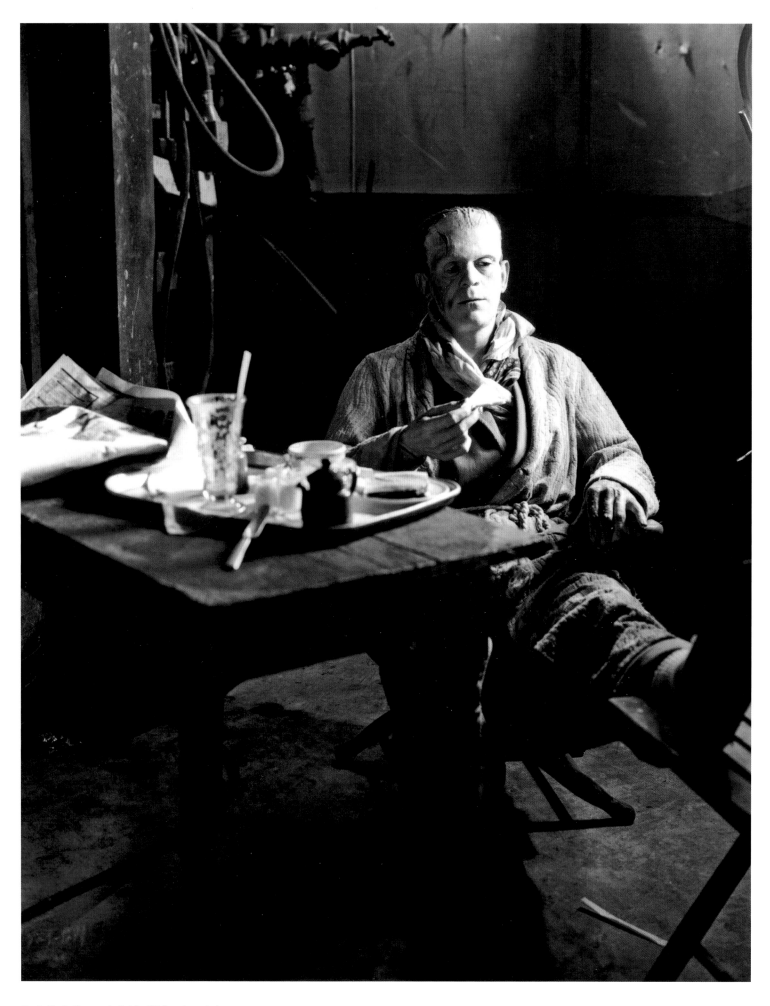

Boris Karloff on set, *Bride Of Frankenstein*
Universal, 1935

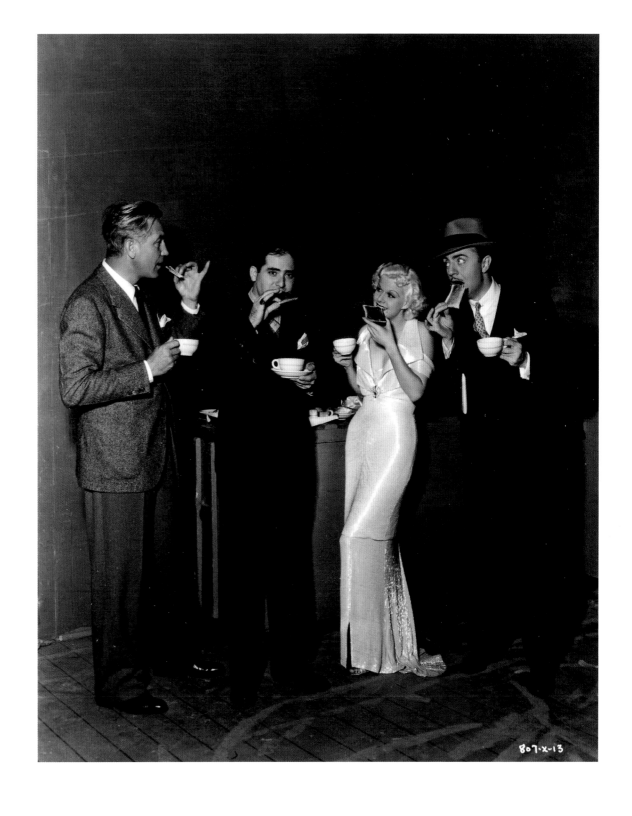

Jean Harlow on set for the musical melodrama *Reckless*
with director Victor Fleming and co-star William Powell
MGM, 1934
Photograph by Virgil Apger

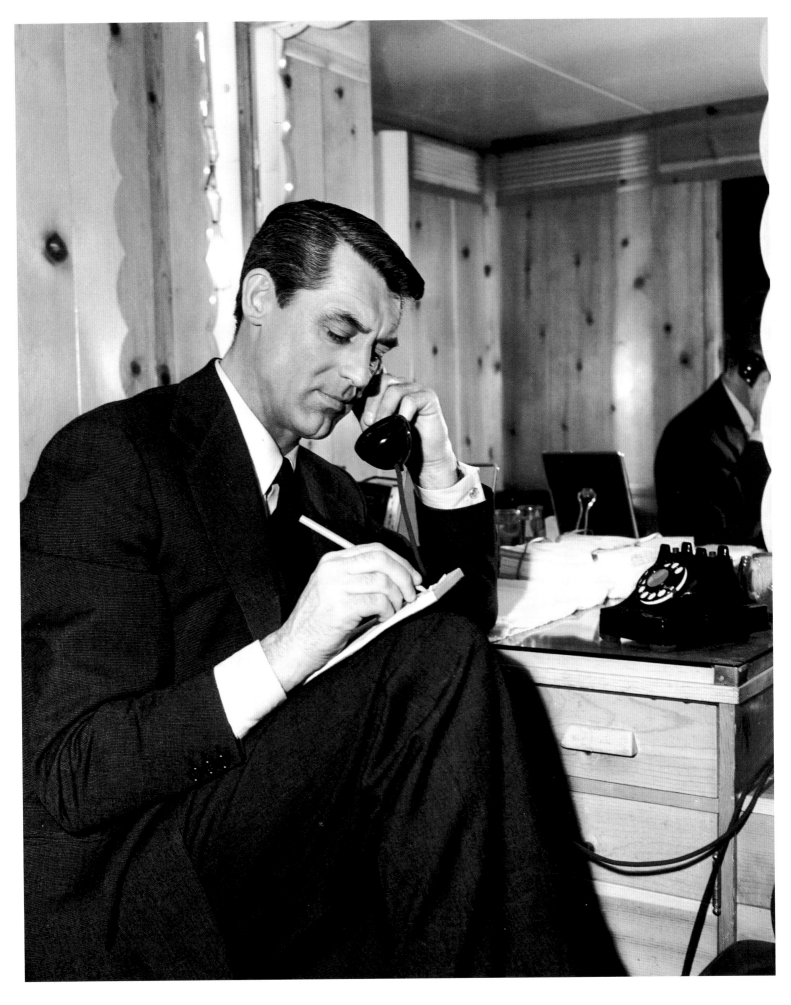

Cary Grant makes a call off set, *Crisis*
MGM, 1950

"*I stopped believing in Santa Claus when I was six. Mother took me to see him in a department store and he asked for my autograph.*"

Shirley Temple

It was common for Studios to set up shots that promoted a potential new star, such as Temple, by linking them with a more established one like Scott – or, as in the case of Marx and Dietrich, to remind the public that they were contracted to a particular Studio – in this case, Paramount Pictures.

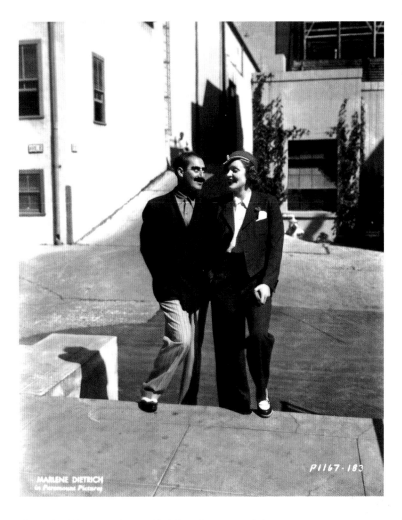

Shirley Temple and Randolph Scott at Paramount
Studios during the filming of *To The Last Man*
Paramount Pictures, 1933

Groucho Marx meets up with fellow Paramount star,
Marlene Dietrich, on the Studio back lot, Los Angeles
Paramount Pictures, 1933
Photograph by Don English

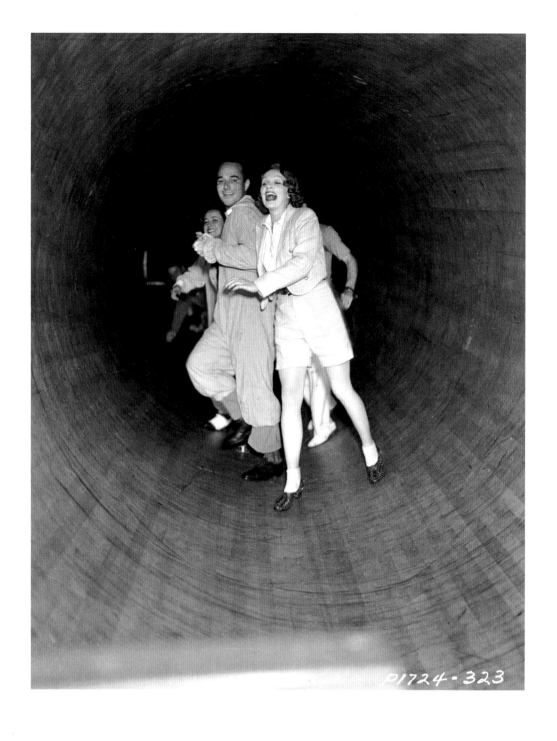

P1724·323

Marlene Dietrich and William Haines at the Venice
Amusement Pier for a party hosted by Carole Lombard
Paramount Pictures, 1935
Photograph by Jerome Zerbe

Cary Grant with actress Toby Wing, director
Mitchell Leisen and friends at the same party
Paramount Pictures, 1935
Photograph by Jerome Zerbe

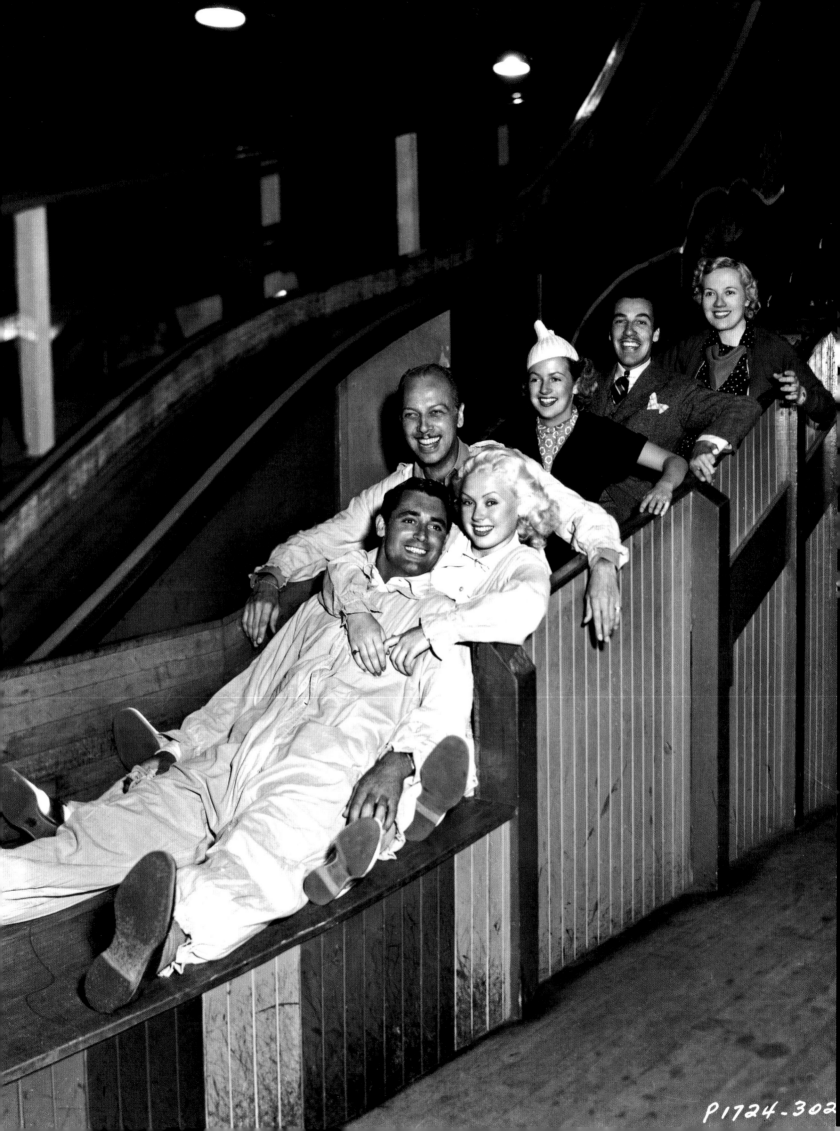

P1724-302

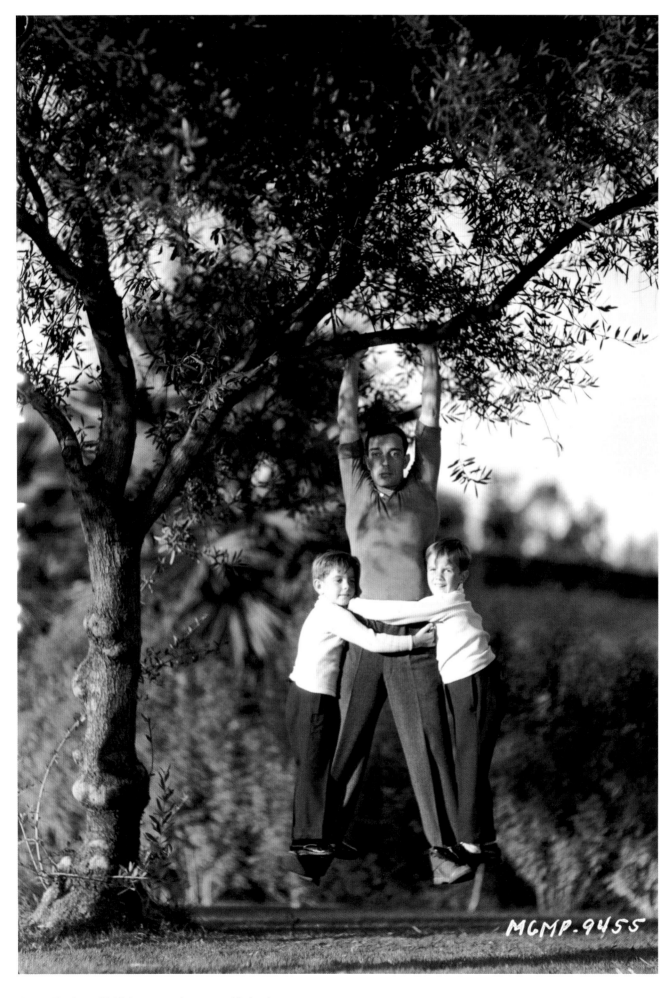

MGMP.9455

Buster Keaton with his two sons, James and Robert
MGM, 1928

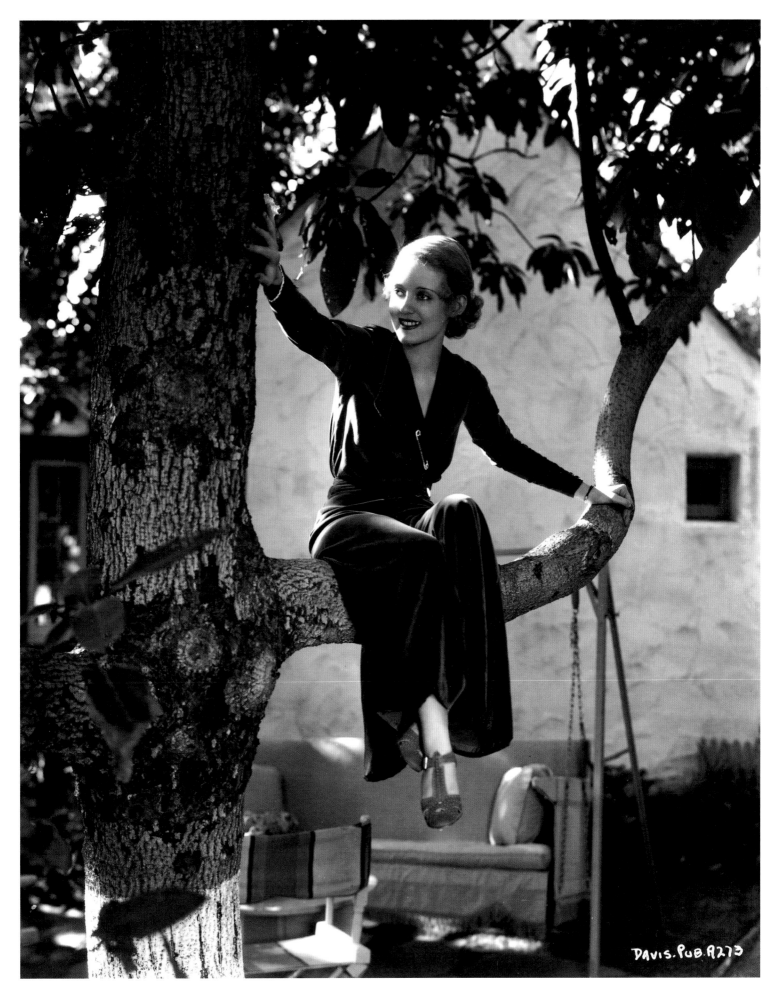

Bette Davis
Warner Brothers, c.1936

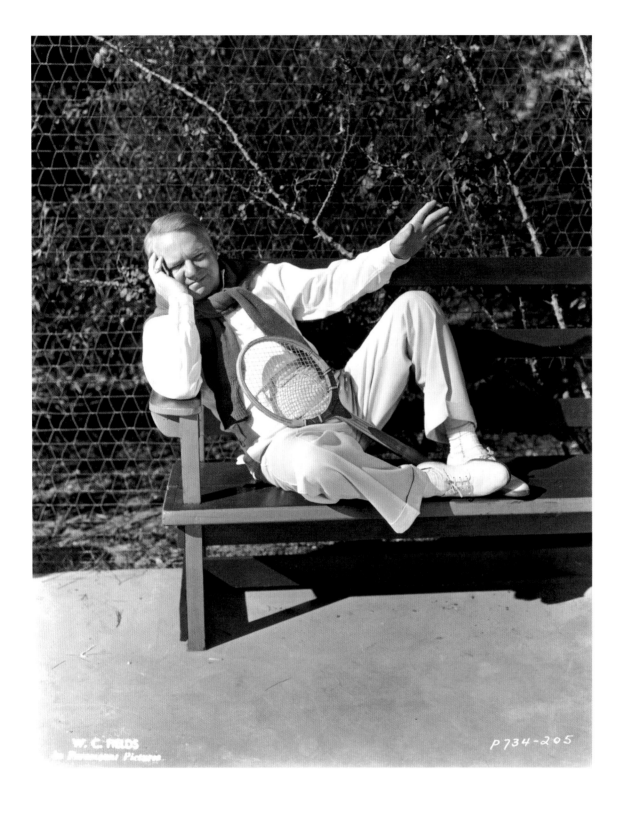

Studios always promoted their stars as leading
healthy lives by showing them engaged in every
outdoor pursuit imaginable. If you had Burt Lancaster
then that was no problem, but Fields' screen image
was more commonly associated with alcohol-related
activities. He may have been wonderful at tennis, but
the public would not have believed it and would
rather have enjoyed the jokey idea portrayed here.

W.C. Fields
Paramount Pictures, c.1934

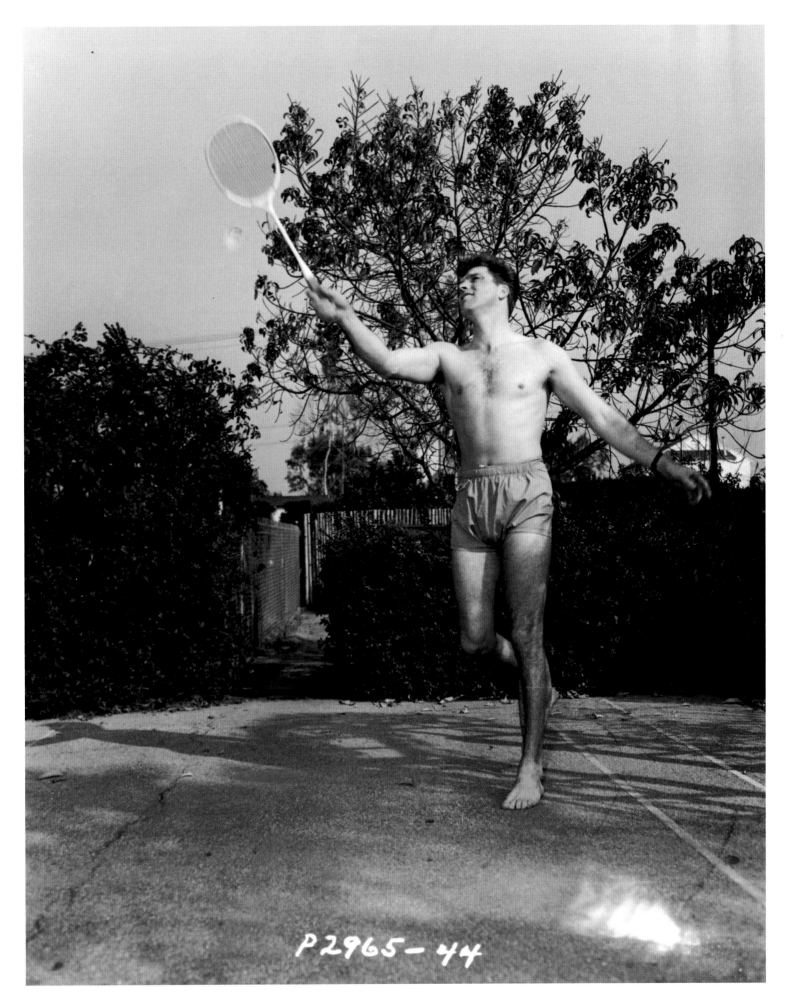

P2965-44

Burt Lancaster
Paramount Pictures, c.1946

Dick Powell and Ruby Keeler relaxing on the beach whilst
publicizing their appearance in *Footlight Parade*
Warner Brothers, 1933

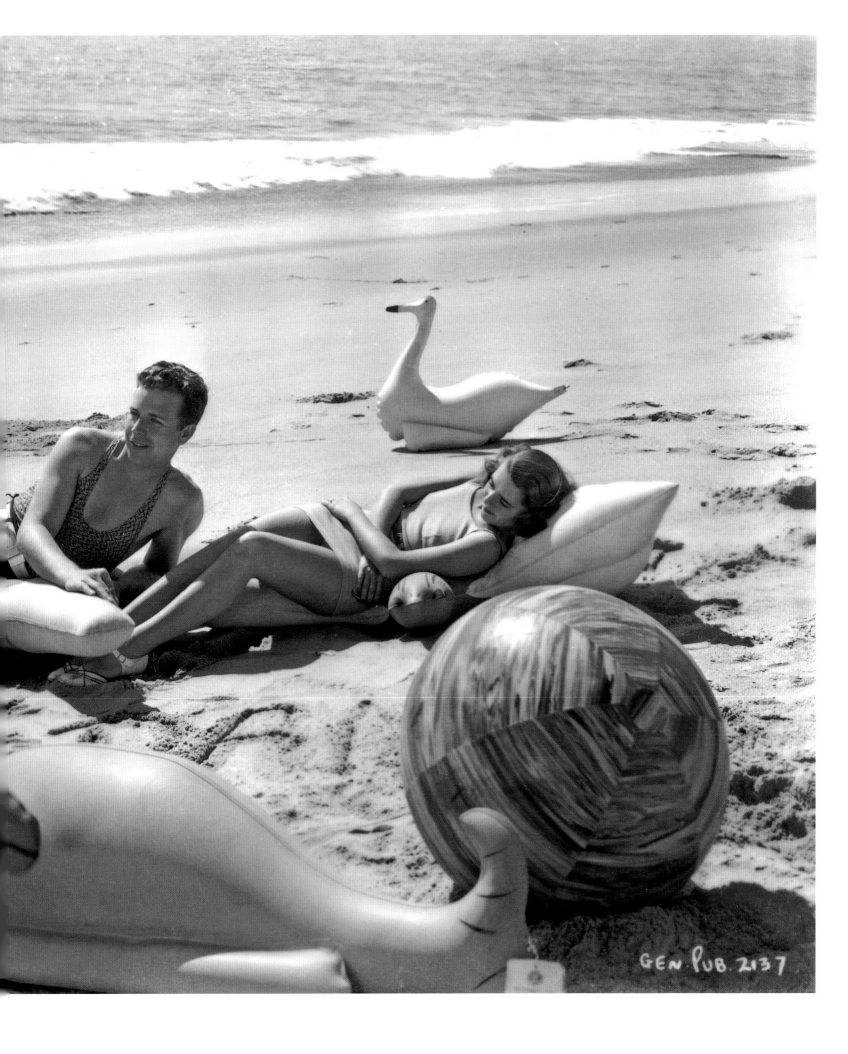

GEN PUB 2137

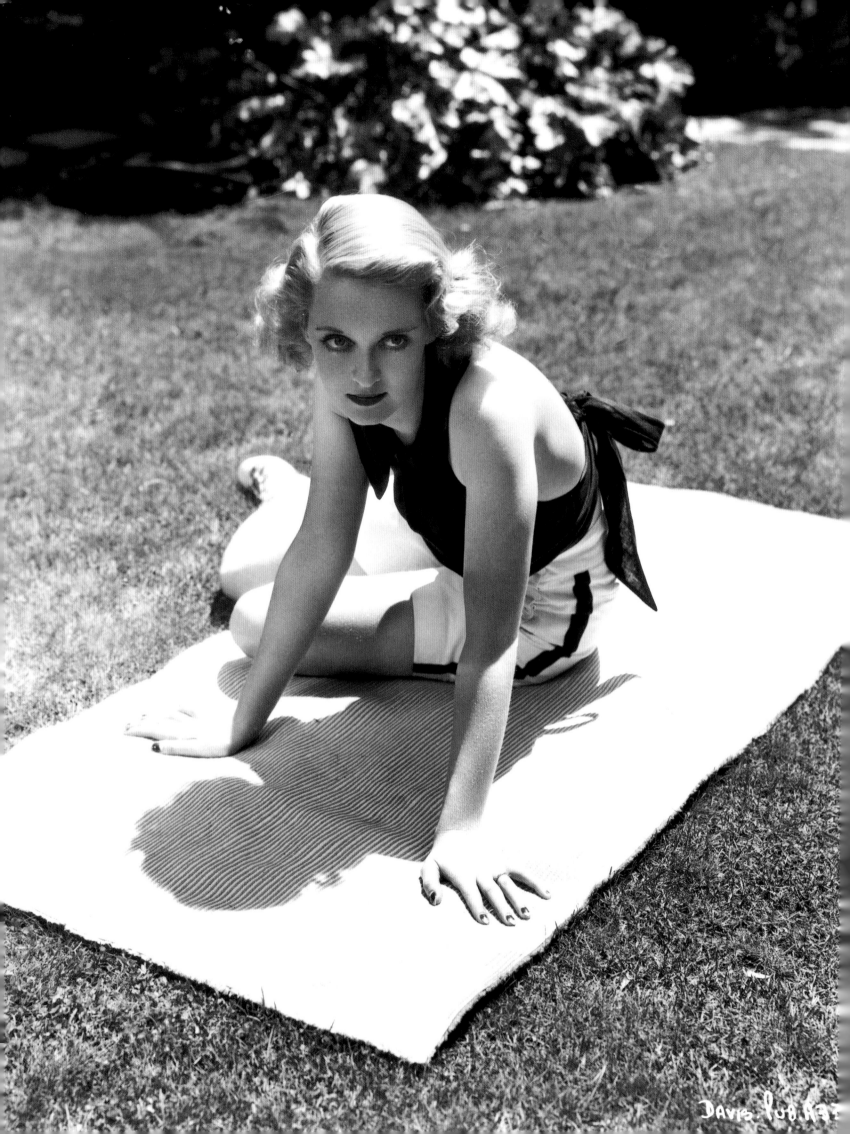

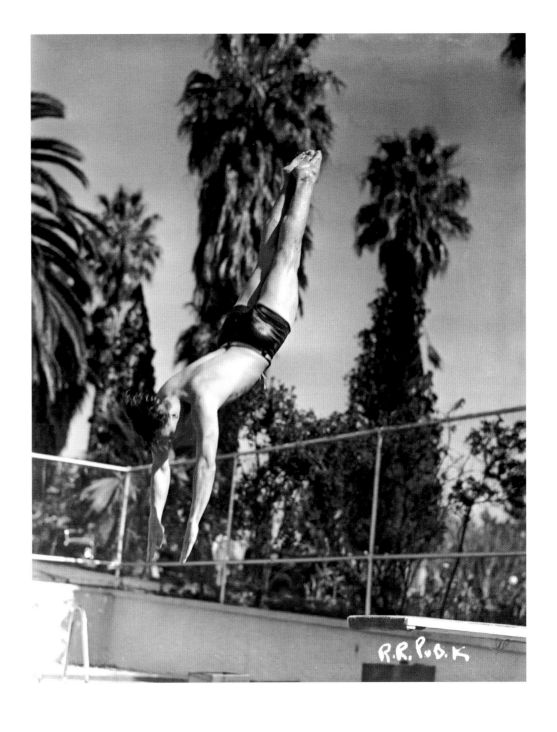

Bette Davis
Warner Brothers, 1931

Ronald Reagan at home, Pacific Palisades, California
Warner Brothers, 1940

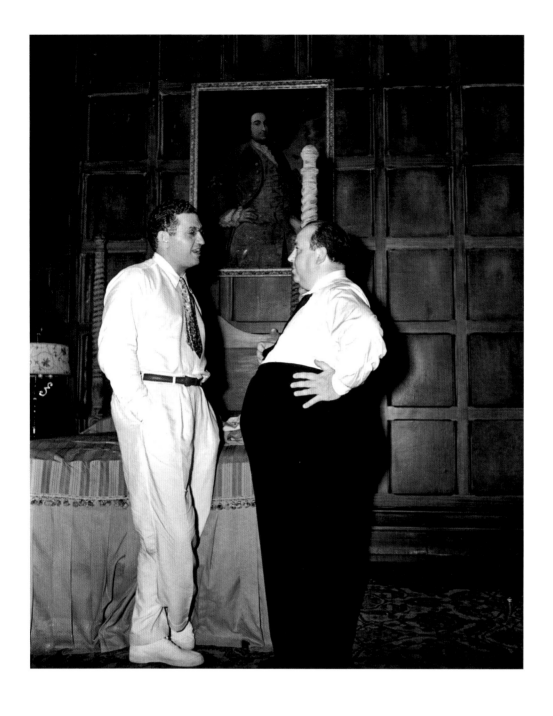

Producer David O. Selznick with director
Alfred Hitchcock on set, *Rebecca*
Selznick International Pictures/United Artists, 1939

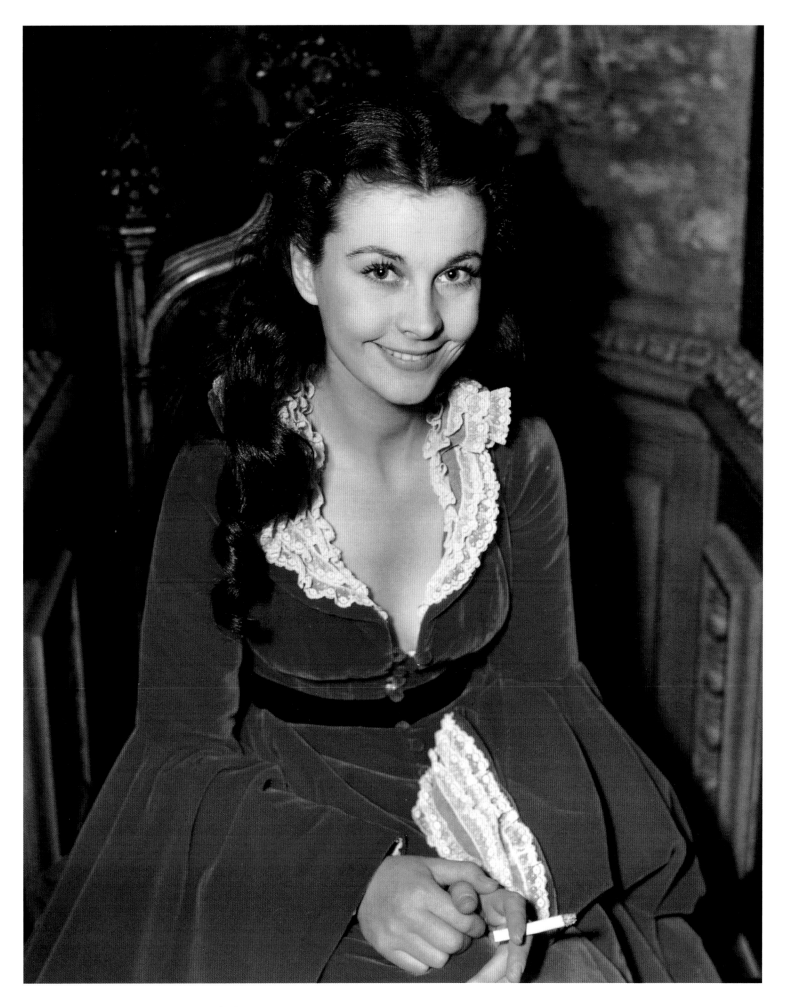

Vivien Leigh taking a break during the filming
of *Gone with the Wind*
MGM, 1939
Photograph by Fred Parrish

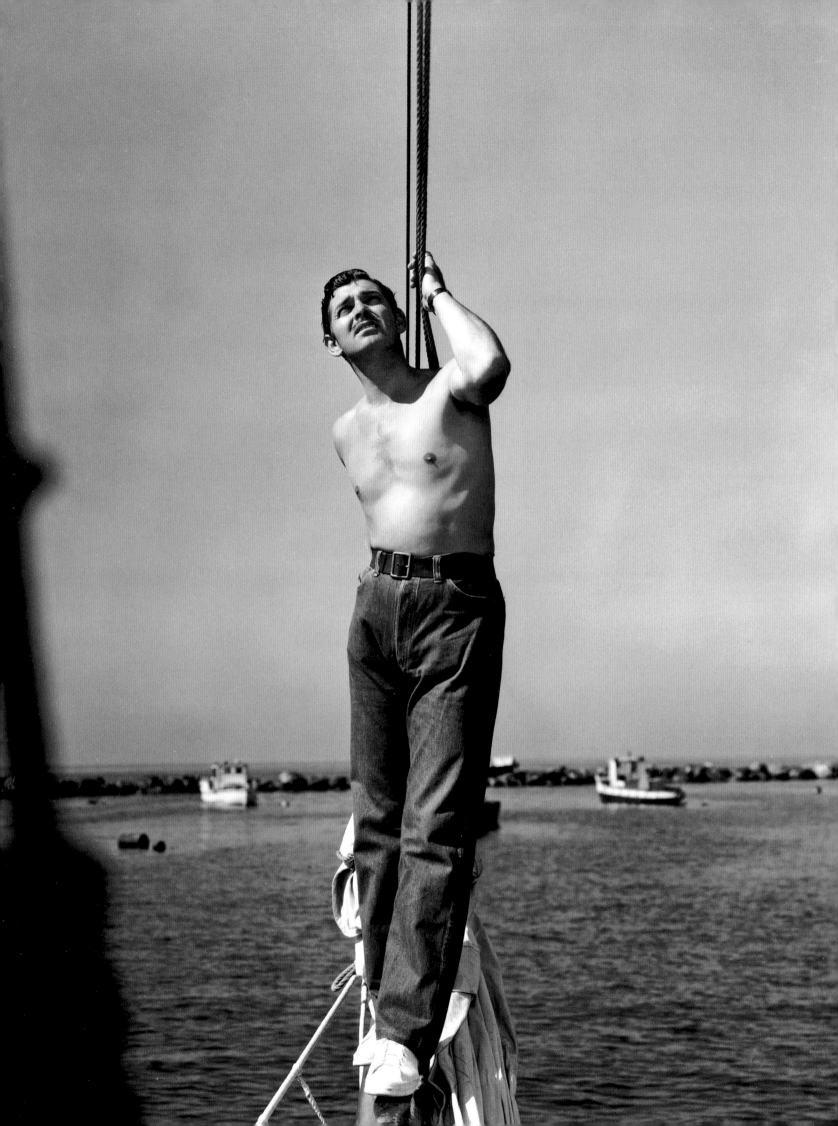

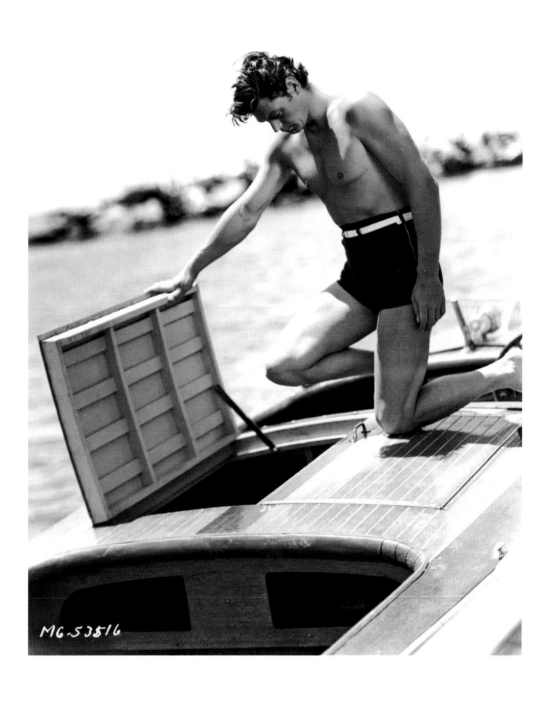

Clark Gable
MGM, 1939
Photograph by Clarence Sinclair Bull

Johnny Weissmuller
MGM, 1936
Photograph by Clarence Sinclair Bull

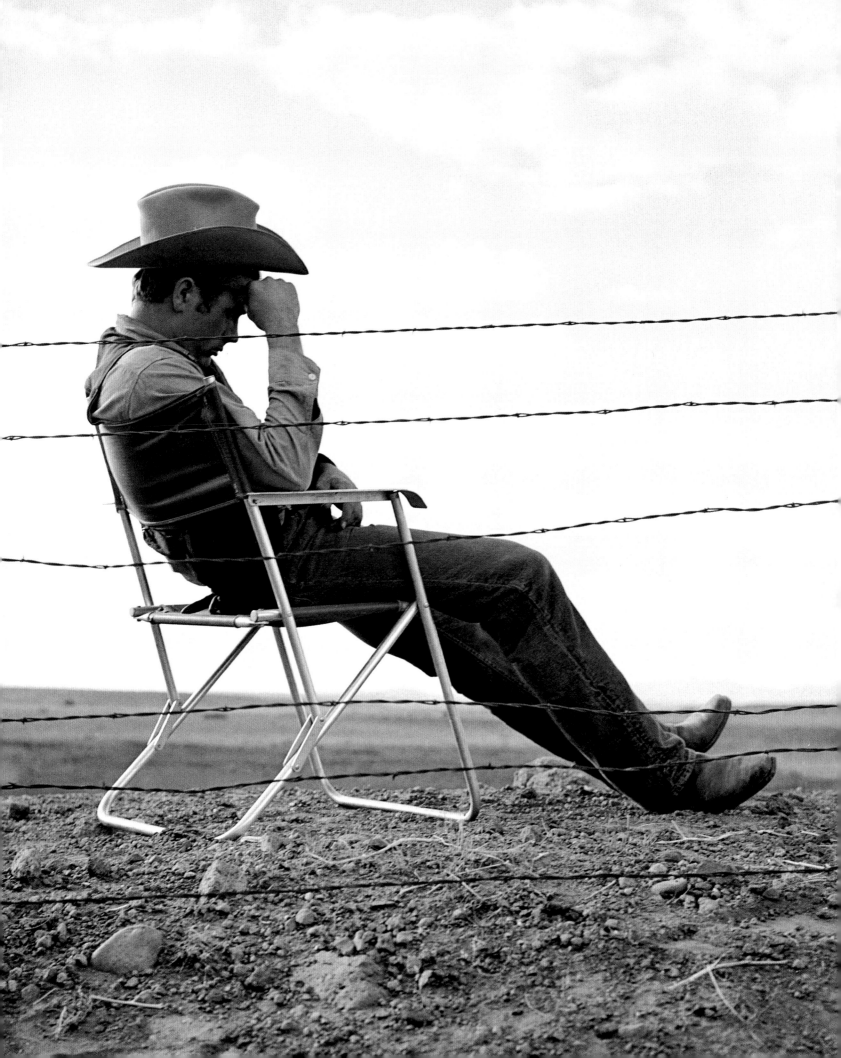

James Dean on set, *Giant*
Warner Brothers, 1956
Photograph by Frank Worth

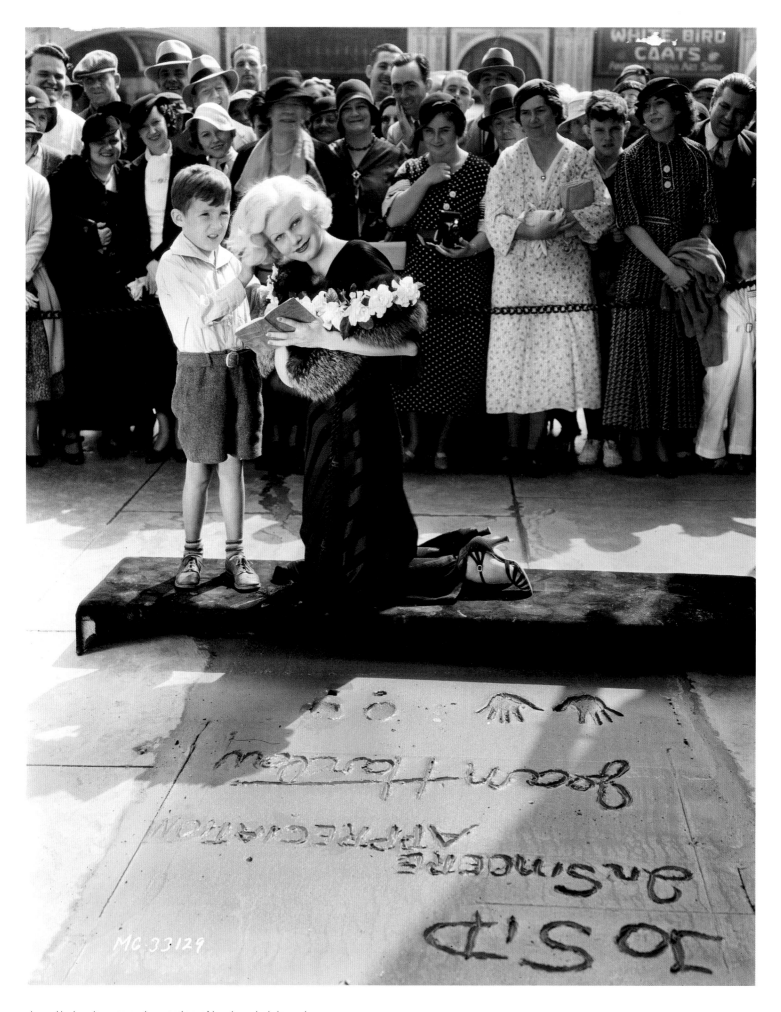

Jean Harlow leaves an impression of her handprints and
a message in the wet cement on the sidewalk outside
Grauman's Chinese Theater on Hollywood Boulevard
MGM, 1933

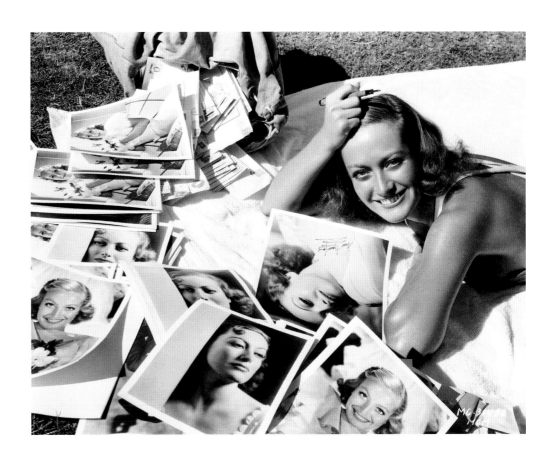

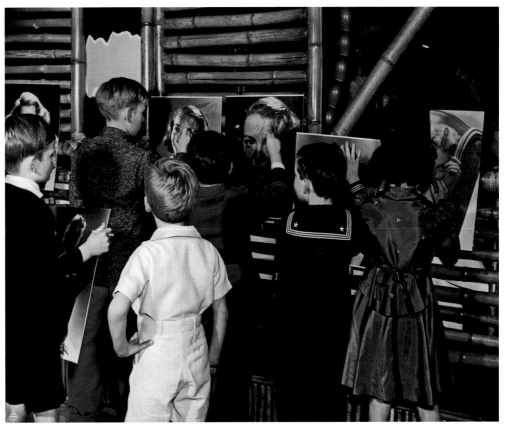

Joan Crawford autographing
photos for fans
MGM, 1933
Photograph by Clarence
Sinclair Bull

At the *Baby Be Good* premiere party, hosted by socialite Elsa
Maxwell, a new game was introduced when she gave prizes
to the children who disfigured star photos in the best way
Warner Brothers, 1940

Stan Laurel and Oliver Hardy signing autographs for
young fans on the set of their second feature film,
Pack Up Your Troubles
MGM, 1932

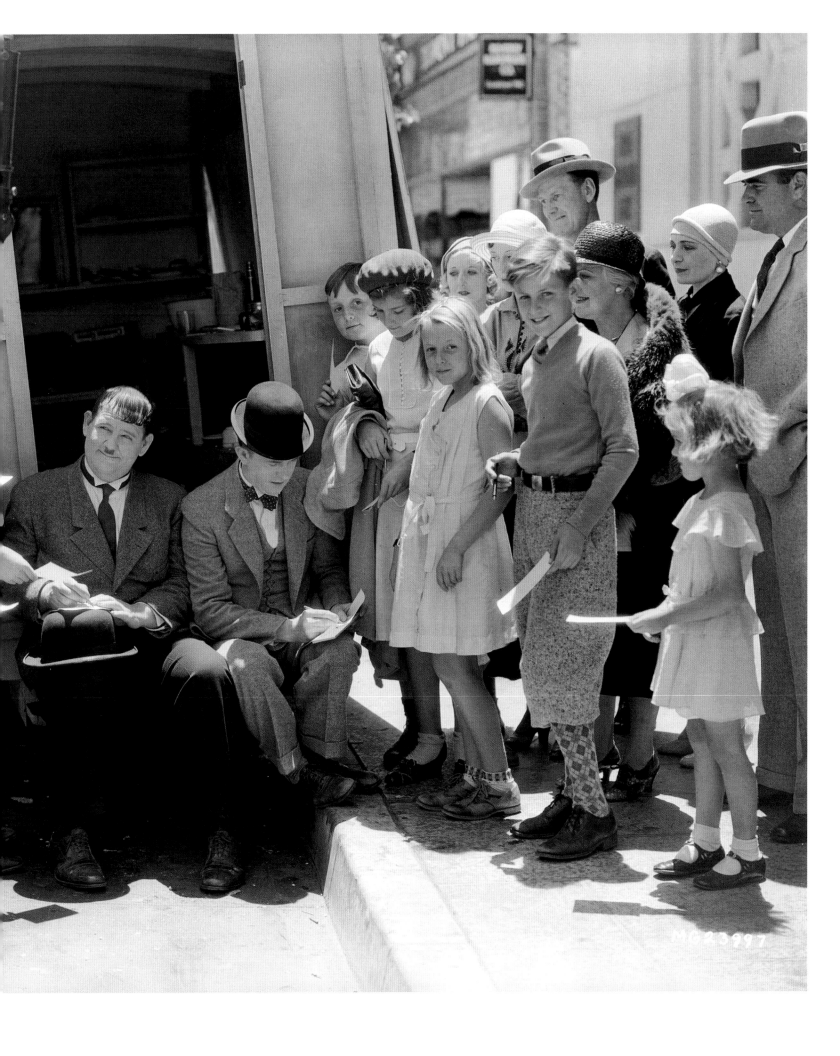

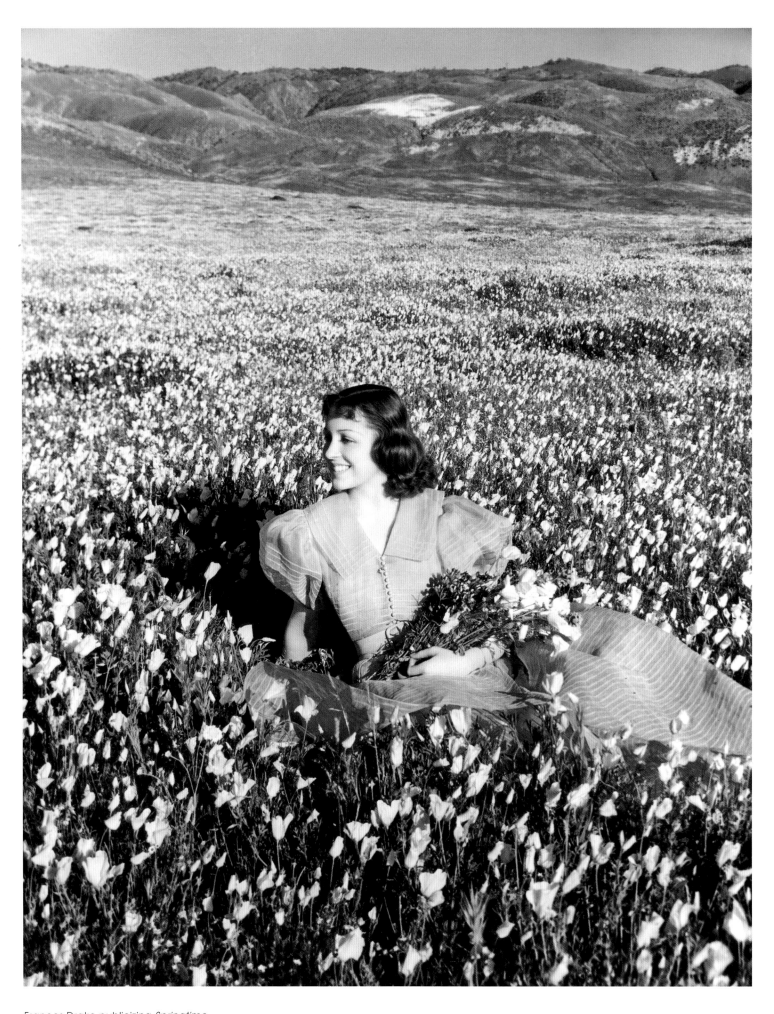

Frances Drake publicizing *Springtime*
Paramount Pictures, 1934

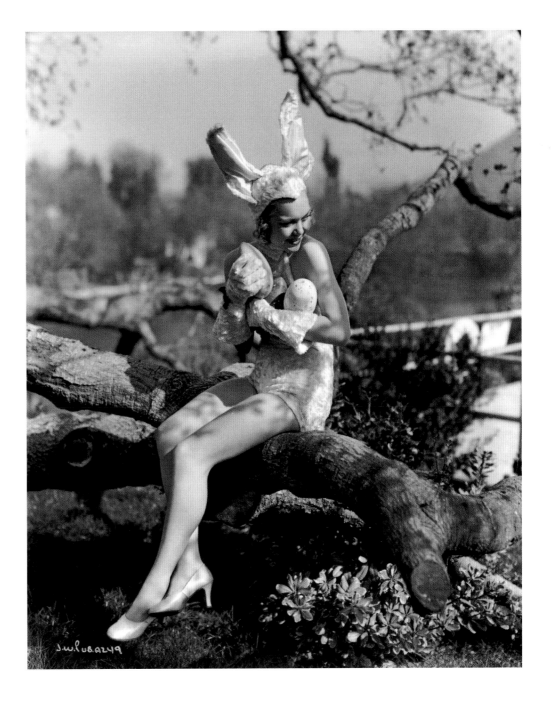

"Wild Flowers Brighten Hollywood – When Spring
comes to Hollywood the surrounding hills take on
the variegated colours of blue and pink lupins,
California poppies, and a score of other varieties.
Frances Drake, Paramount actress, is shown when
she gathered some of the blooms at Tejon ranch.
Snow still fringed the nearby hilltops."

Original Paramount Pictures photo caption

Jane Wyman as the Easter Bunny
Warner Brothers, 1936

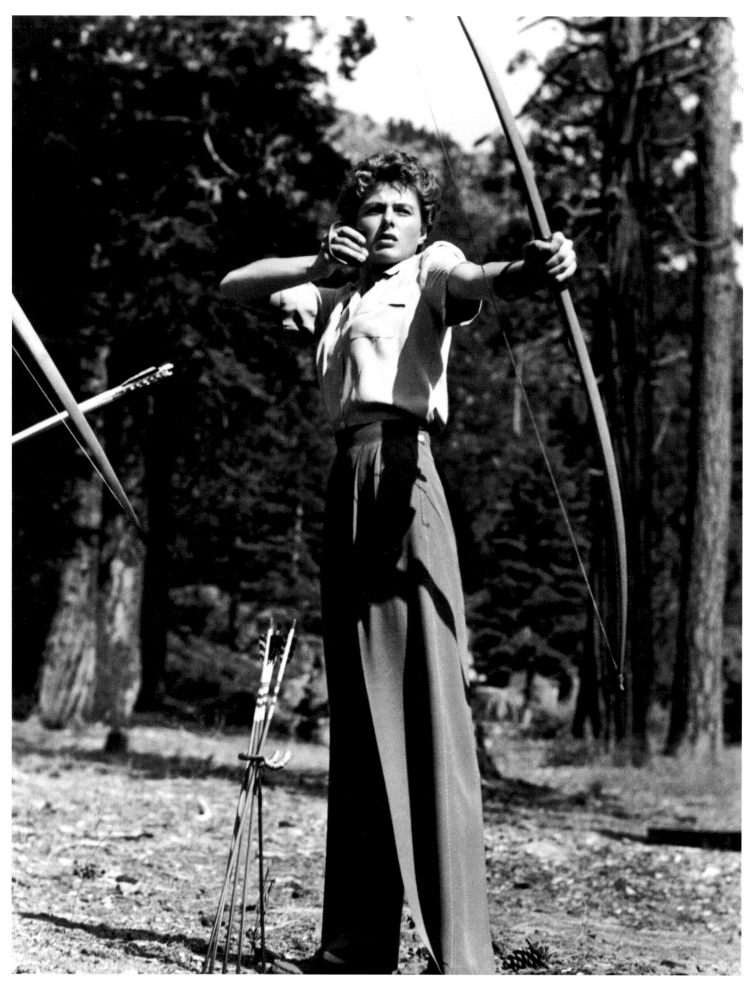

Ingrid Bergman
Paramount Pictures, c.1943

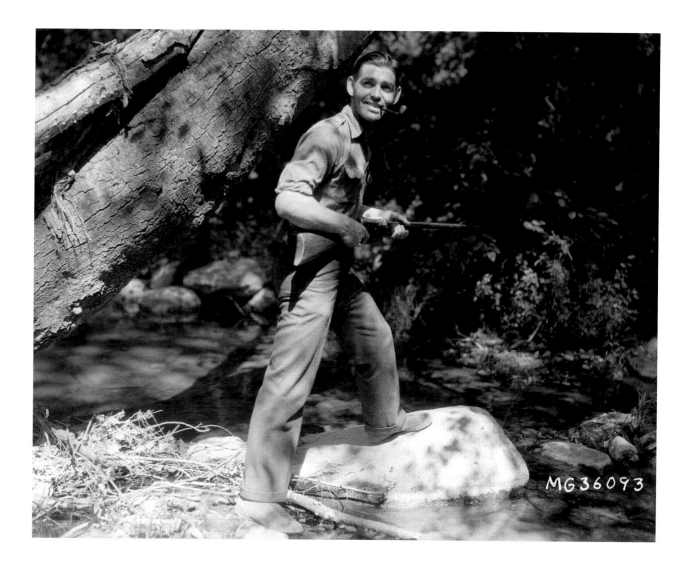

MG36093

The Studios were constantly trying to fix the image of a potential star in the minds of the public. They often tried all angles – from the outdoor, healthy, sporty type to the sophisticated city-dweller and partygoer – before settling on the one that worked best. Here Ingrid Bergman stretches her bow (and in other pictures can be seen fishing or cycling) to try to persuade us of her healthy, active credentials. However, Bergman's Swedish bloom gave her a naturally healthy appearance, and it was the images from her wonderful films like *Casablanca*, *Gaslight*, *Spellbound* and *Indiscreet* which eventually stuck in our minds, and not the posed Studio portraits.

Clark Gable was an interesting case because he was naturally an urban animal, but MGM felt his image should also be that of a rugged "man of the world" who enjoyed outdoor pursuits. The Studio trained him up and Gable, who had never done any of those things before, got to enjoy them so much that his created image became a reality.

Clark Gable
MGM, 1931

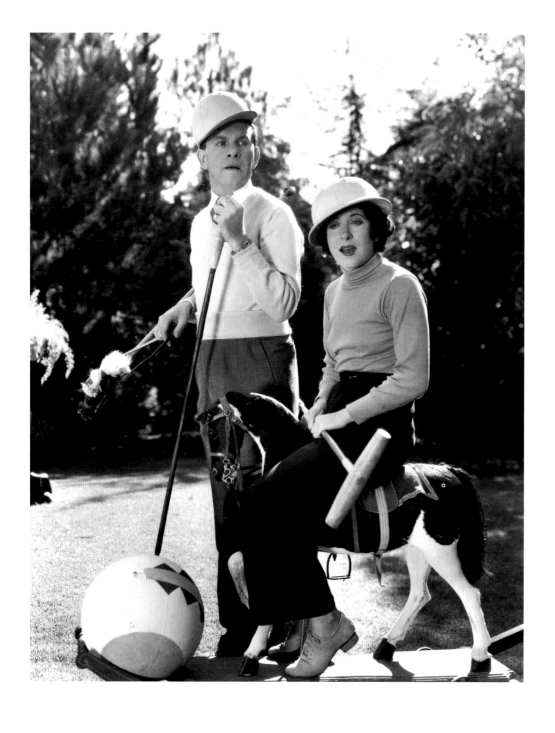

Husband and wife, the comedy duo George Burns and
Gracie Allen, enjoying a multi-sport moment in their garden
Paramount Pictures, c.1936

Jean Harlow at the Riviera Country Club,
Pacific Palisades, California
MGM, 1932
Photograph by Clarence Sinclair Bull

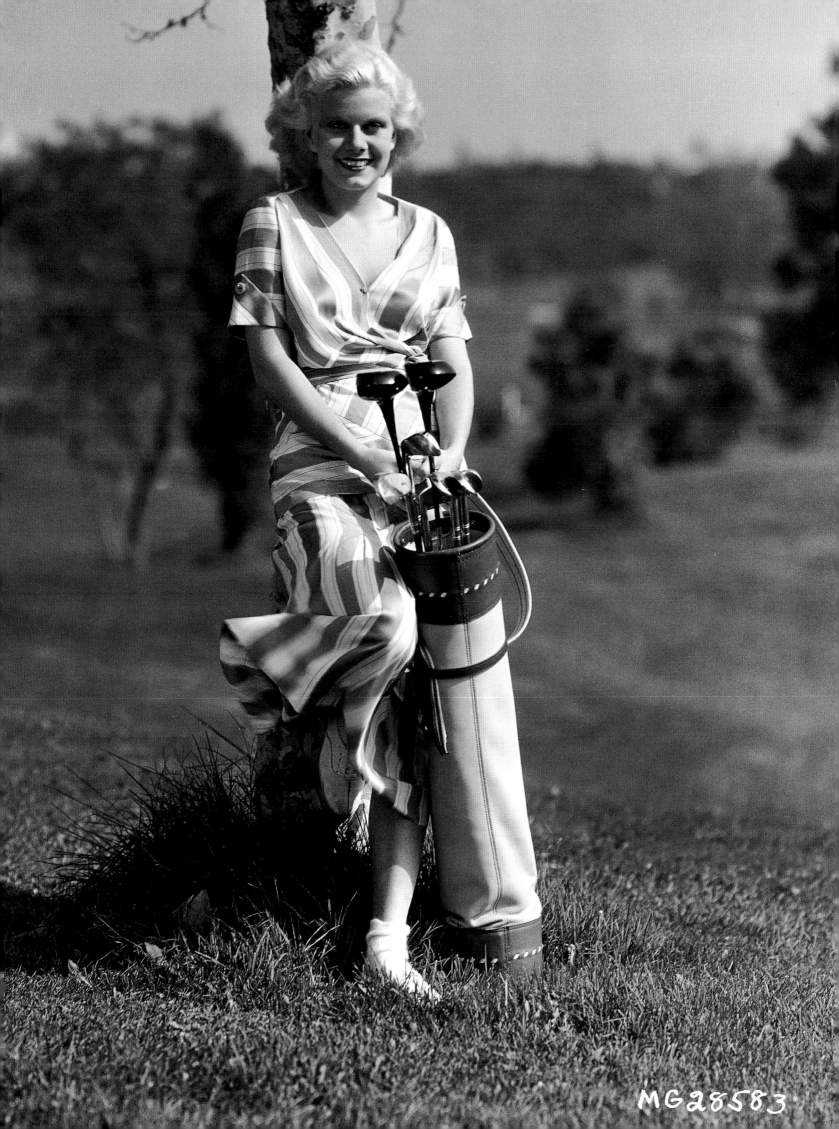

P2001-633

Joan Blondell
Paramount Pictures, c.1940

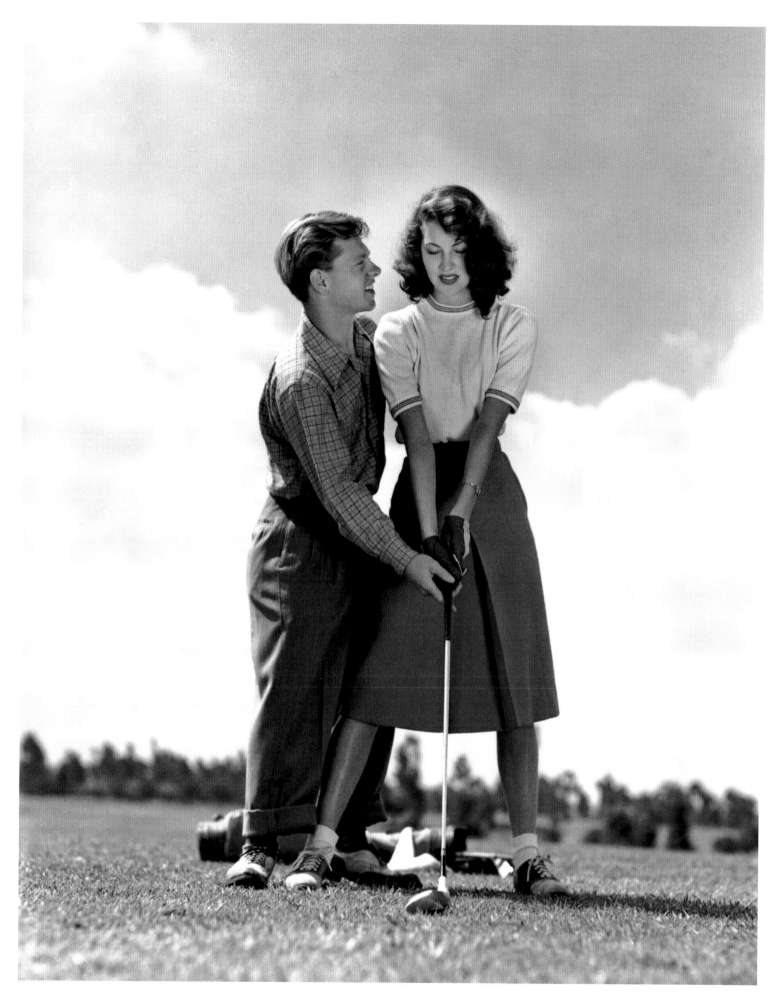

Mickey Rooney and his first wife, Ava Gardner
MGM, 1942
Photograph by Eric Carpenter

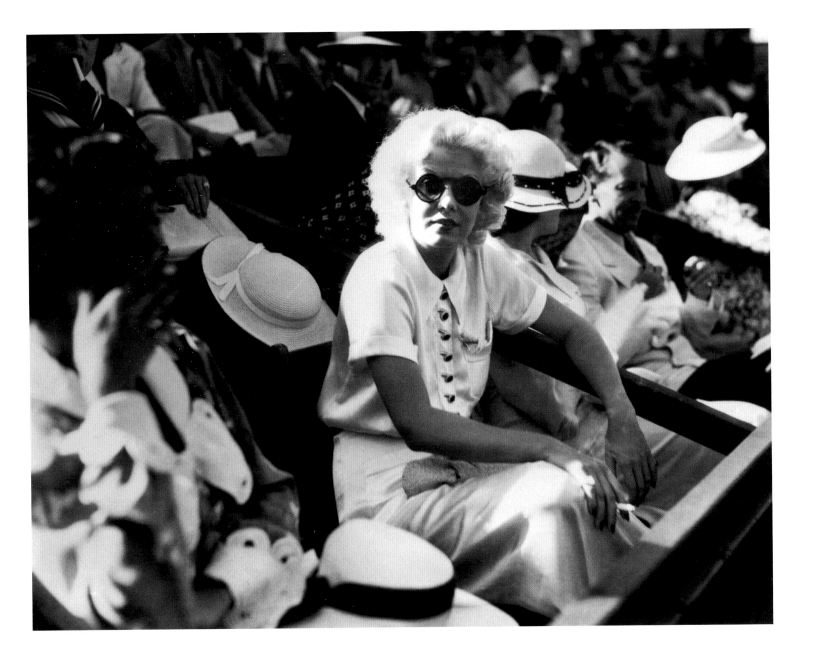

Jean Harlow at the National Air Races, California
MGM, 1933

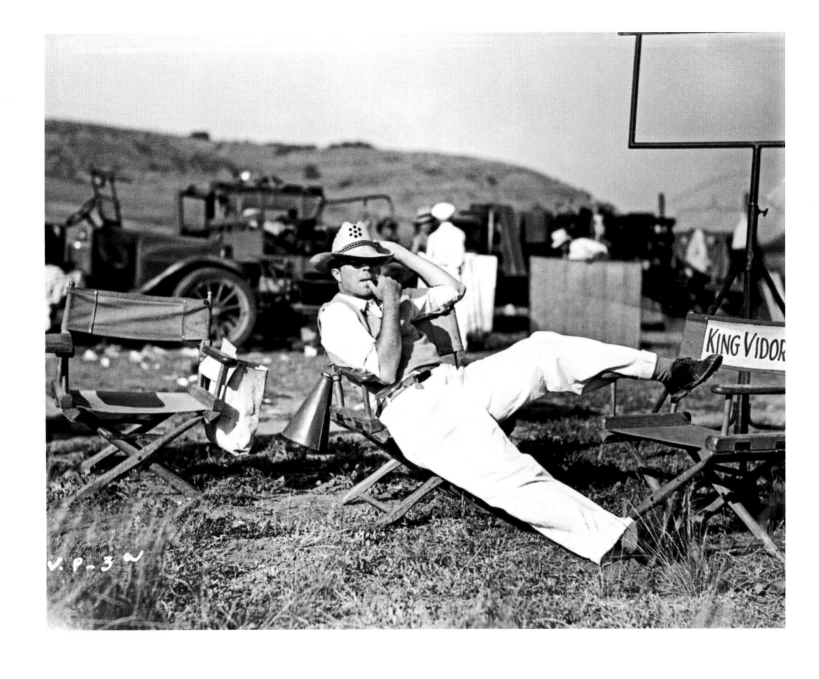

King Vidor on set, *Our Daily Bread*
United Artists, 1934

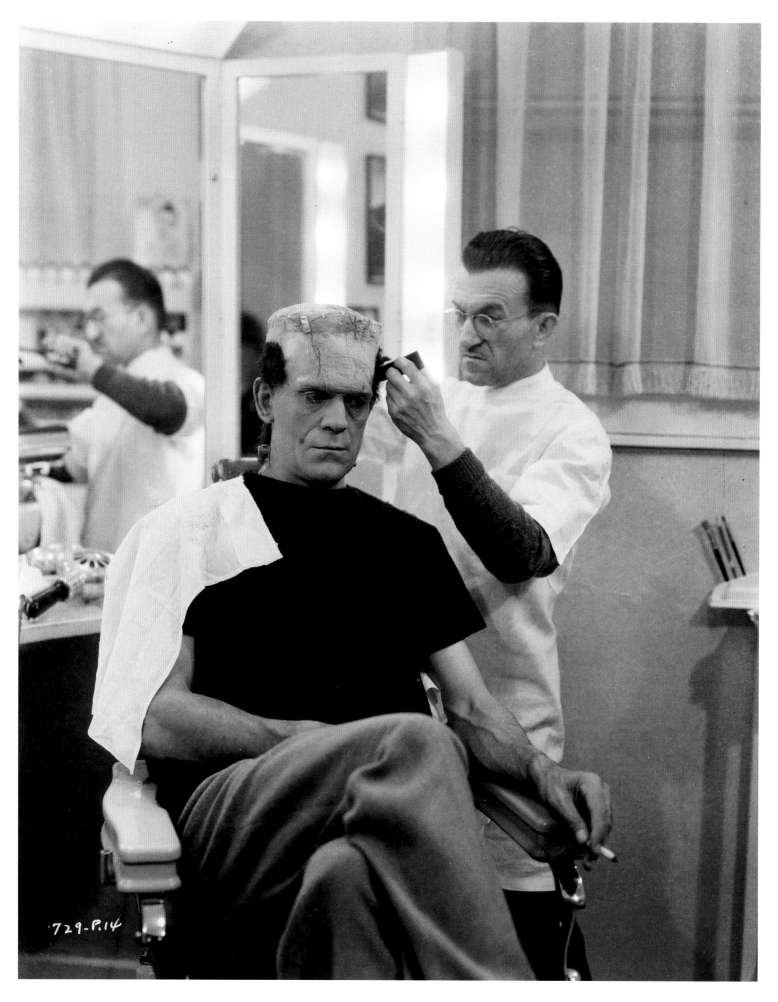

Make-up artist Jack P. Pierce transforms Boris Karloff
into the monster for *Bride of Frankenstein*
Universal, 1935

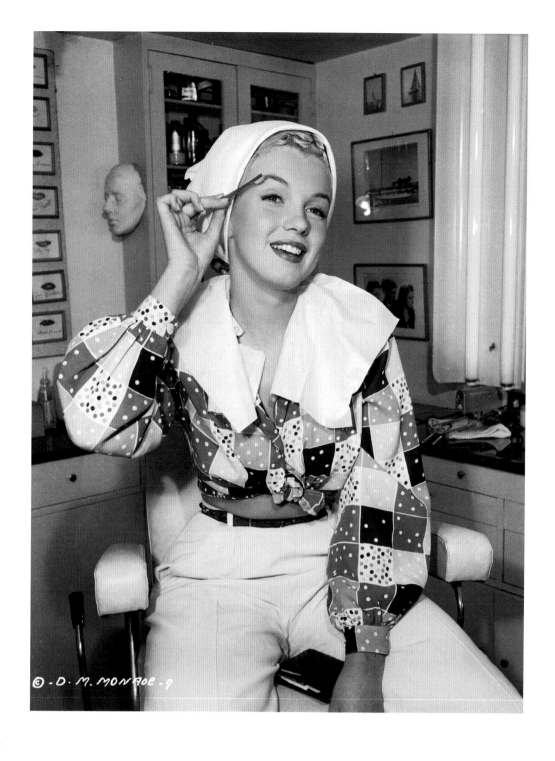

Marilyn Monroe does a make-up test
Columbia, 1948

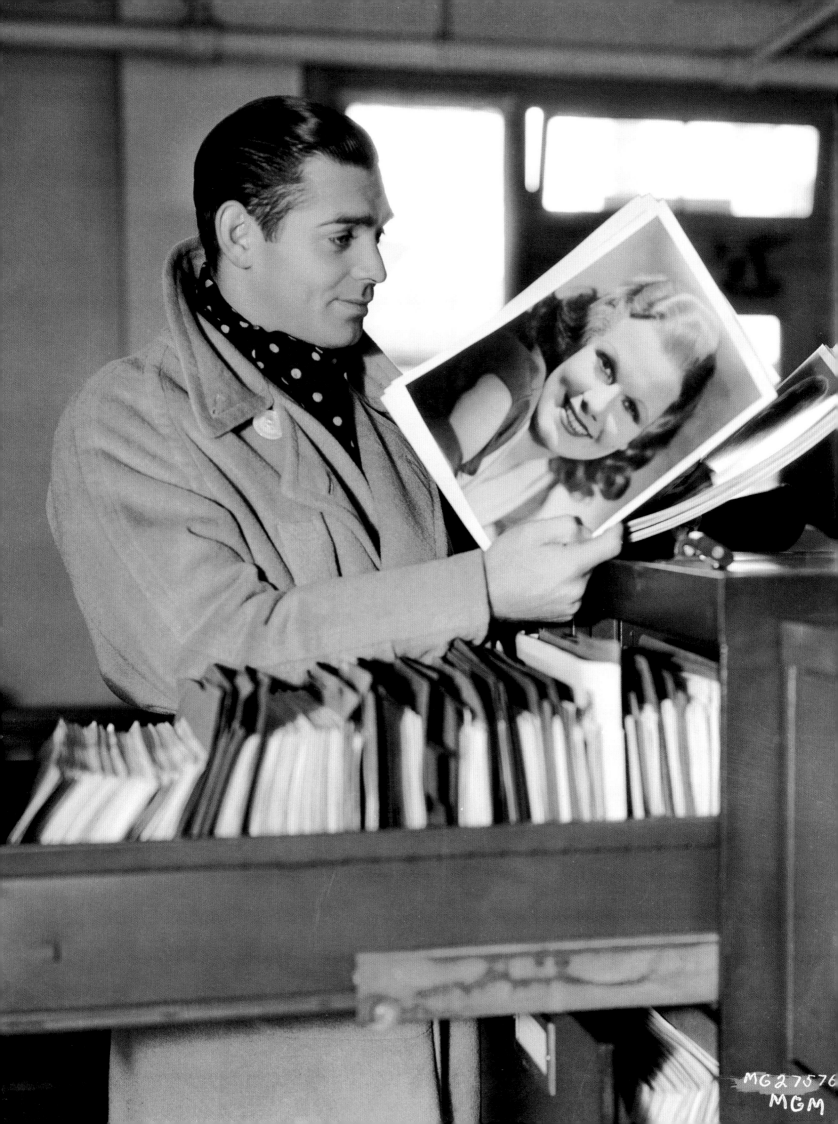

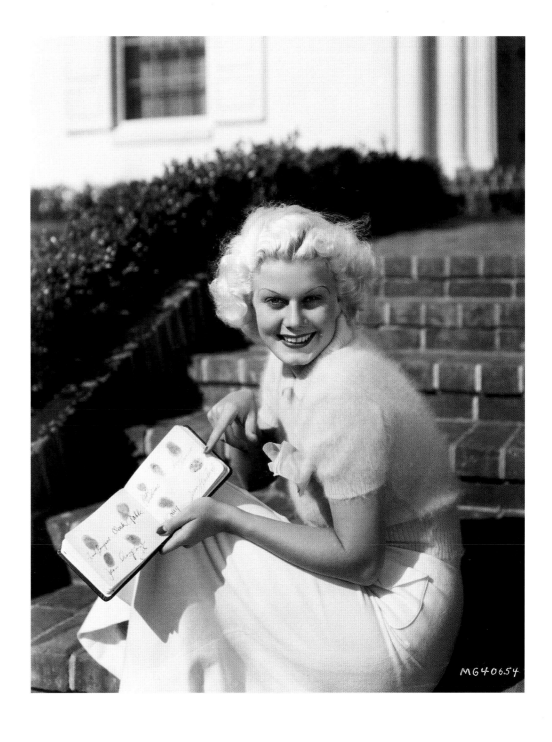

Clark Gable admiring photographs
of actress Jean Harlow, with whom
he co-starred in six films including
Red Dust and *Saratoga*
MGM, 1932

Jean Harlow with her book of autographed
fingerprints, including those of Joan Crawford
and Clark Gable
MGM, 1934

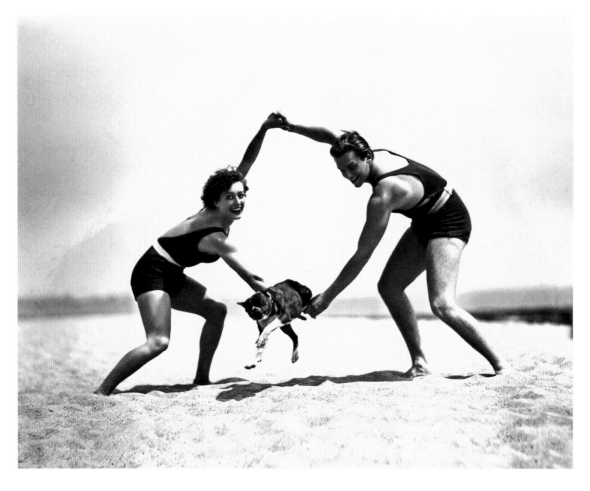

Joan Crawford and her first husband, Douglas Fairbanks Jnr,
on Santa Monica Beach, California
MGM, 1929
Photograph by Clarence Sinclair Bull

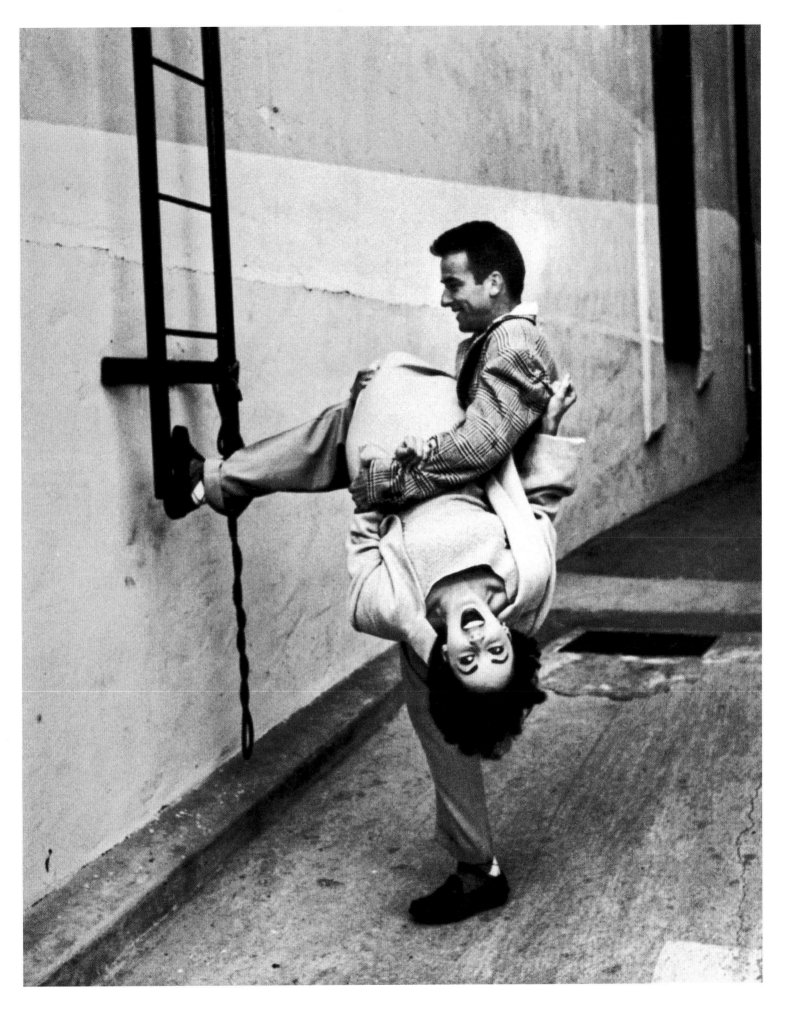

Montgomery Clift and Elizabeth Taylor outside the sound
stage at Paramount Studios whilst filming *A Place in the Sun*
Paramount Pictures, 1950
Photograph by Peter Stackpole

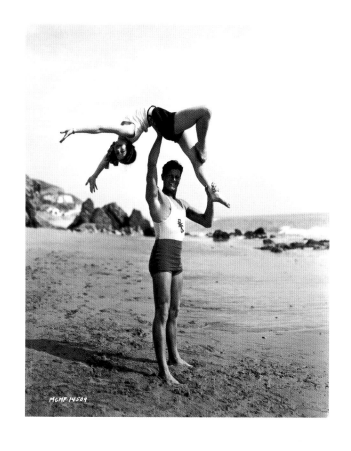

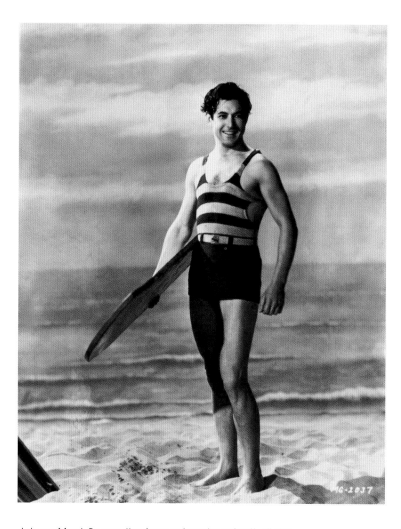

Joel McCrea and MGM starlet, Dorothy Sebastian
MGM, 1928
Photograph by Don Gillum

Johnny Mack Brown, the former American football star,
promoting summer sports on a "beach" in the photo
gallery on the studio back lot
MGM, 1930

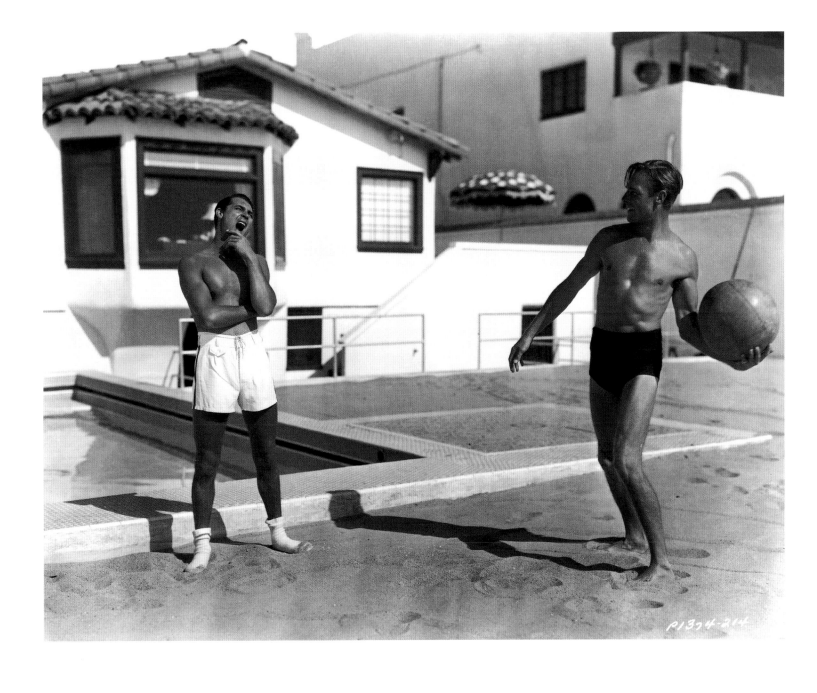

Cary Grant and Randolph Scott on the beach outside
"Bachelor Hall", the nickname of their shared house in Malibu
Paramount Pictures, 1935
Photograph by Jerome Zerbe

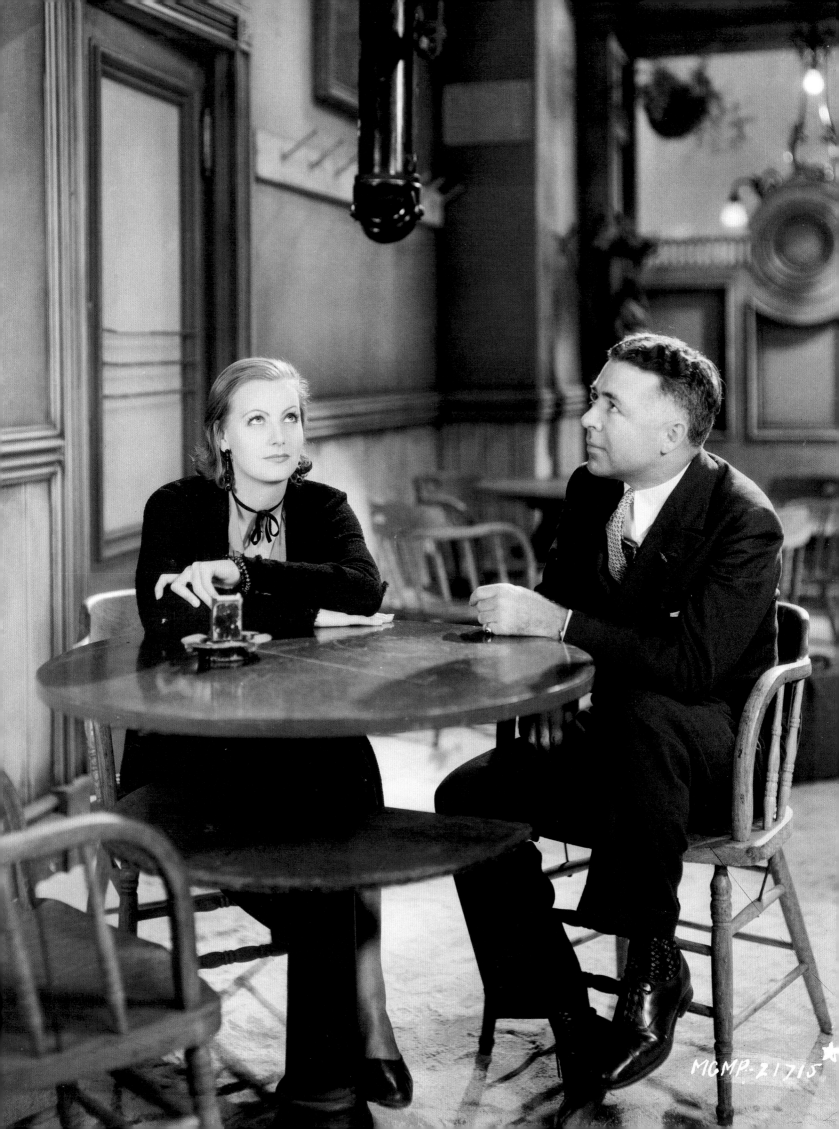

"Garbo Talks!" proclaimed the banner posters for this film. Before it was released, there was considerable concern at MGM that her strong foreign accent would not work in the talkies. However, her continued box office potency proved these fears groundless.

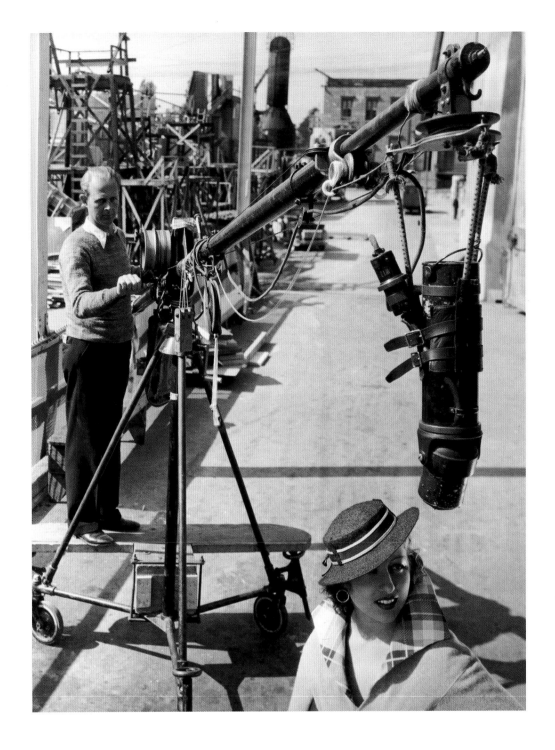

"Catching a Whisper – The sound man drops the ever intrusive microphone sufficiently close to Frances Drake to record even her most softly spoken confidences. Miss Drake appears opposite George Raft in the leading feminine role of *The Trumpet Blows*, at Paramount."

Original Paramount Pictures photo caption

Greta Garbo and director Clarence Brown on set for *Anna Christie* MGM, 1929

Frances Drake
Paramount Pictures, 1934

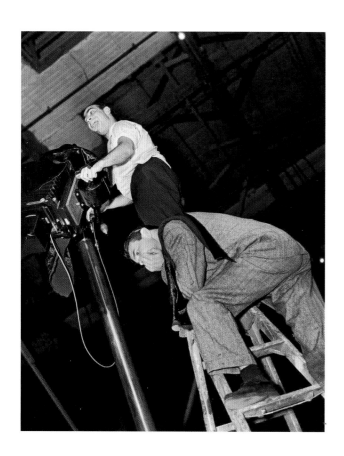

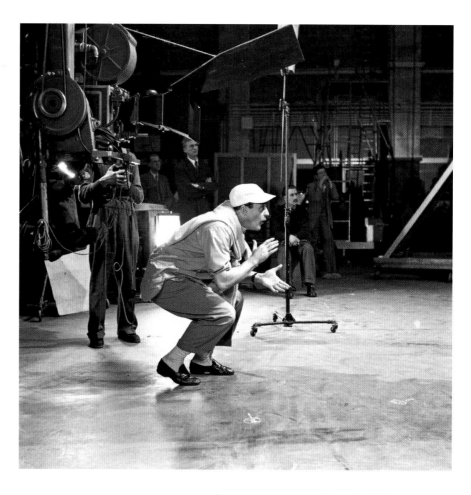

Photographer Laszlo Willinger encouraging a sitter during
a photo portrait session at the Los Angeles Studios
MGM, c.1940

Gene Kelly directing *Invitation to Dance*
MGM, 1956
Photograph by Davis Boulton

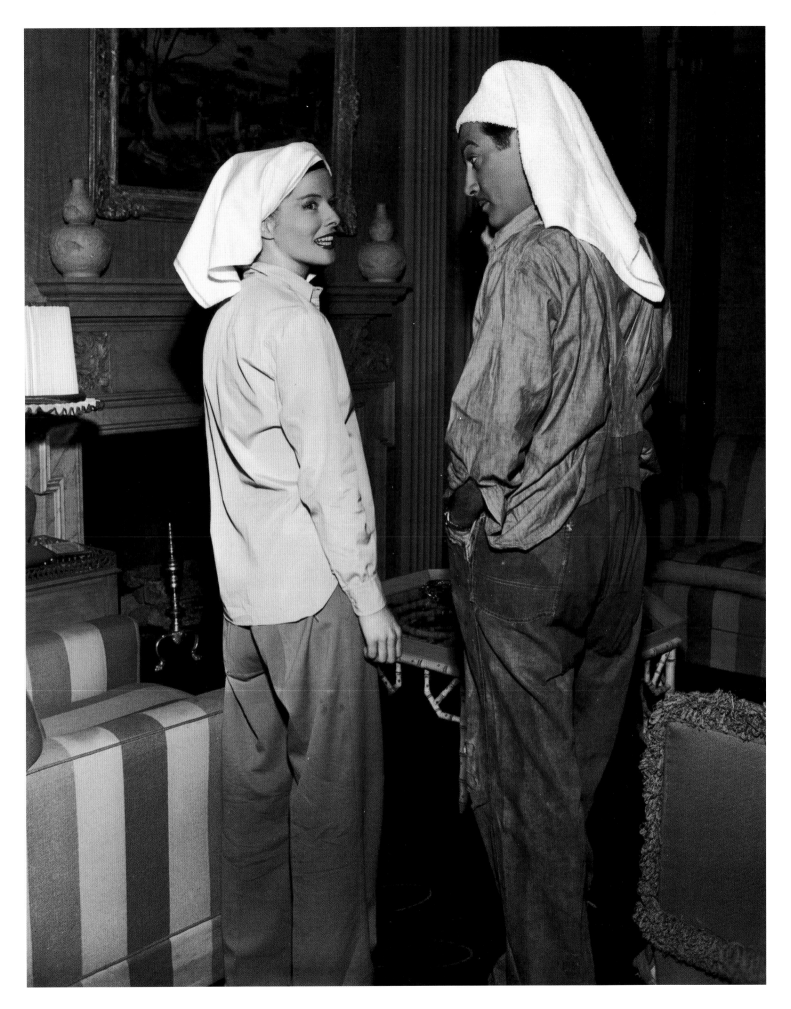

Katharine Hepburn and Robert Taylor on set,
Vincente Minnelli's *Undercurrent*
MGM, 1946
Photograph by James Manatt

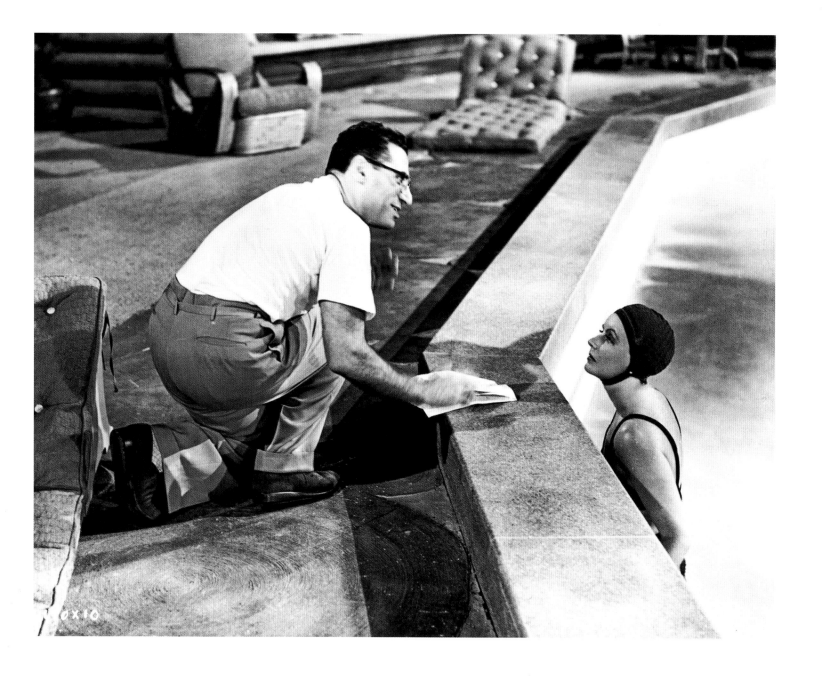

Director George Cukor and Greta Garbo
on set, *Two-Faced Woman*
MGM, 1941

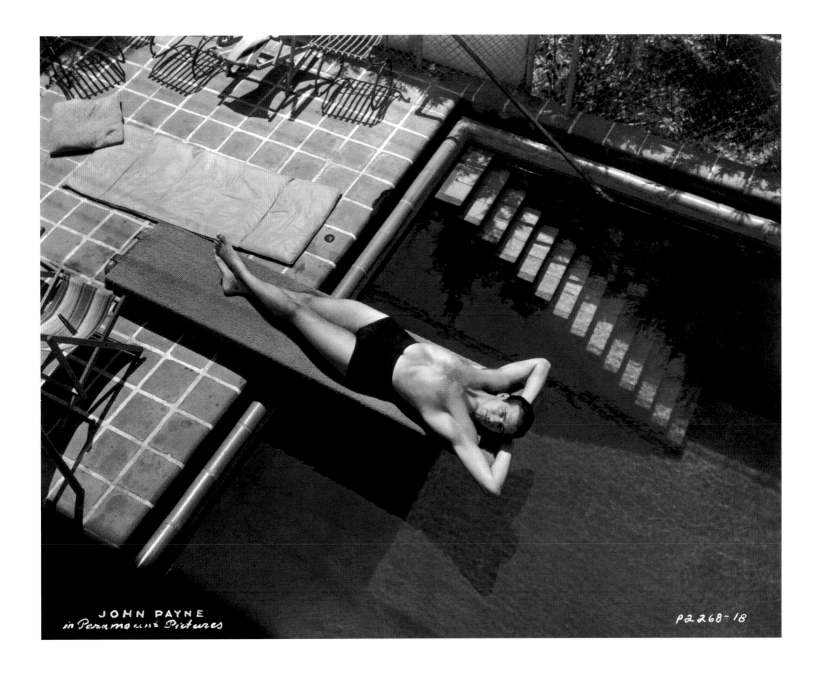

John Payne
Paramount Pictures, c.1945

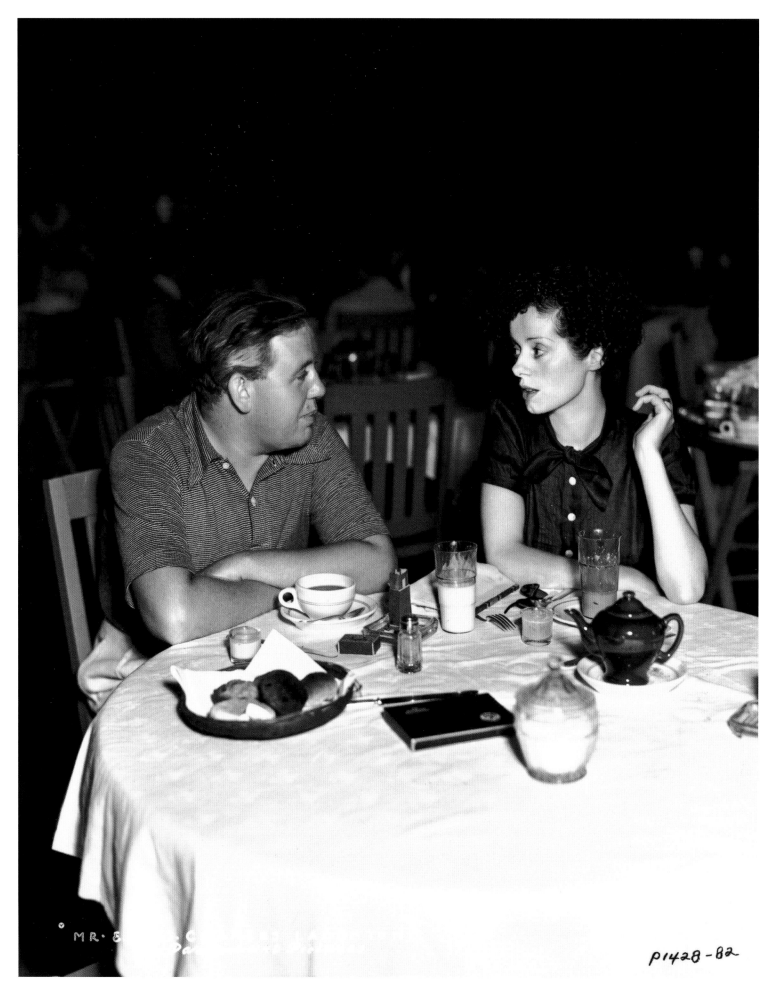

MR·8 ·22

P1428-82

Charles Laughton and his wife Elsa Lanchester
at the Paramount Studios Commissary
Paramount Pictures, c.1936

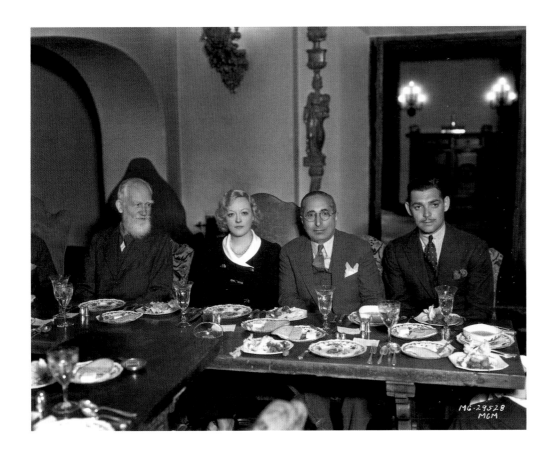

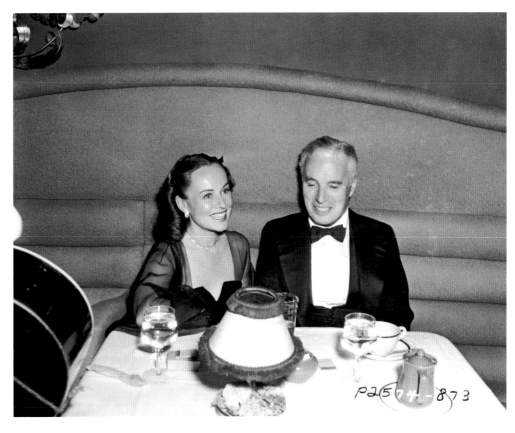

George Bernard Shaw, Marion Davies, Louis B. Mayer and
Clark Gable at La Cuesta Encantada, the San Simeon
house Davies shared with William Randolph Hearst
MGM, 1933

Charlie Chaplin and his third wife, Paulette Goddard,
dining together in Los Angeles
Paramount Pictures, c.1940

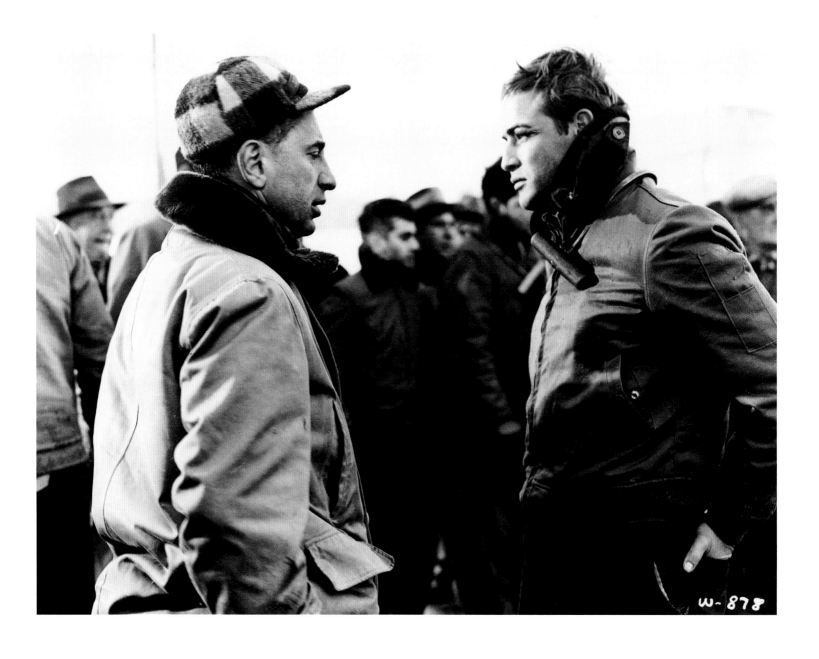

Director Elia Kazan and Marlon Brando on set, *On The Waterfront*. The film won eight Oscars, including Best Actor for Brando and Best Director for Kazan
Columbia, 1954

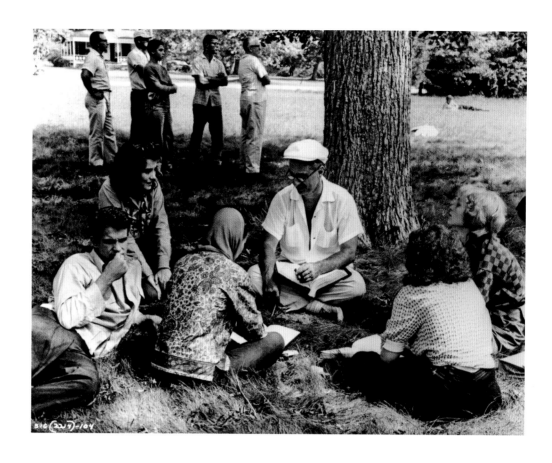

Warren Beatty sitting with director Elia Kazan and
Natalie Wood (with her back to camera) off set,
Splendor in The Grass
Warner Brothers, 1961

Katharine Hepburn checking her
make-up on set, *Morning Glory*
RKO, 1933

Robert Montgomery
MGM, 1937
Photograph by Clarence Sinclair Bull

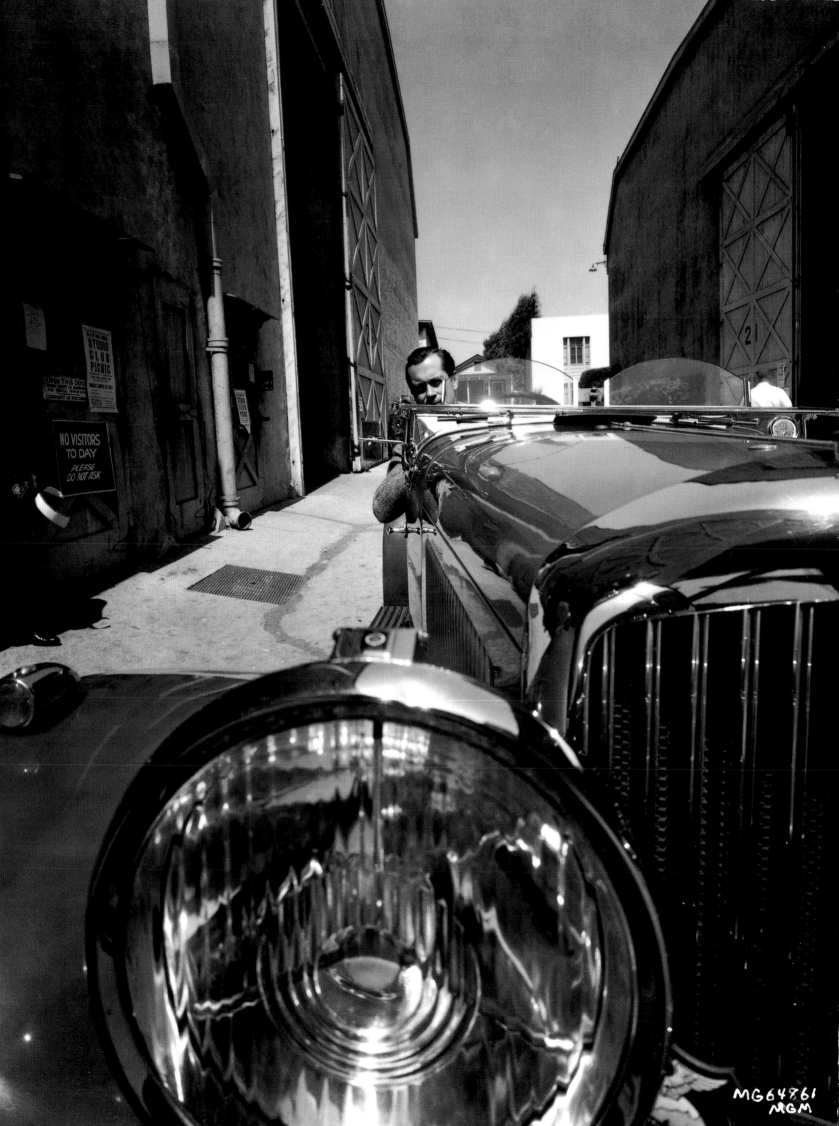

MG64861
MGM

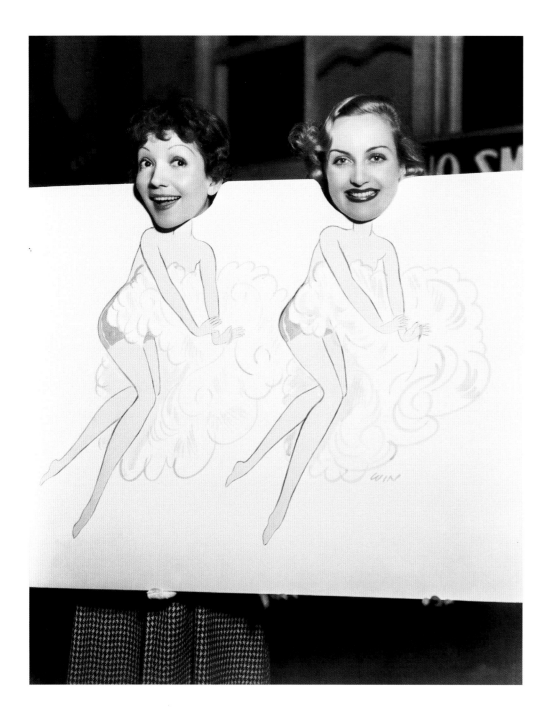

Both Colbert and Lombard vied for the title of 'Queen of the Screwball Comedies'. On-screen, Colbert's tongue-in-cheek manner and Lombard's air of honest-to-goodness exasperation helped make them both very popular stars.

Claudette Colbert and Carol Lombard larking around at a Hollywood party
Paramount Pictures, c.1934

Bing Crosby watches co-star Fred Astaire rehearse some dance steps for *Blue Skies*
Paramount Pictures, 1946

P2748-59

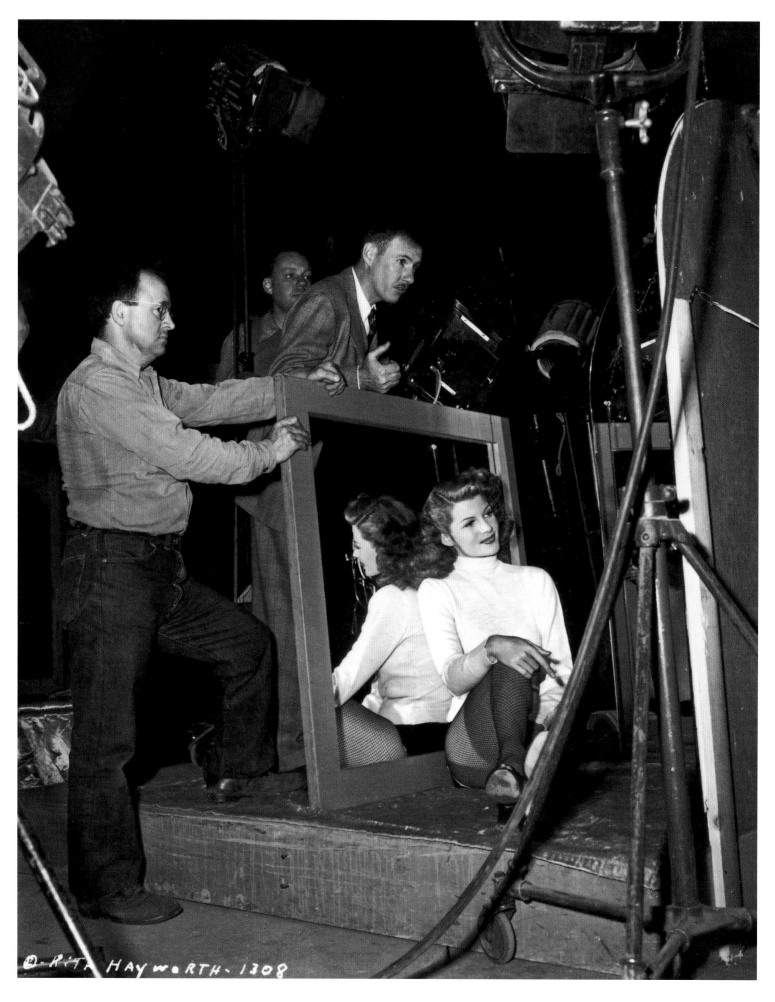

Rita Hayworth preparing for a portrait session with
photographer Robert Coburn Snr for *Cover Girl*
Columbia, 1943

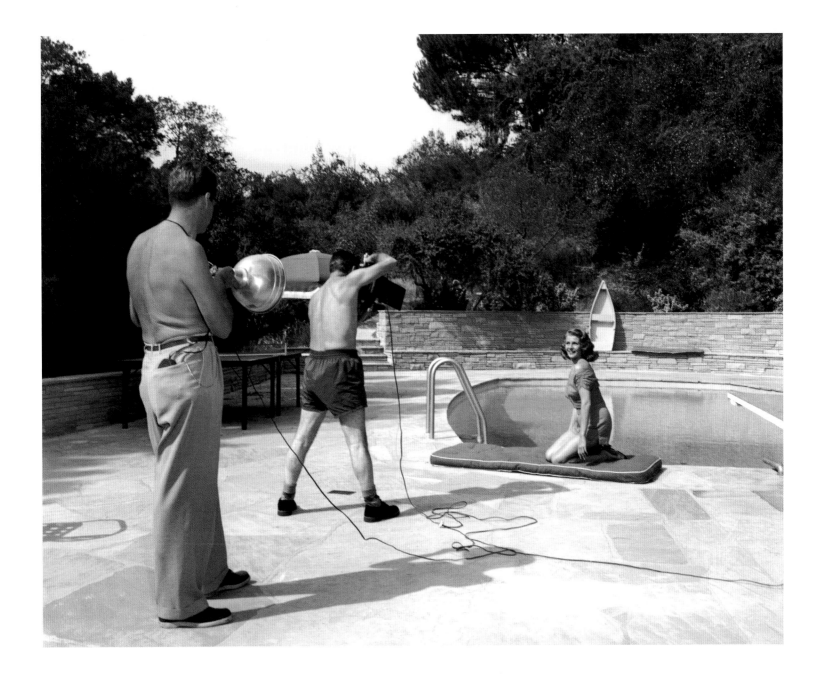

Rita Hayworth posing beside her pool for
a Columbia Studios photographer
Columbia, c.1946

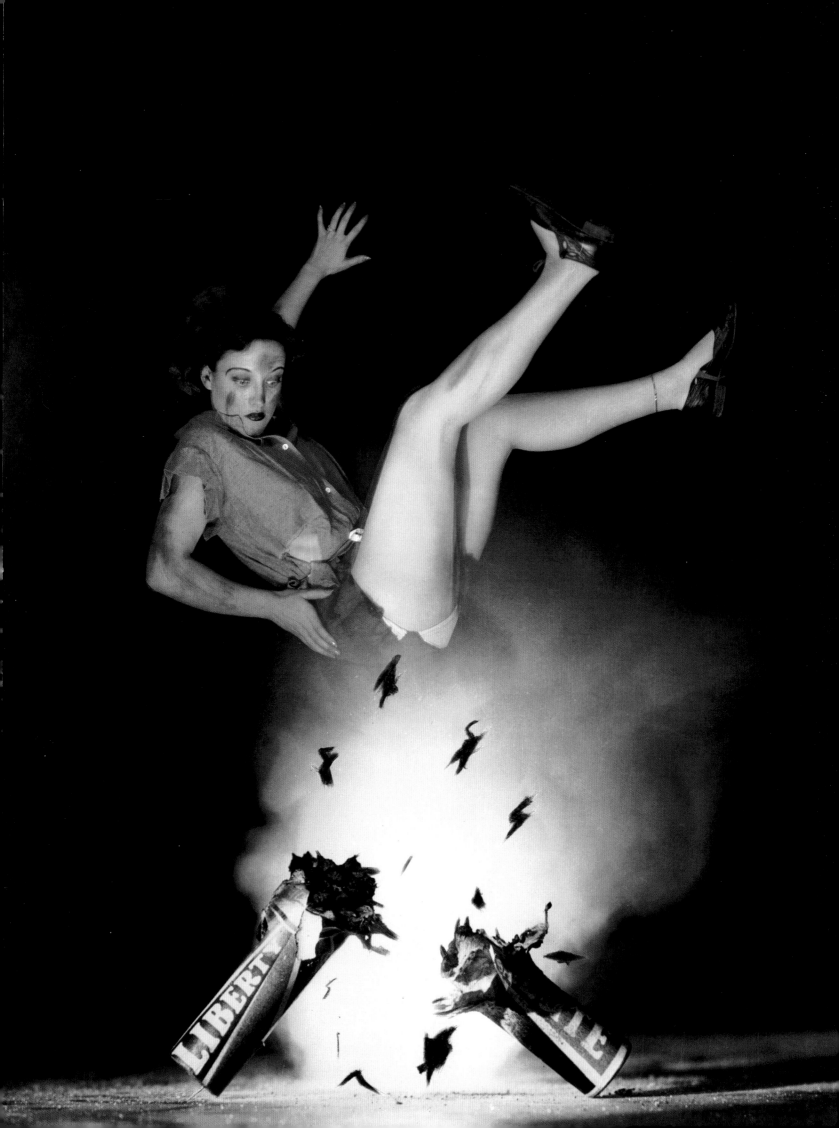

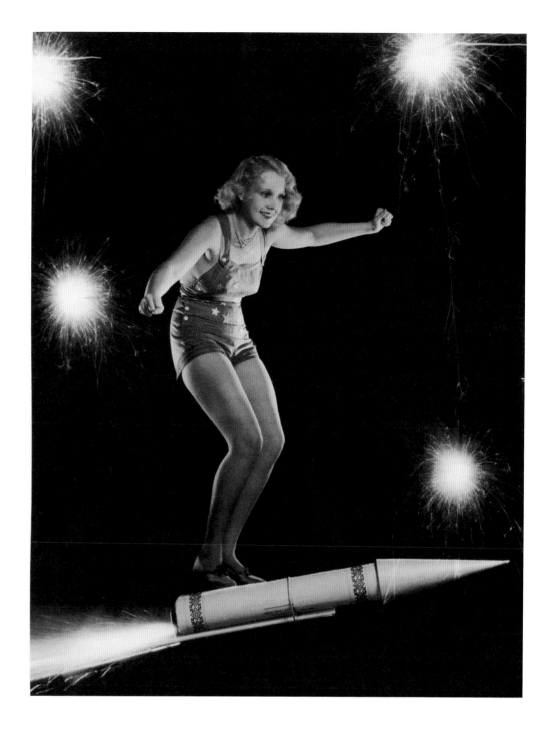

Starlet Joan Crawford joining in the
Fourth of July (US Independence Day)
celebrations
MGM, 1927

Anita Page rocketing away on
the Fourth of July
MGM, 1931

Johnny Weissmuller performs his famous Tarzan call
for Jean Harlow off set, *Hold Your Man*
MGM, 1933

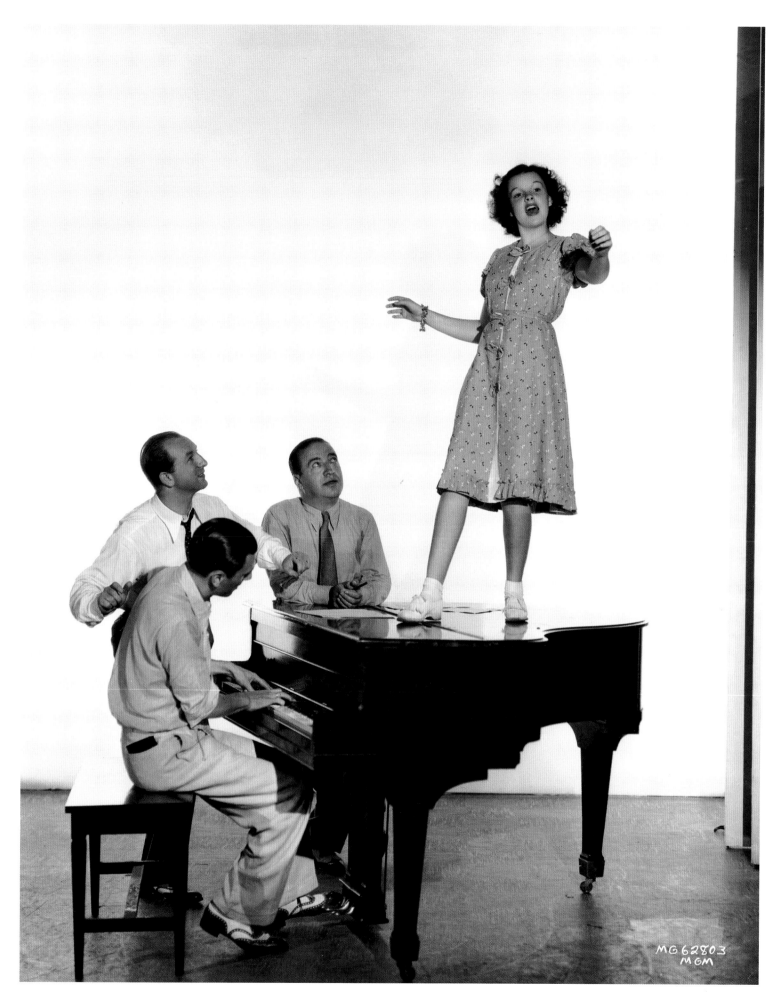

Judy Garland rehearsing *Got A Brand New Pair Of Shoes* for
Thoroughbreds Don't Cry with Nacio Herb Brown and Arthur Freed
MGM, 1937
Photograph by Virgil Apger

Joan Crawford off set, during the filming
for *Rose-Marie* with writer Lucien Hubbard
MGM, 1928

Rita Hayworth, from a publicity shoot
to promote *Cover Girl*
Columbia, 1944

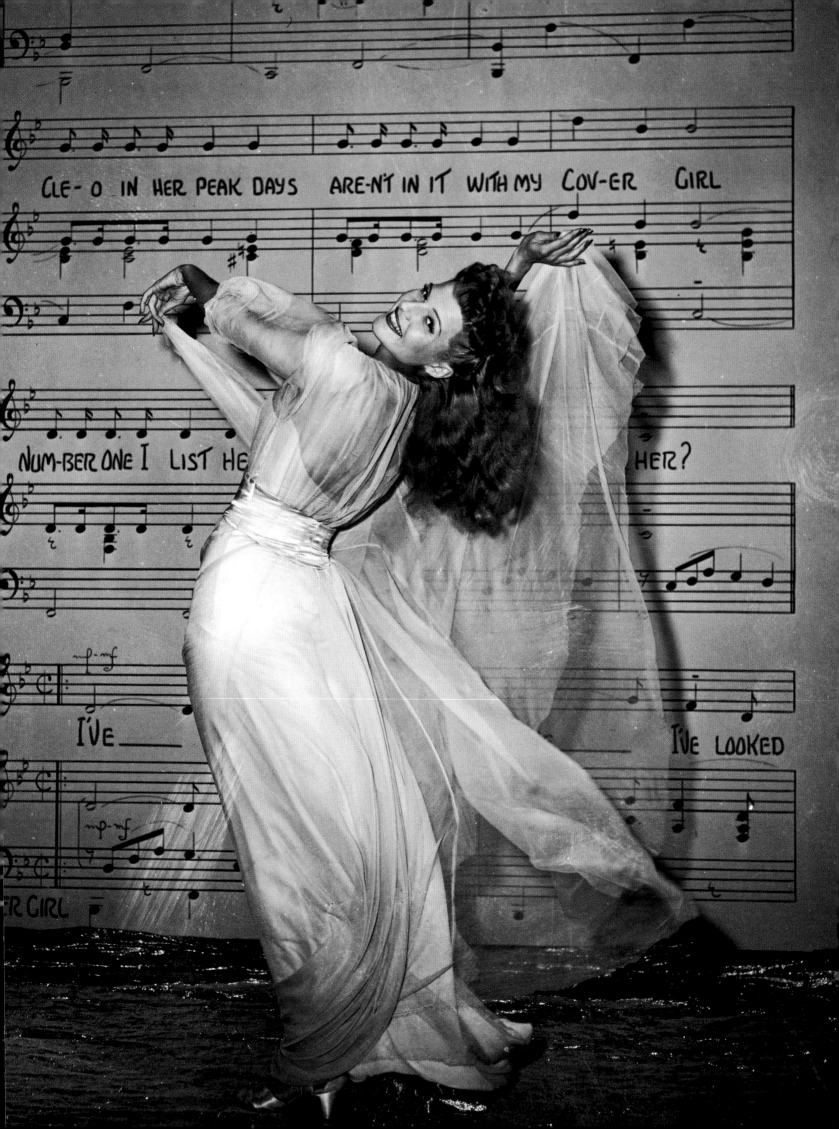

In between various marriages, Grant and Scott were roommates for nearly ten years. There have long been rumours that they were lovers but this has never been fully substantiated. The Studios had their eyes and ears everywhere and always looked to protect their stars from any fallout about their private lives. It is hard to believe that they would have allowed these photos to circulate if this rumour was true, as it would have seriously affected both stars' careers if it went public, particularly Grant's role as the urbane lover of beautiful women.

Cary Grant with his first wife, Virginia Cherrill
Paramount Pictures, 1934

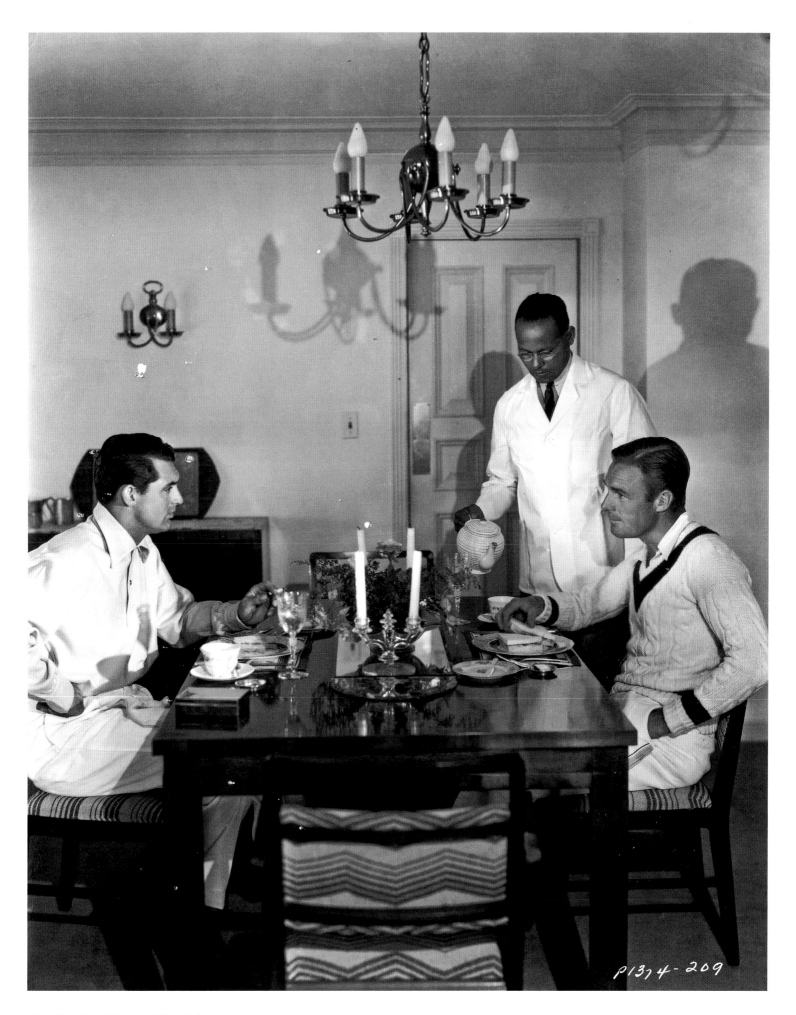

Cary Grant and Randolph Scott dining
at their Malibu beachside house
Paramount Pictures, 1935
Photograph by Jerome Zerbe

91

The male stars, in particular, did not enjoy these kinds of publicity shots and had to be pressed into them, as illustrated here by the lack of enthusiasm on the faces of Fonda and Stewart.

Henry Fonda and James Stewart
Paramount Pictures, 1937

Norma Shearer
MGM, 1929

Colleen Moore
MGM, 1932

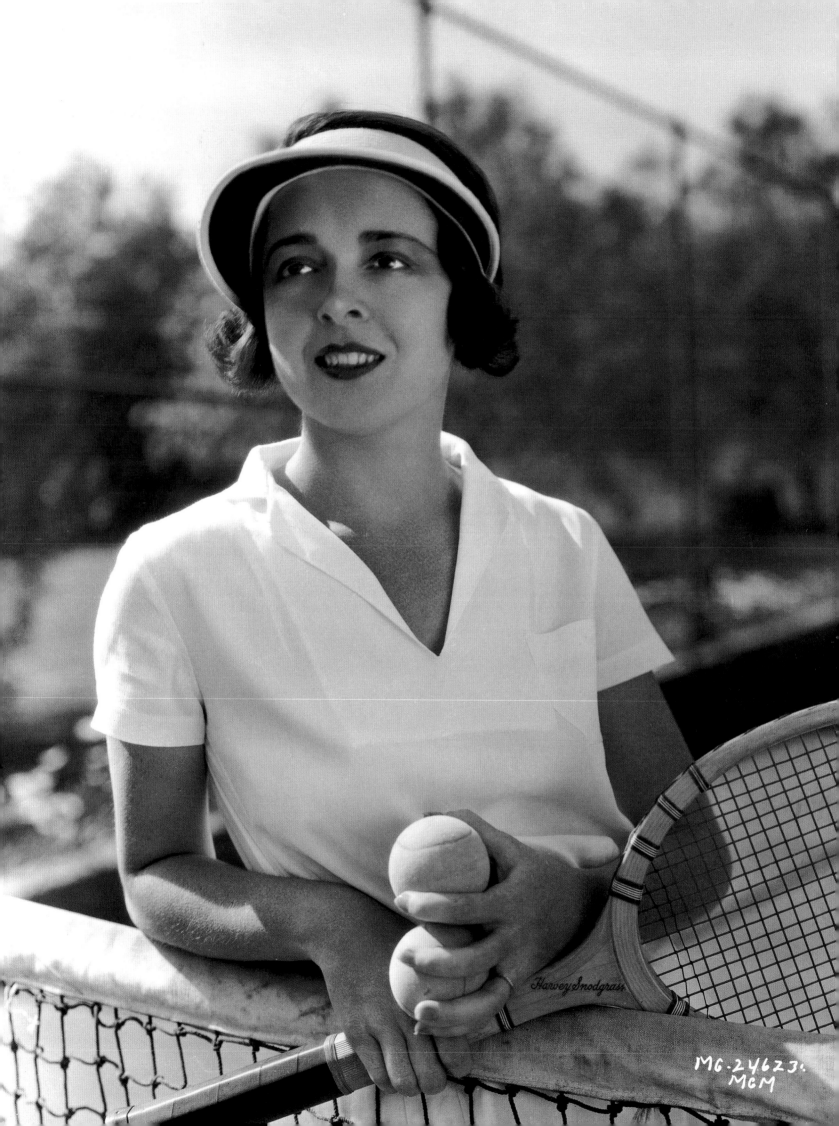

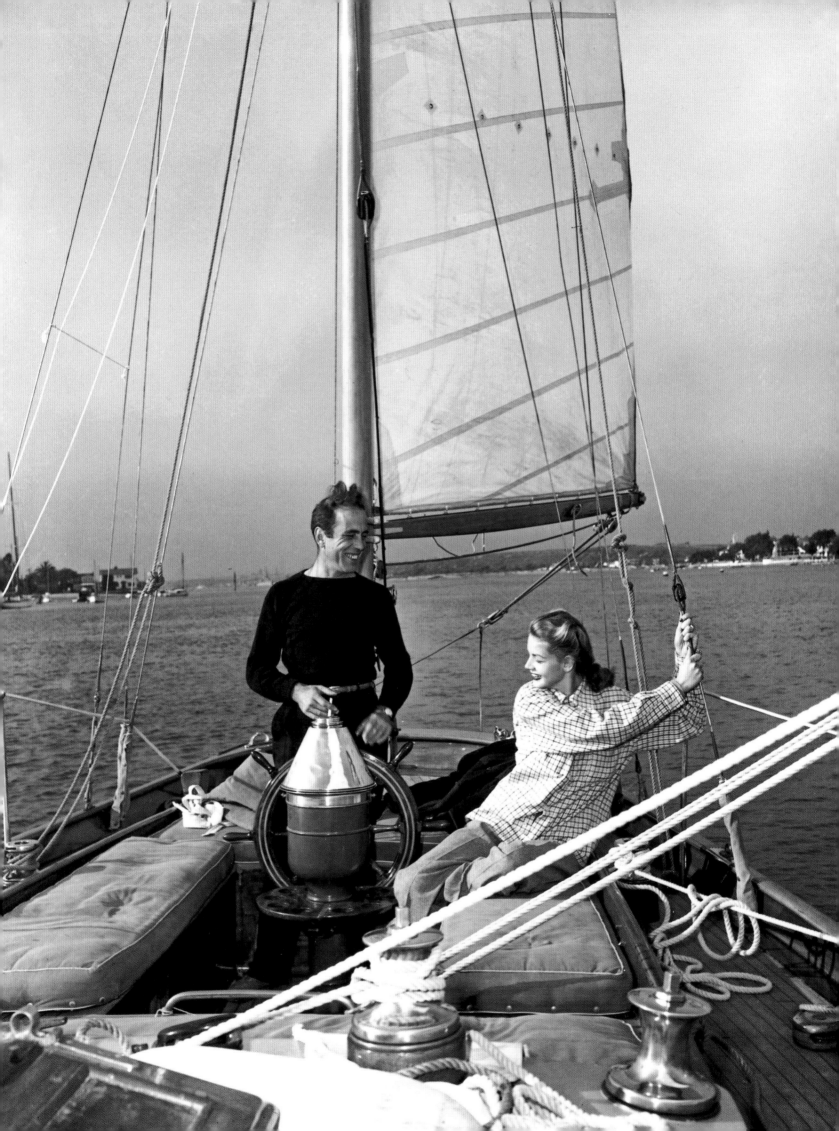

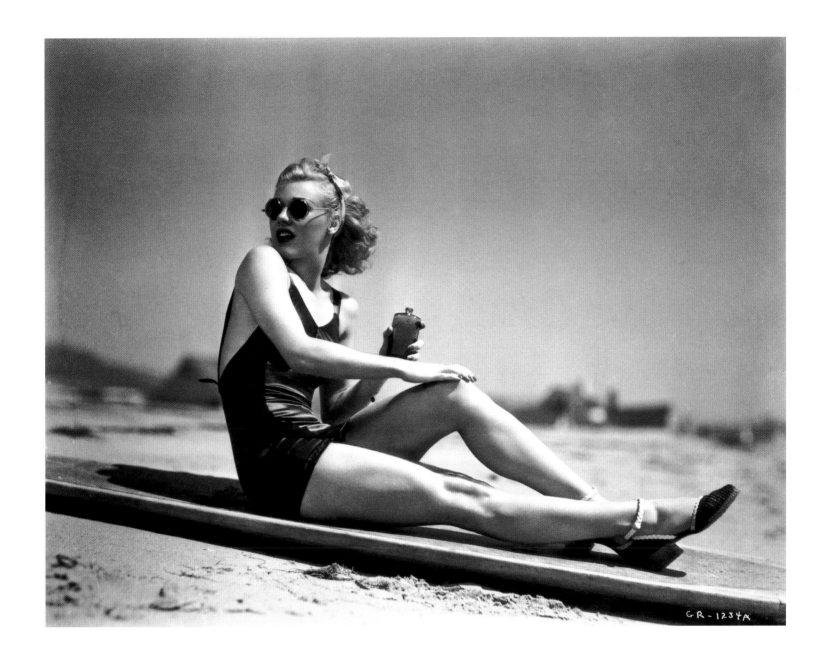

Santana was a fifty-five-foot sailing yacht, which Bogart bought from Dick Powell in the 1940s. The vessel subsequently achieved celebrity status as "Bogie's Boat" due to his numerous seafaring expeditions, and Bogart even named his production company, Santana Productions, after her. There was speculation that Warner Brothers part-owned the boat as they used it to stage photo opportunities to gain publicity for their leading actors.

Humphry Bogart on board his yacht
Santana with Lauren Bacall
Warner Brothers, c.1945

Ginger Rogers
RKO, 1936

Gary Cooper yachting off the Californian coast
Paramount Pictures, c.1940

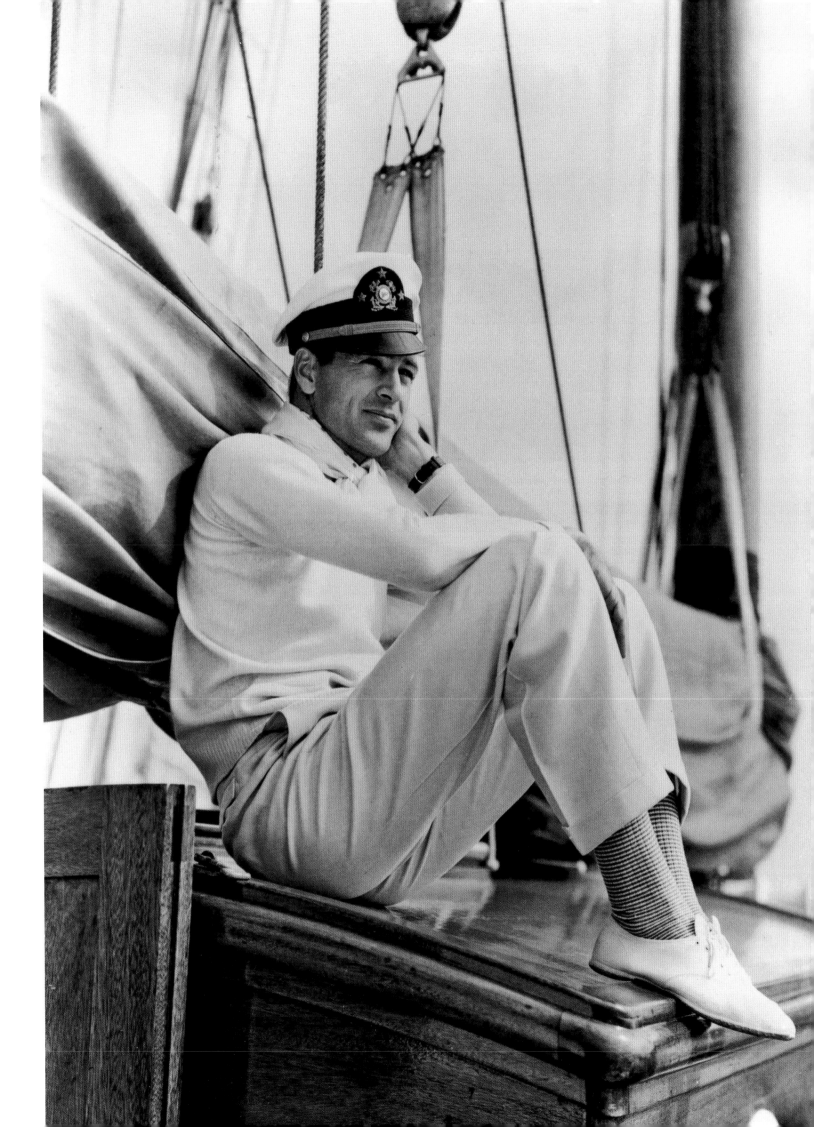

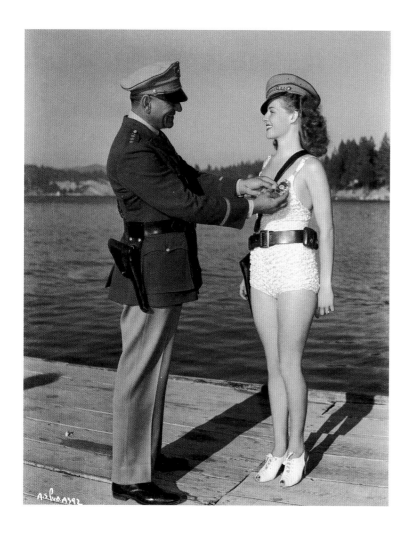

This still, to promote healthy living, appears to advocate snow skiing on Californian beaches! The Studio publicists who dreamt up these still shots simply ran out of ideas on occasion.

Ann Sheridan is appointed as an honorary sheriff of Beverly Hills, despite being improperly dressed for the occasion
Warner Brothers, 1938

Ava Gardner
MGM, 1945

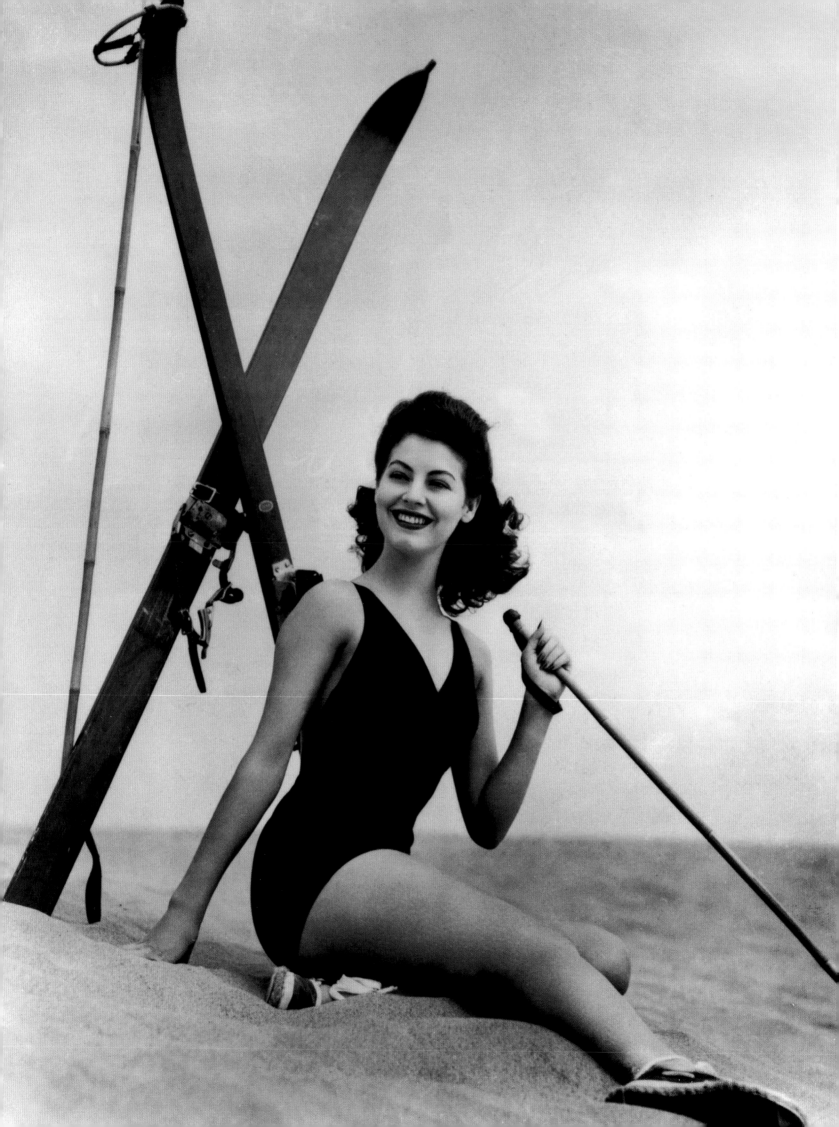

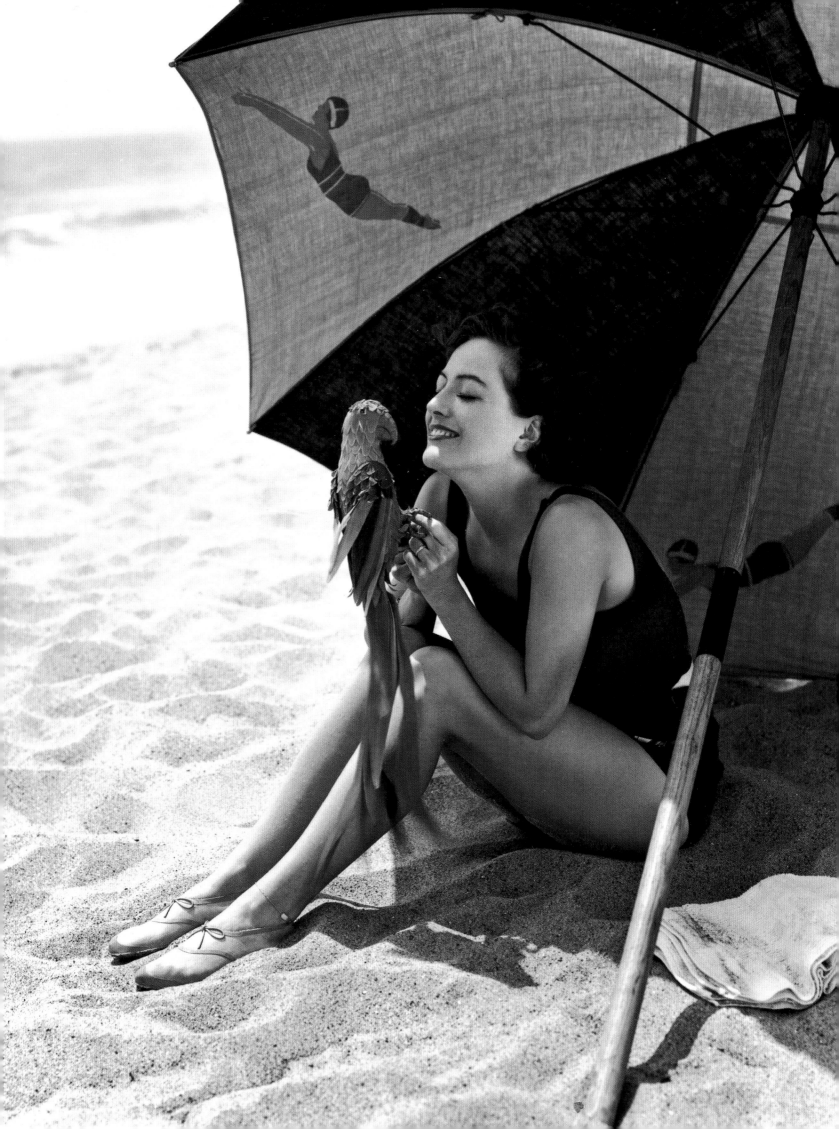

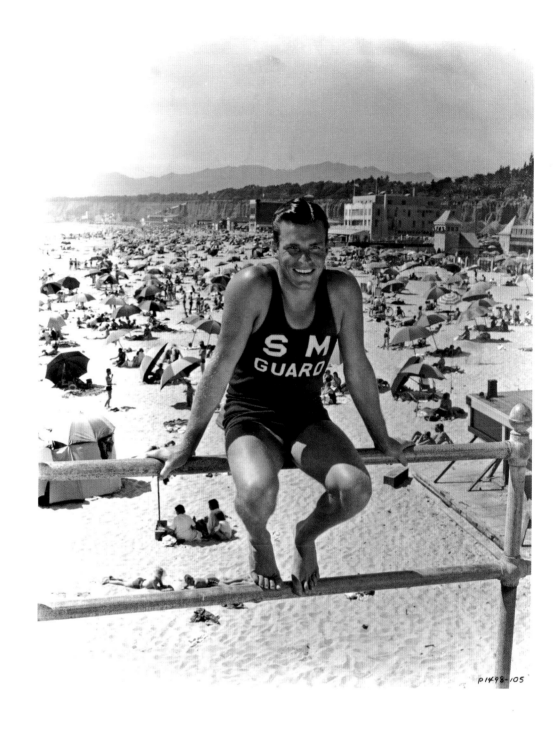

Joan Crawford on Santa Monica
Beach, California
MGM, 1929
Photograph by Clarence Sinclair Bull

Buster Crabbe at Santa Monica
Beach, California
Paramount Pictures, 1935

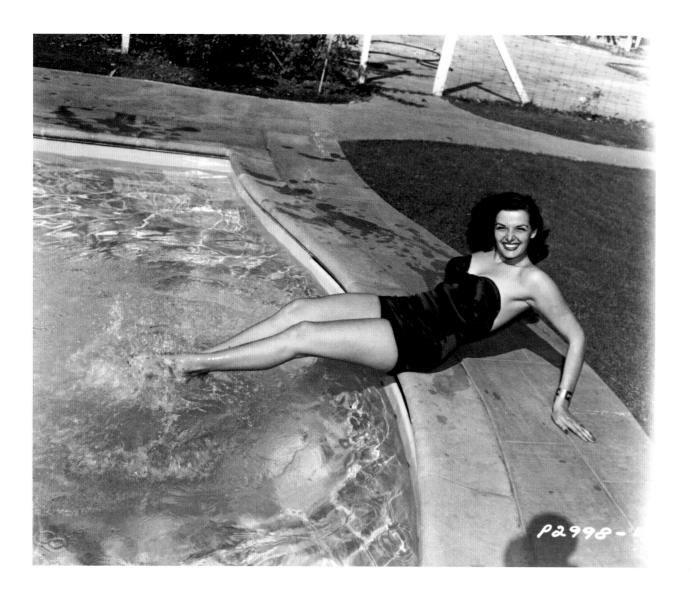

Jane Russell
Paramount Pictures, c.1952

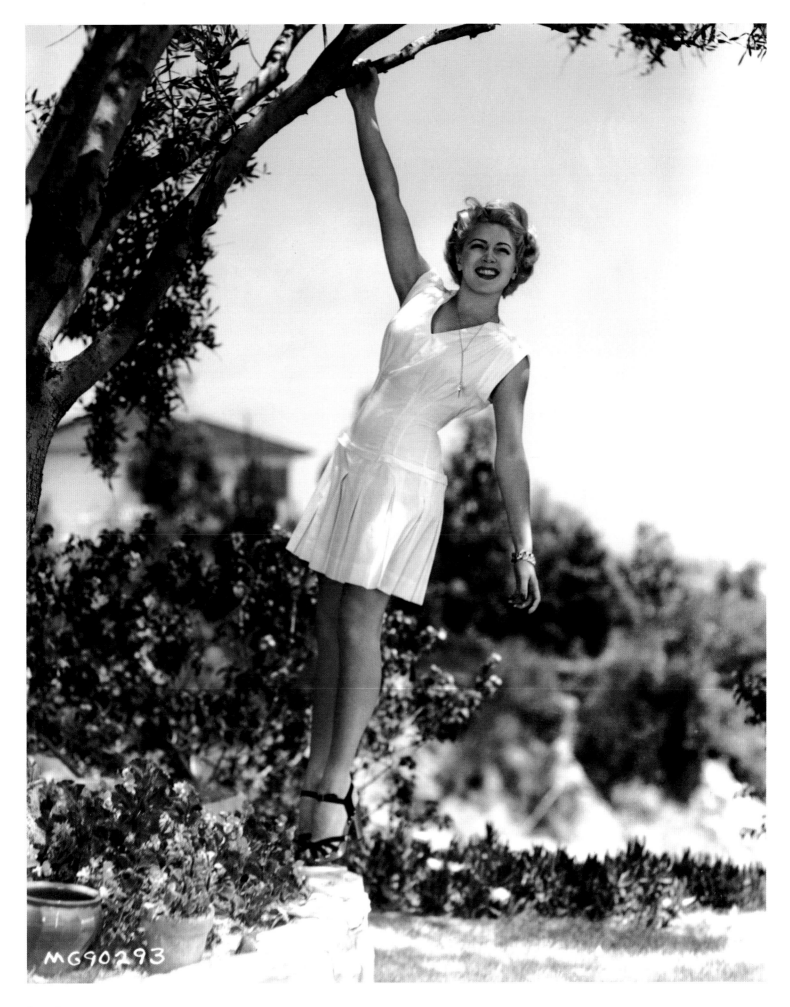

MG90293

Lana Turner
MGM, 1942
Photograph by Eric Carpenter

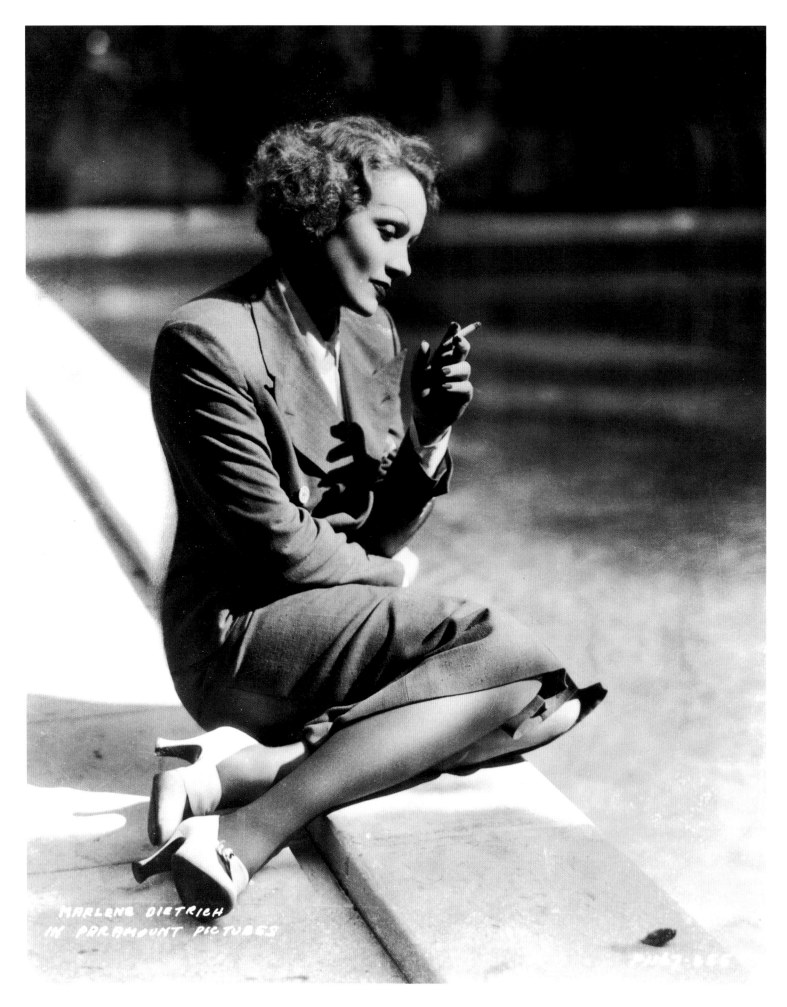

Marlene Dietrich by her pool, wearing one
of her trademark suits with a male jacket
Paramount Pictures, 1932

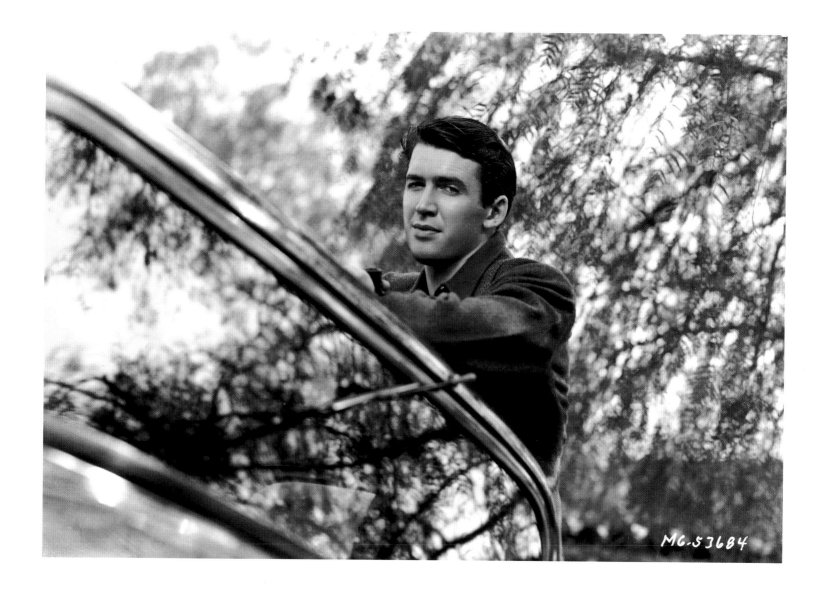

MC-53684

James Stewart
MGM, 1936
Photograph by Ted Allan

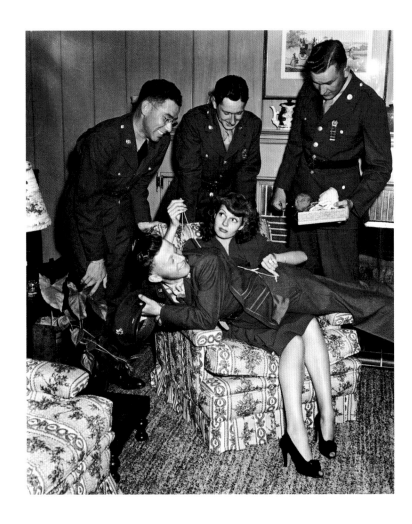

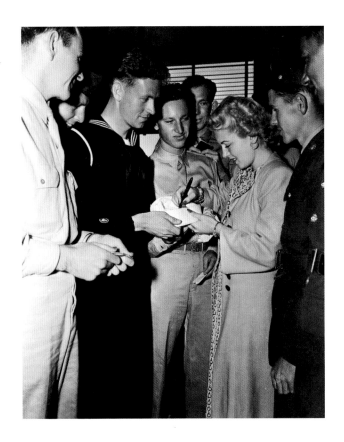

Lana Turner signing autographs for starstruck members
of the armed forces
Warner Brothers, c.1942

Rita Hayworth is overwhelmed by a group of servicemen
Columbia, 1943

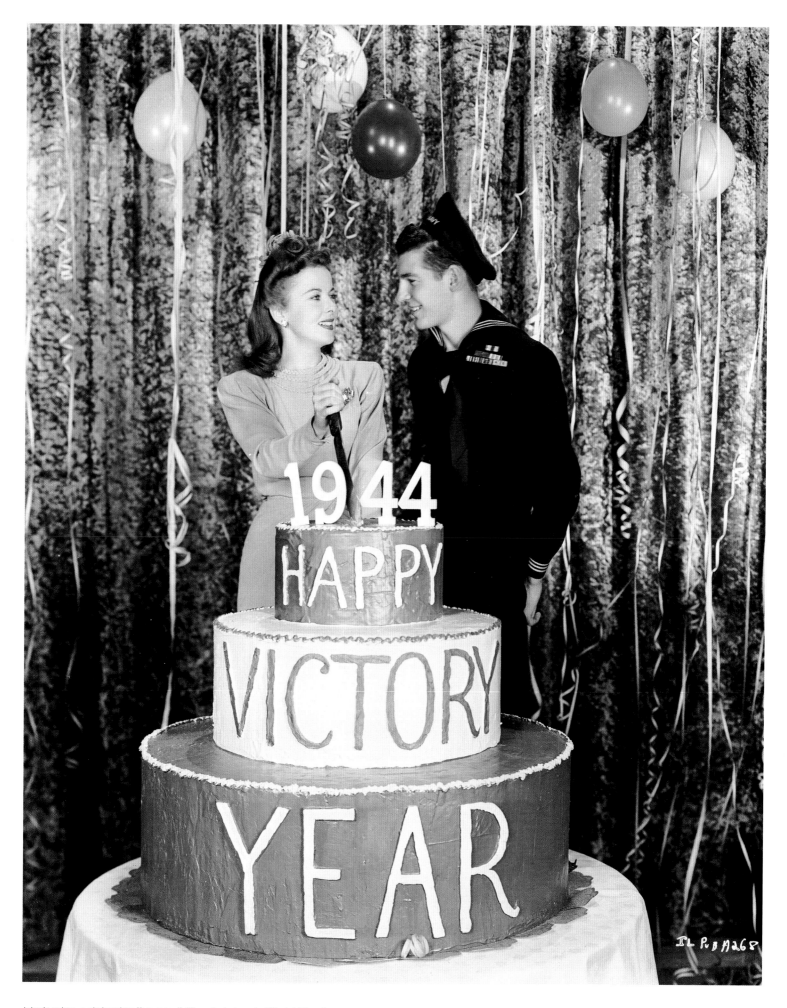

Ida Lupino celebrates the possibility of victory in World War II
Warner Brothers, 1944

Lauren Bacall and Vice President (soon to be President)
Harry S. Truman entertaining American Servicemen at
the National Press Club canteen, Washington DC
Warner Brothers, February 1945

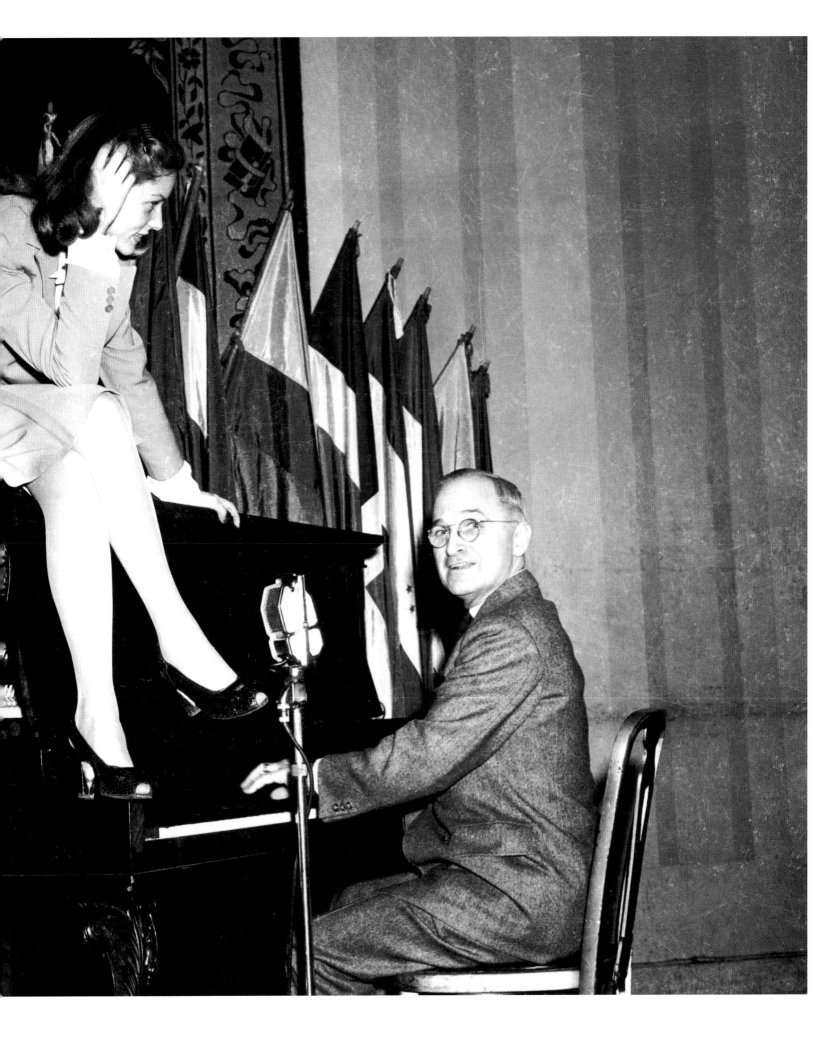

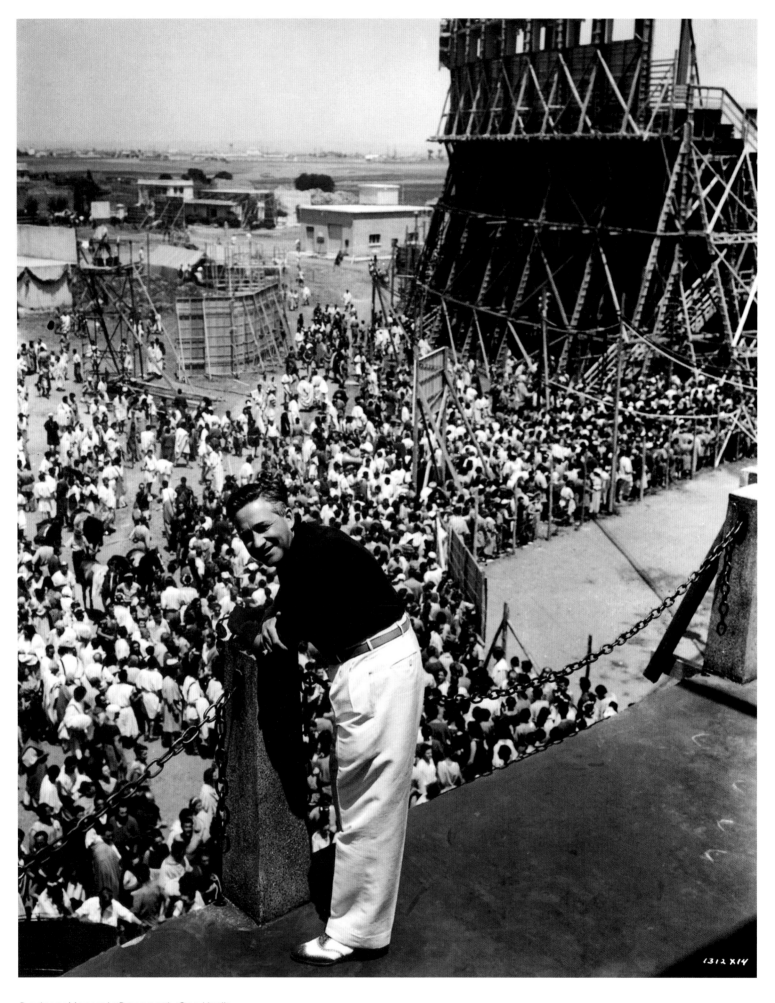

Producer Mervyn LeRoy on set, *Quo Vadis*
MGM, 1950

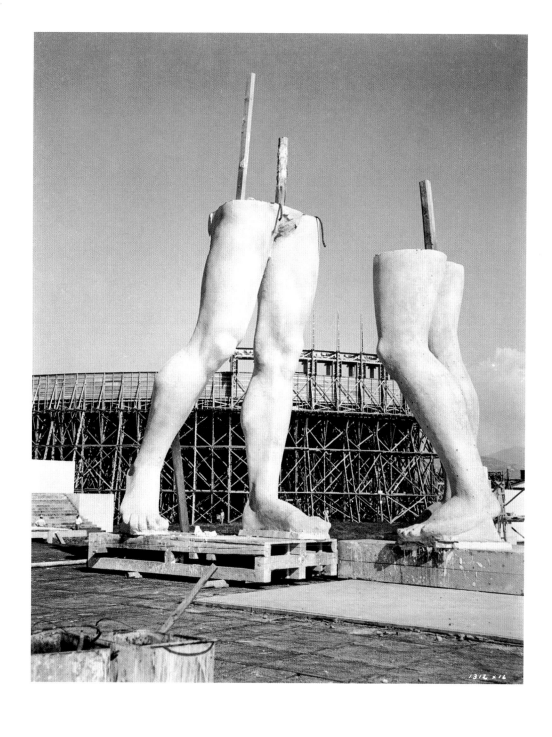

Constructing the set for the Roman epic *Quo Vadis*
MGM, 1950
Photograph by Davis Boulton

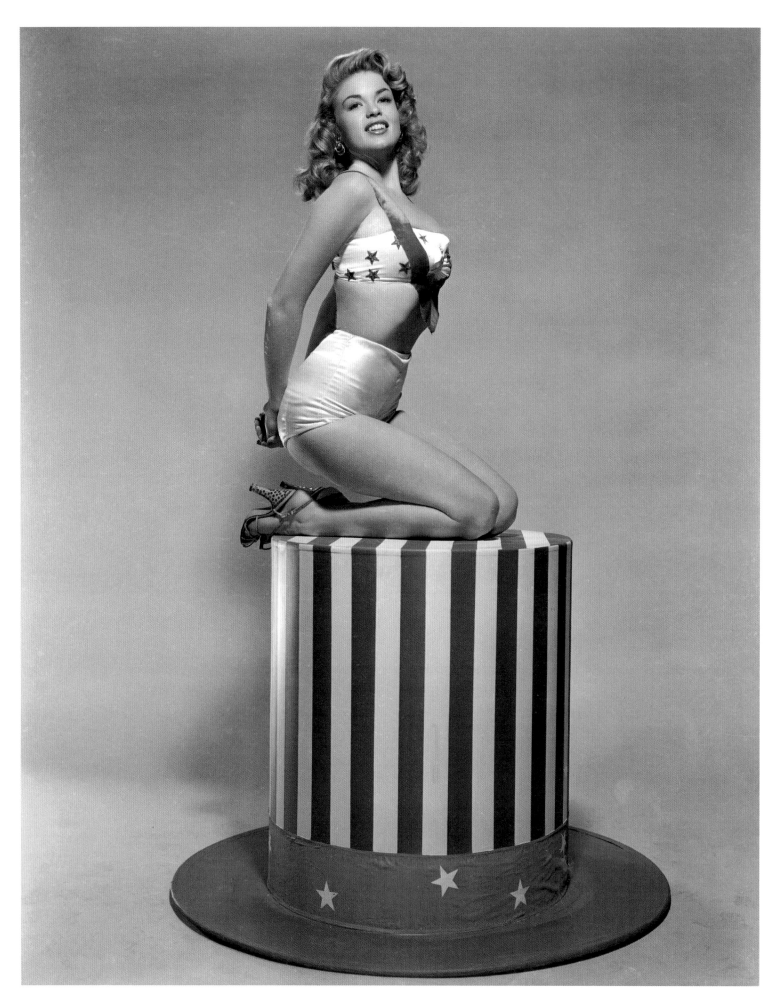

Jayne Mansfield on top of a large scale model
of Uncle Sam's hat to celebrate the Fourth of July,
US Independence Day
20th Century Fox, 1955

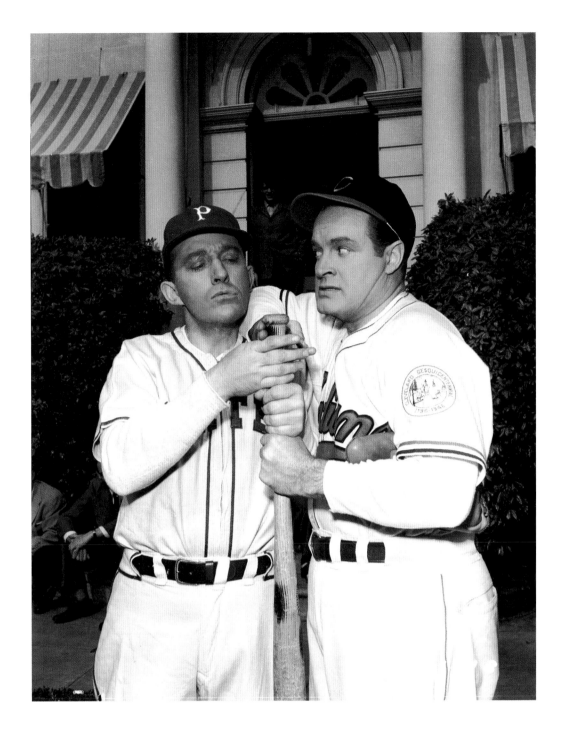

Bob Hope and Bing Crosby; both men were part-owners of baseball teams and are seen here wearing the shirts of their respective Pittsburgh Pirates and Cleveland Indians Paramount Pictures, c.1945

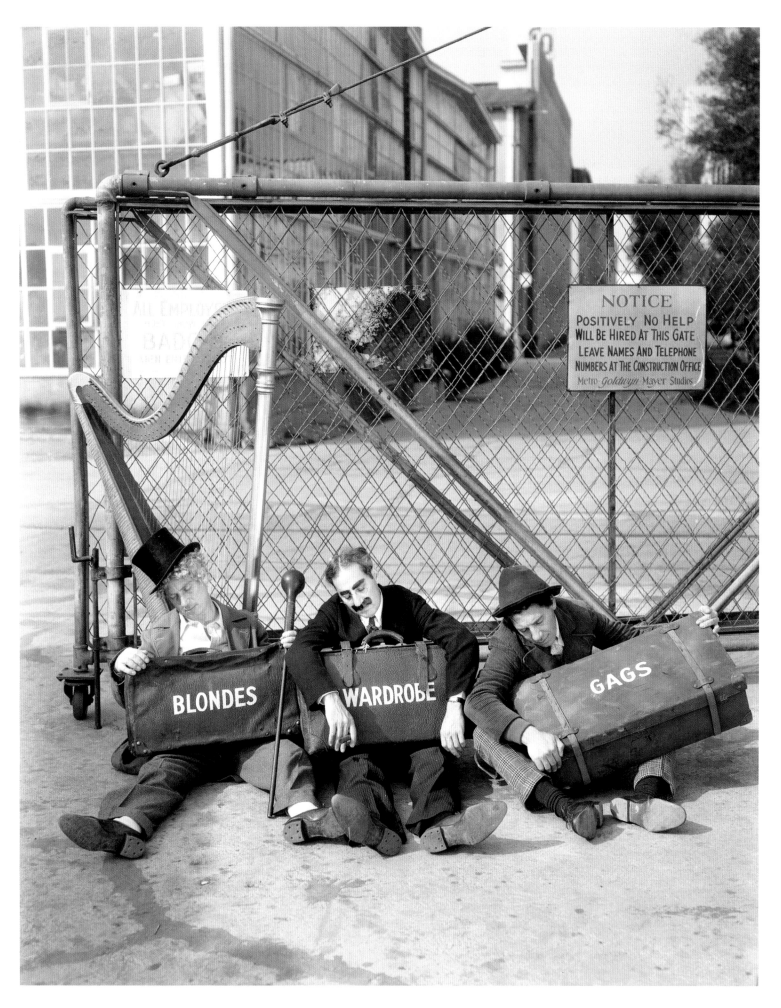

Harpo, Groucho and Chico Marx outside the gates
of the Los Angeles Studios
MGM, 1934
Photograph by Virgil Apger

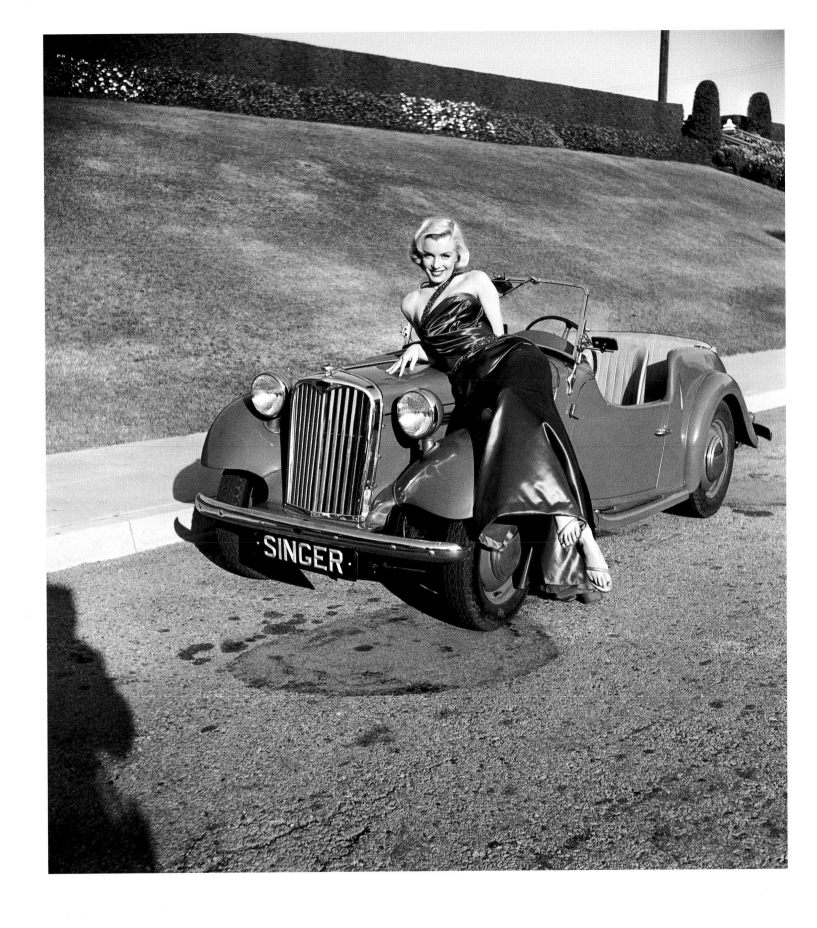

Marilyn Monroe sits demurely on a Singer car doing a promotional tie-in;
she is wearing the dress made famous in *How To Marry a Millionaire*
20th Century Fox, 1953
Photograph by Frank Worth

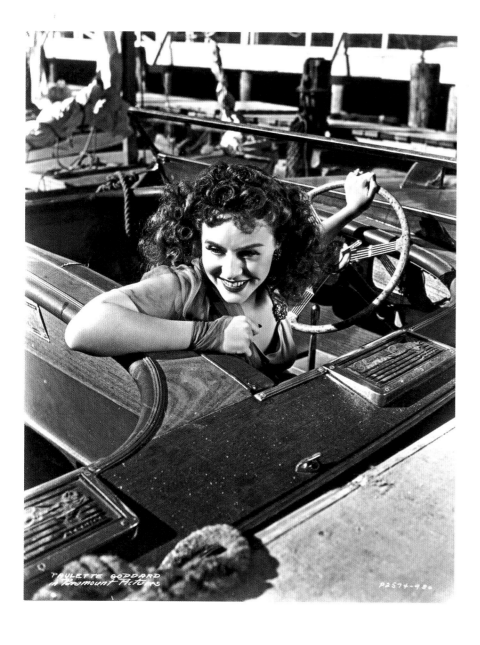

Paulette Goddard
Paramount Pictures, 1940

Cary Grant and Grace Kelly relaxing on
set in the South of France for the Alfred
Hitchcock thriller *To Catch A Thief*
Paramount Pictures, 1954

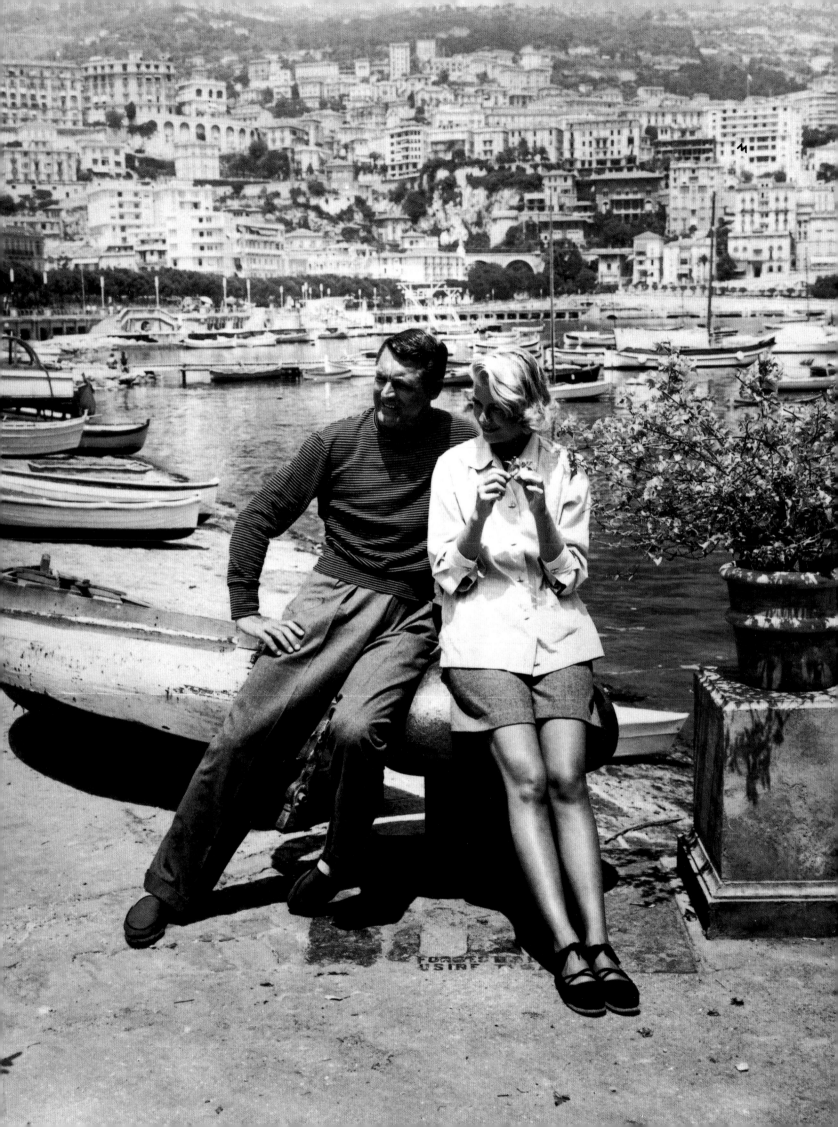

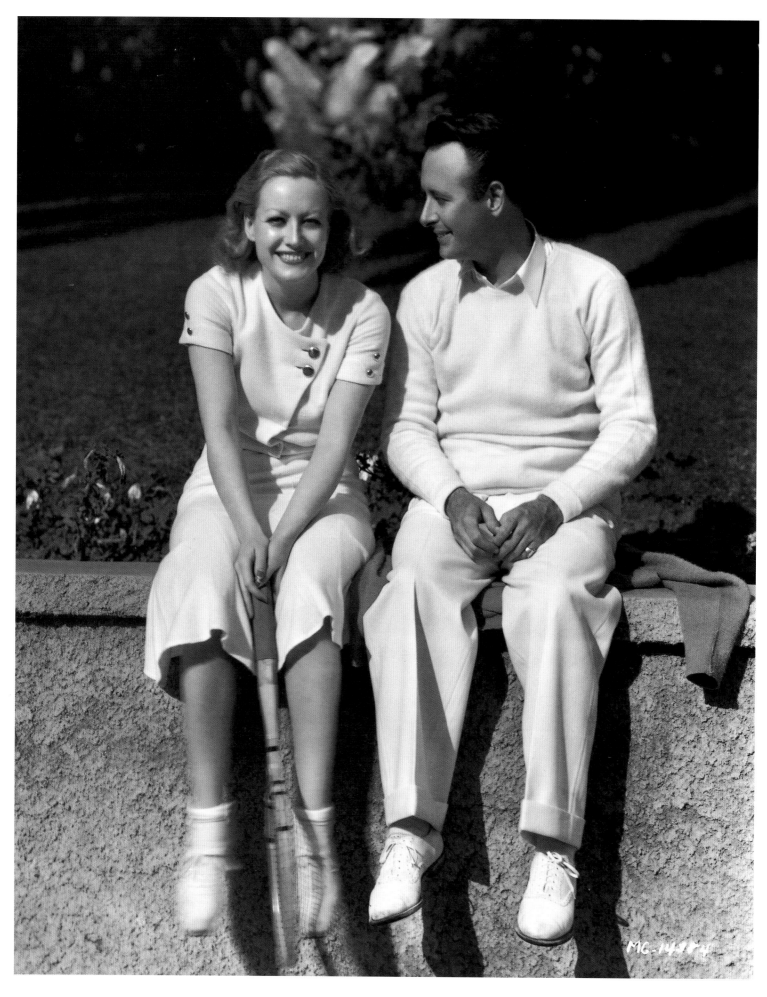

Joan Crawford and her brother, Hal
MGM, c.1930

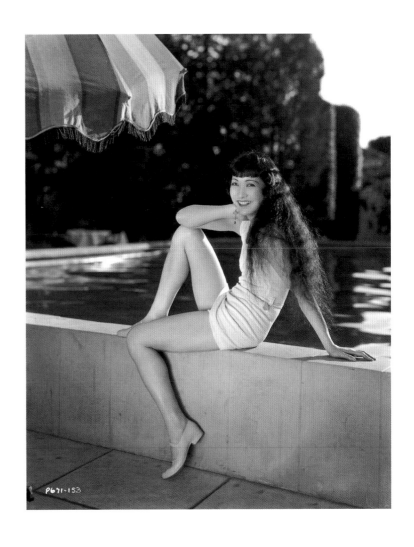

Clark Gable
MGM, 1931
Photograph by Clarence Sinclair Bull

Anna May Wong
Paramount Pictures, c.1937

121

Elizabeth Taylor
MGM, 1952
Photograph by Davis Boulton

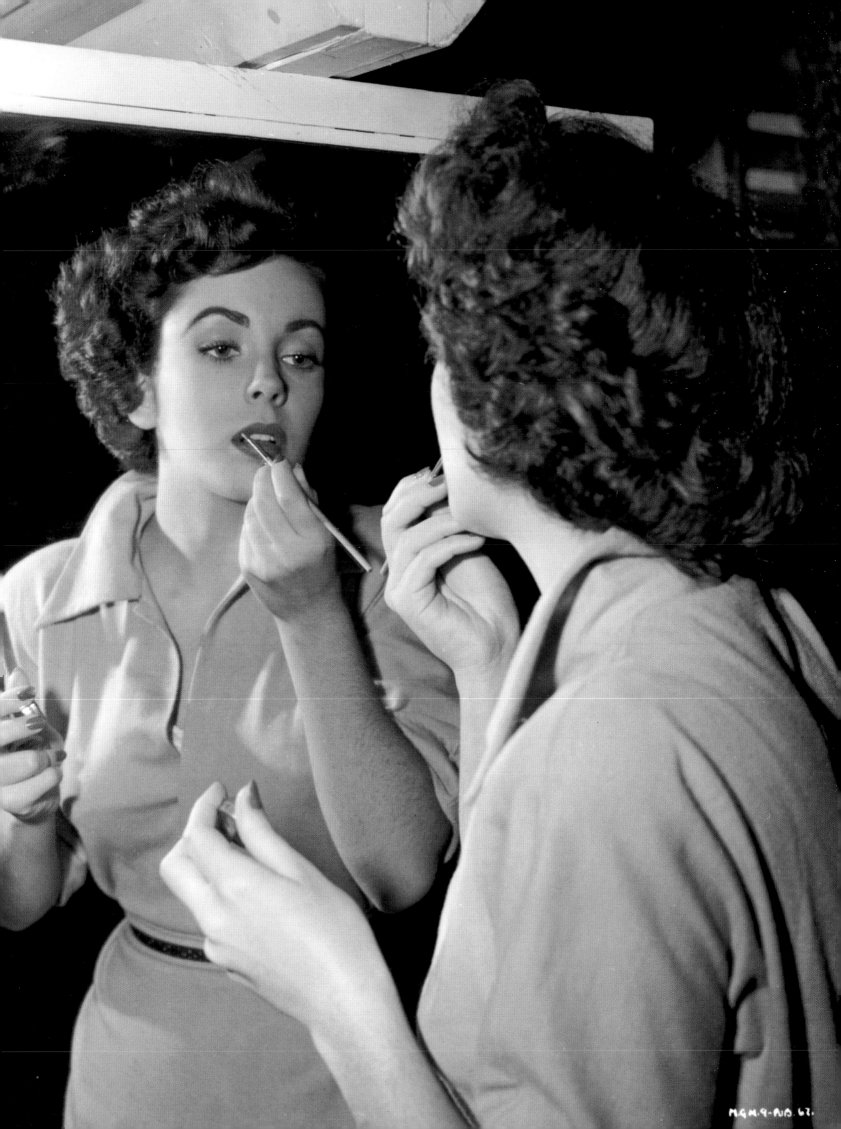

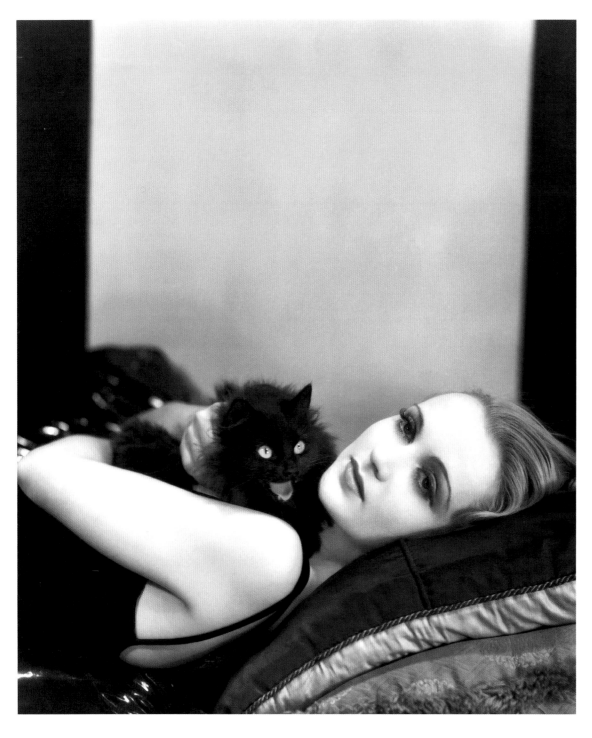

Carole Lombard with her "cat"
Paramount Pictures, c.1932

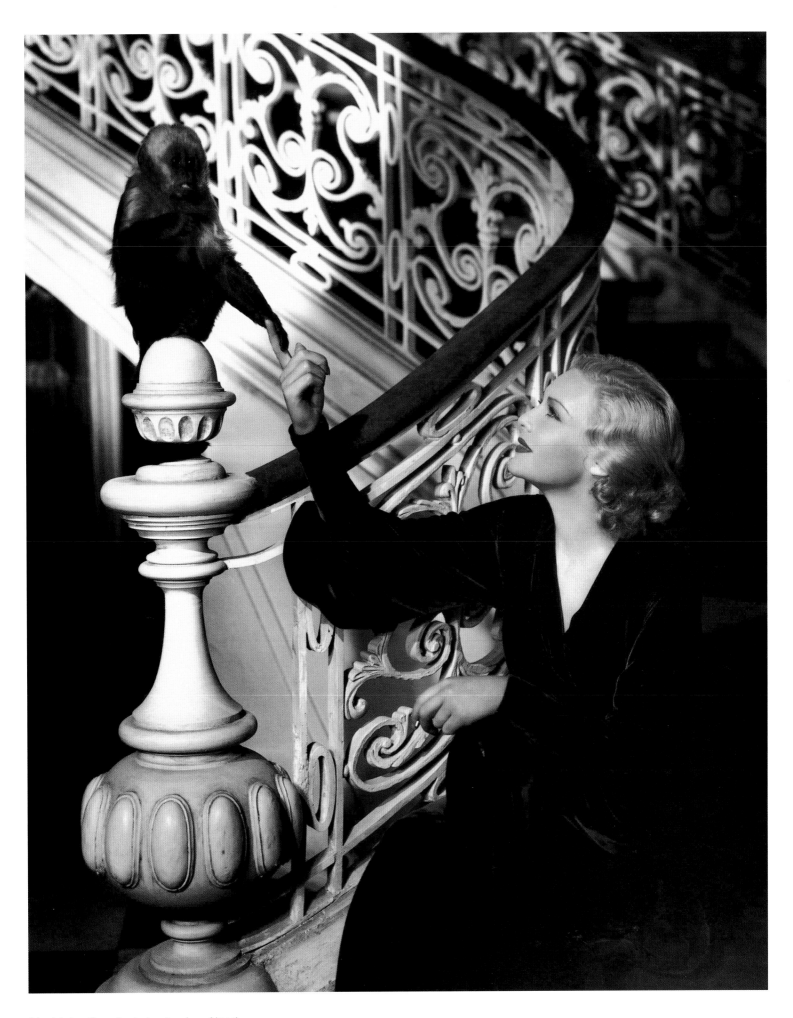

Madeleine Carroll admires her furry friend
Paramount Pictures, c.1936

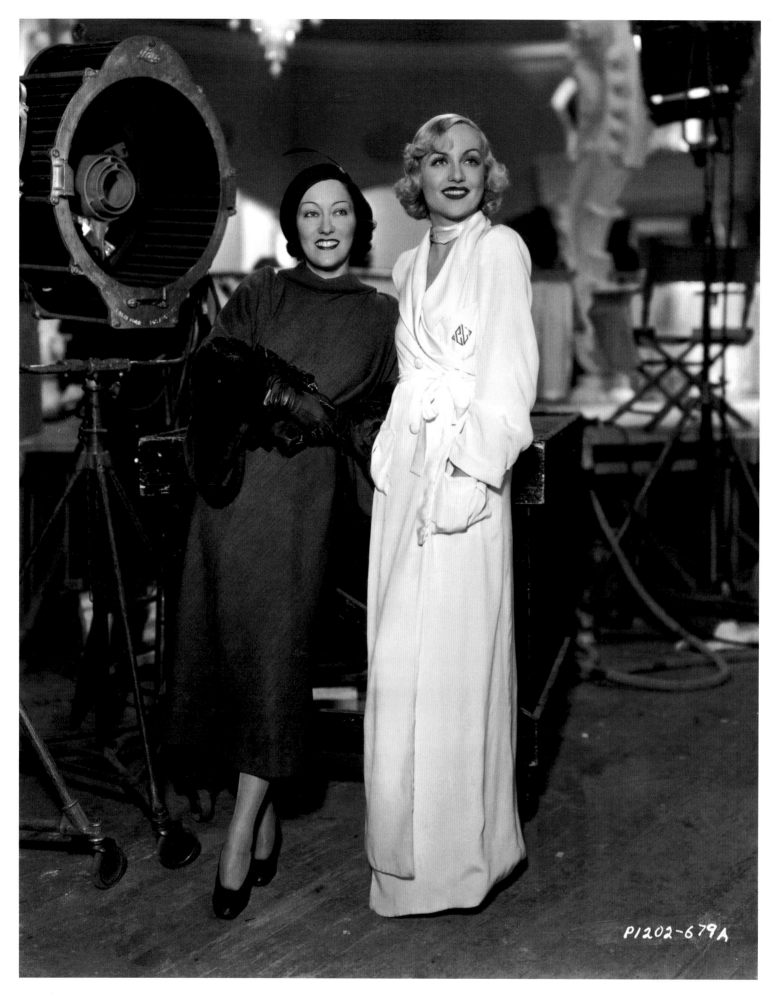

P1202-679A

Gloria Swanson makes a set visit to Carole Lombard
at Paramount Studios, Los Angeles
Paramount Pictures, c.1935

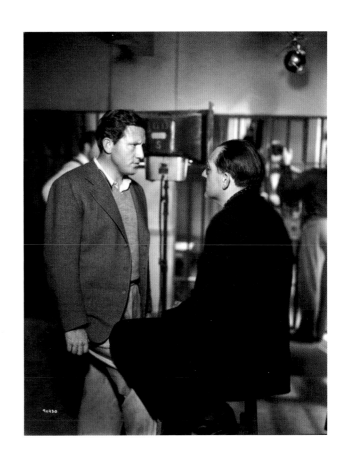

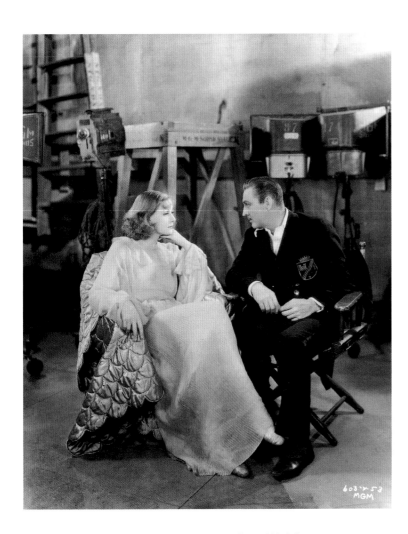

Greta Garbo and John Barrymore on set, *Grand Hotel*
MGM, 1932

Spencer Tracey with Director Fritz Lang on set, *Fury*
MGM, 1936

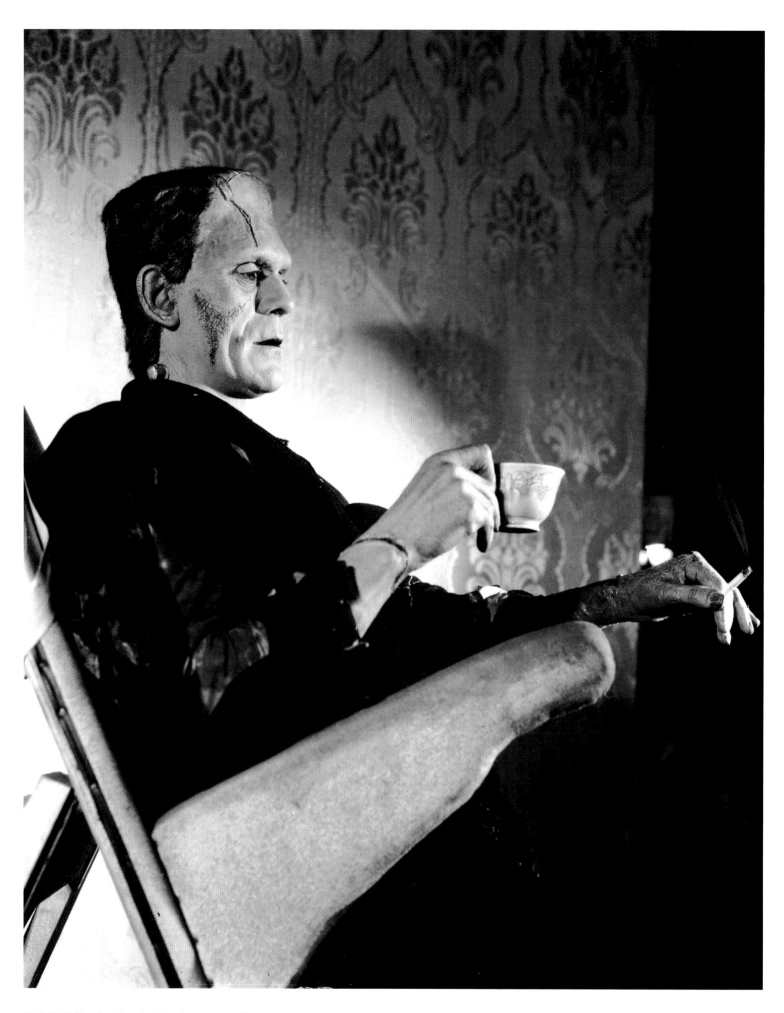

Boris Karloff as Frankenstein having a cup of tea
during shooting for *Bride of Frankenstein*
Universal, 1935

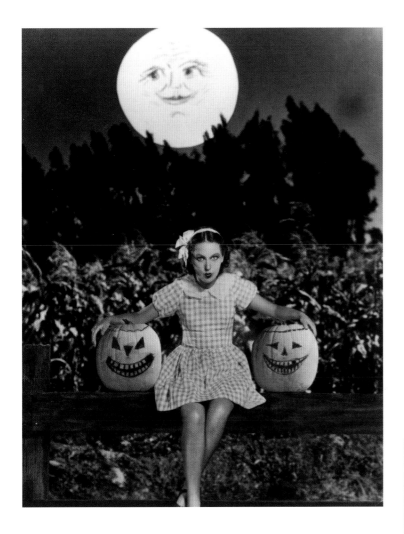

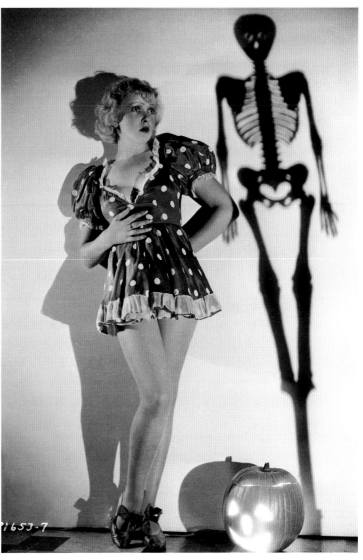

Dorothy Jordan celebrates Halloween
MGM, c.1930
Photograph by Clarence Sinclair Bull

Ida Lupino scaring up Halloween
Paramount Pictures, c.1934

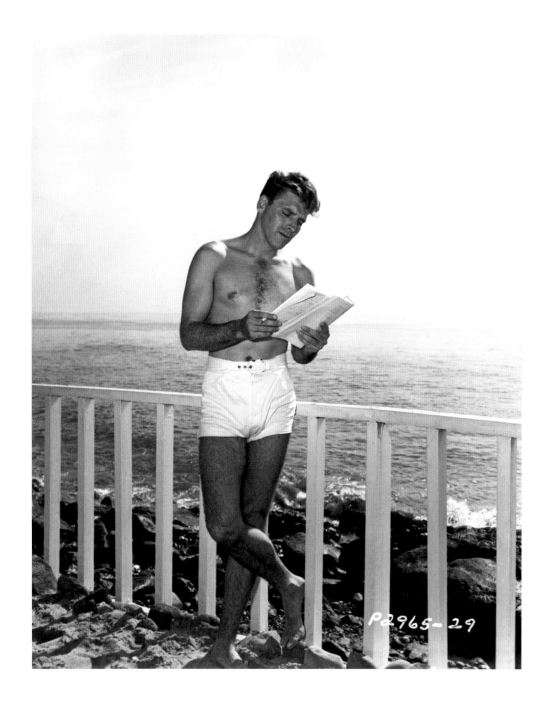

Burt Lancaster learning his lines
Paramount Pictures, c.1948

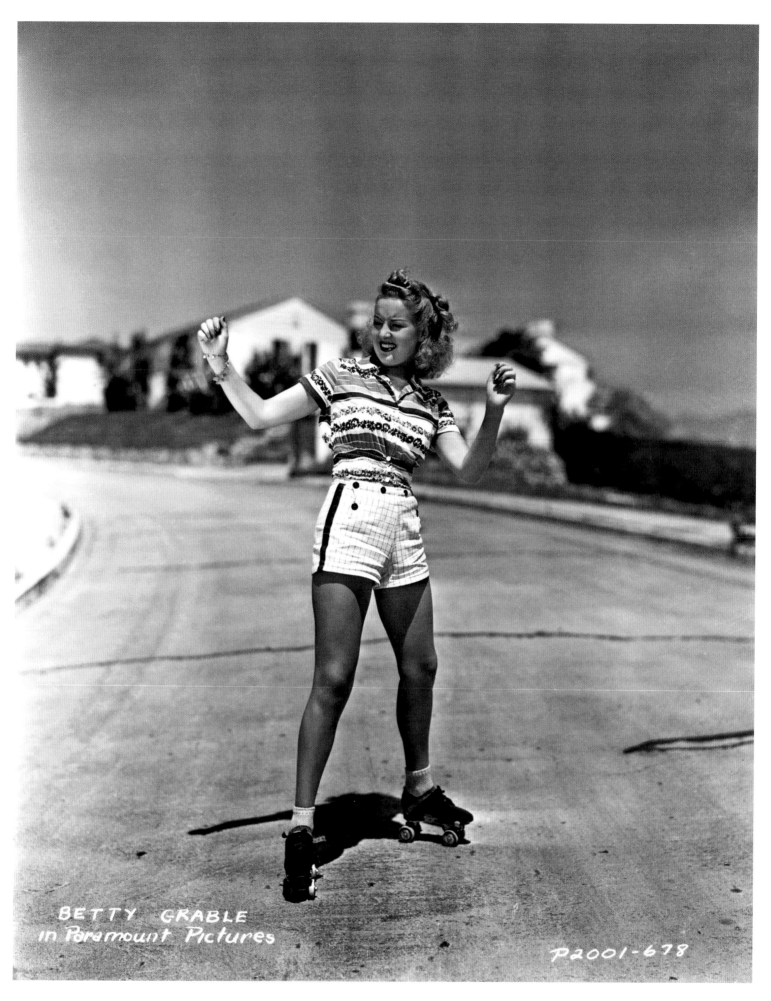

Betty Grable
Paramount Pictures, 1936

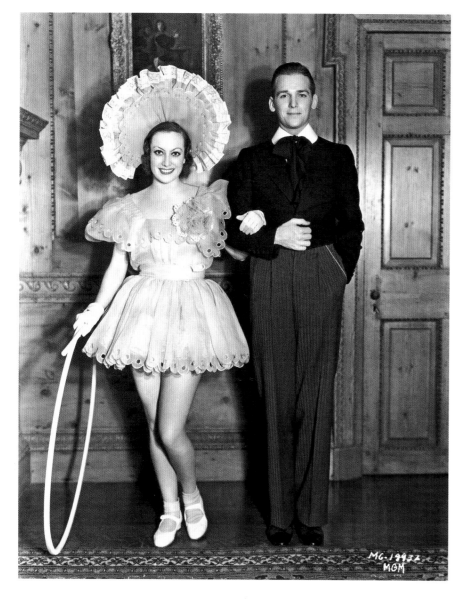

Joan Crawford with her first husband, Douglas Fairbanks Jnr, at a
costume party at Marion Davies' beach house in Santa Monica
MGM, 1931
Photograph by James Manatt

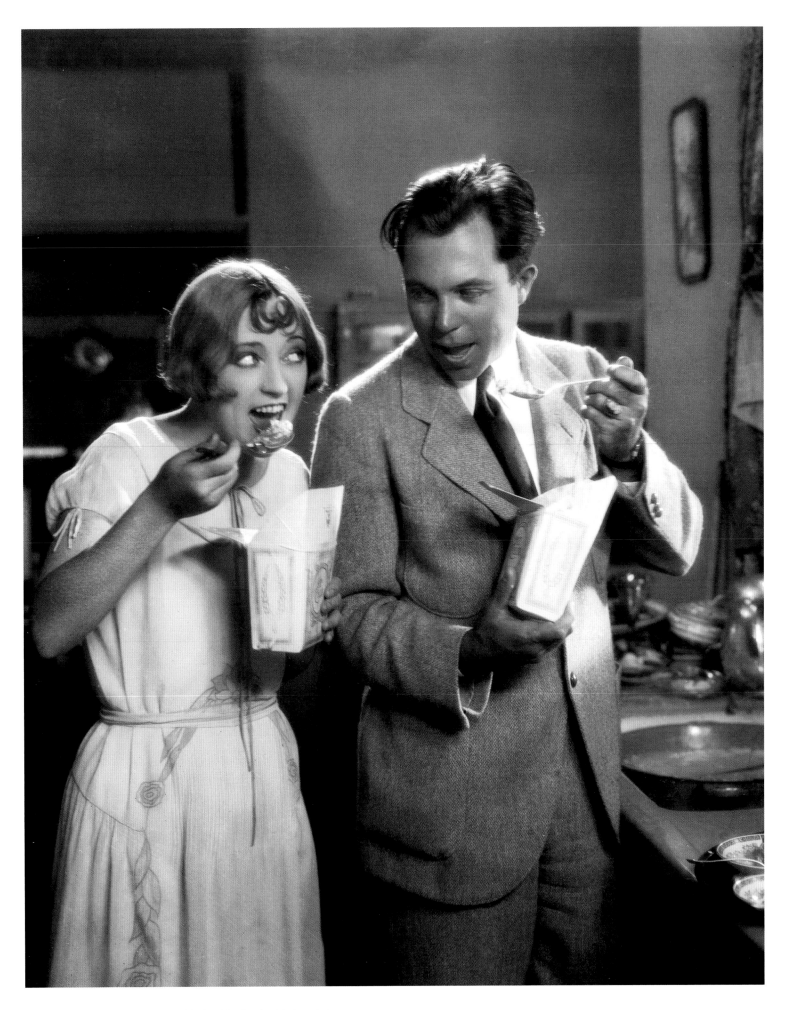

Director King Vidor and actress Marion Davies tuck into a takeaway
meal during the filming of *The Patsy*, aka *The Politic Flapper*
MGM, 1927

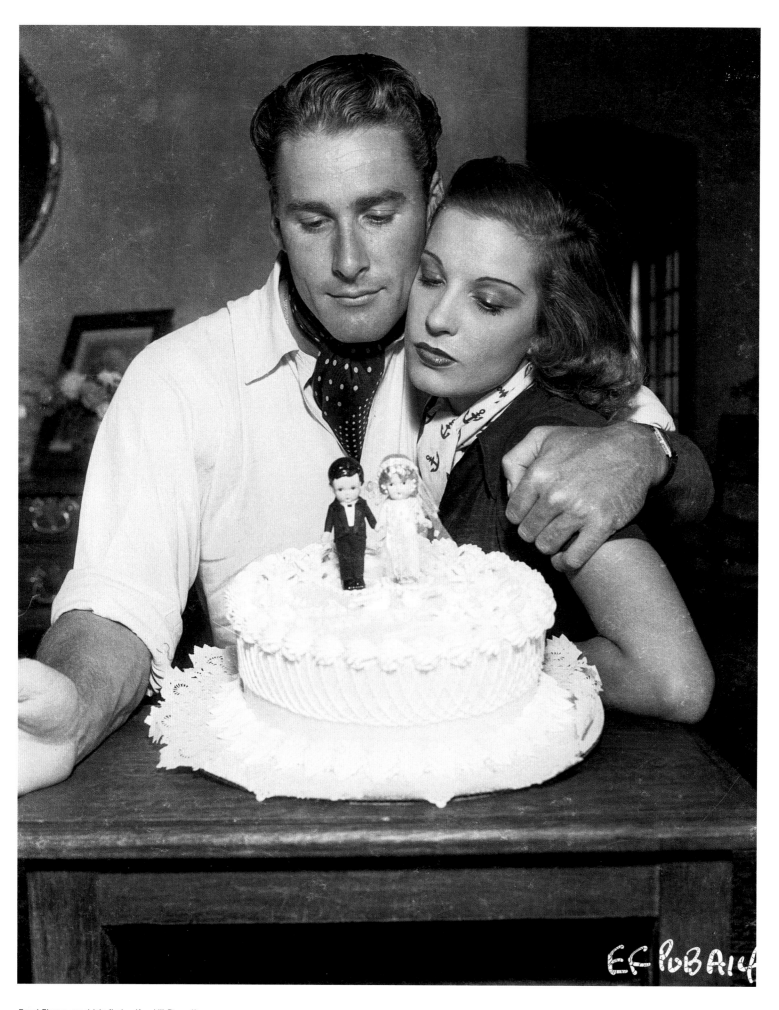

Errol Flynn and his first wife, Lili Damita,
posing with their wedding cake
Warner Brothers, 1935

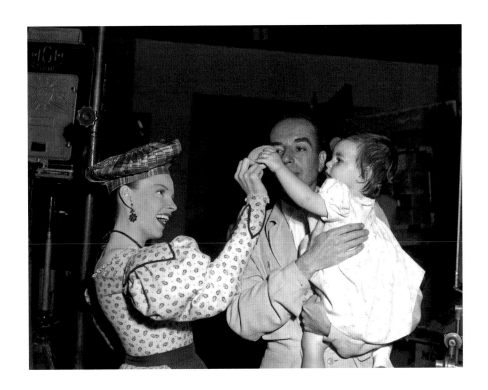

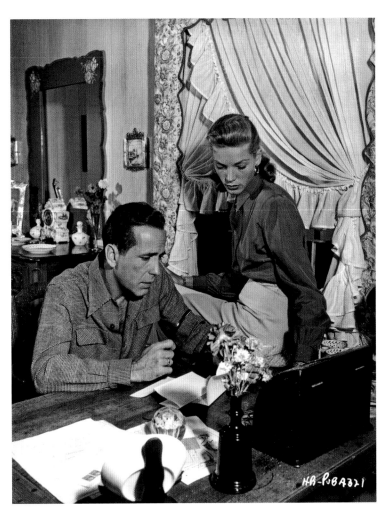

Judy Garland and her second husband, director
Vincente Minnelli, with their daughter Liza
MGM, 1948

Humphrey Bogart and Lauren Bacall at home
Warner Brothers, c.1945

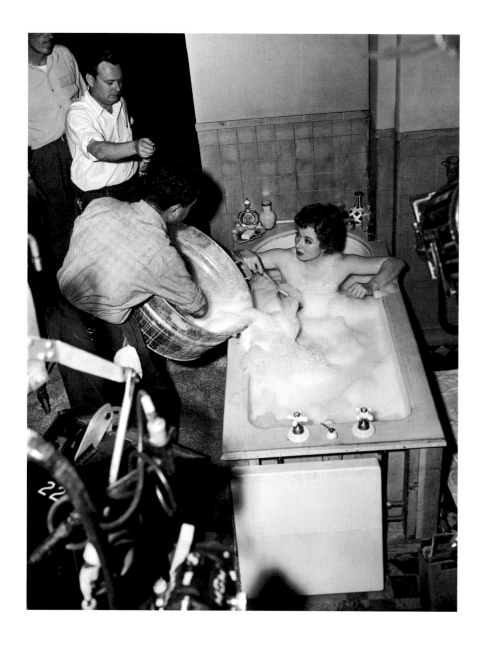

"GARSON TAKES A BATH! ... with two million
bubbles... And some outside help for comedy
scenes in Metro-Goldwyn-Mayer's *Julia
Misbehaves.* Assisting Miss Garson in the frothy
preparations are prop men Tony Ordoqui and
Carl Nugent."
Original MGM photo caption

Greer Garson
MGM, 1948

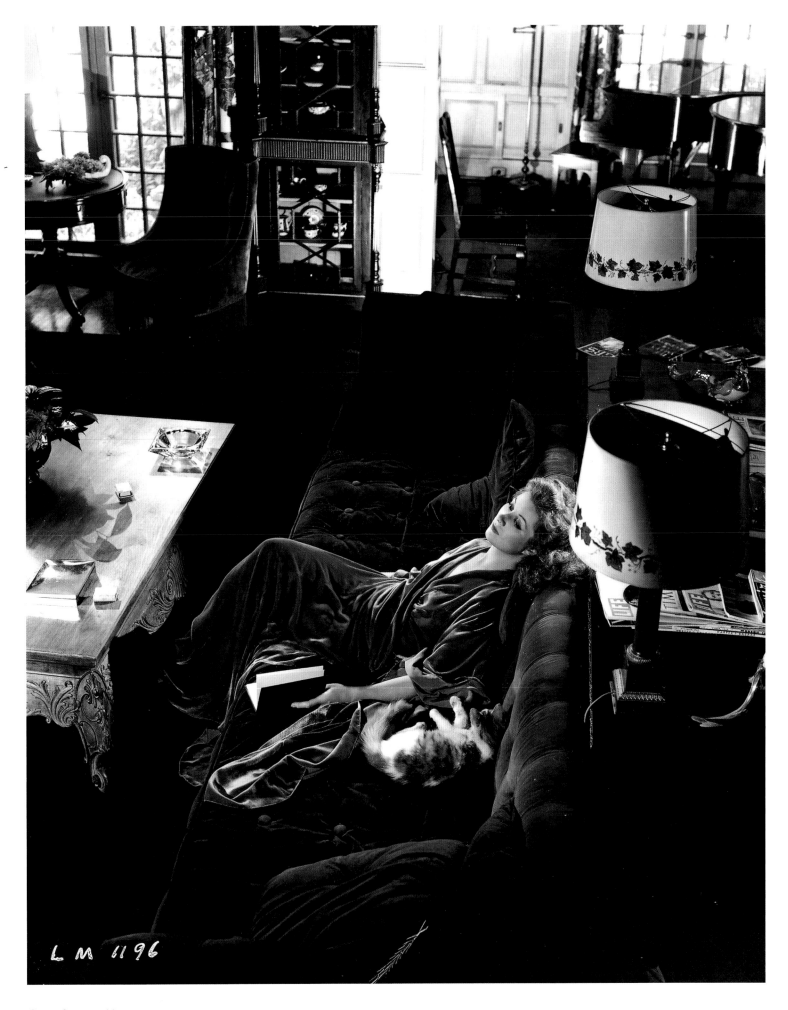

LM 1196

Greer Garson at home
MGM, 1941

The poodle came from Natalie's mother, who
regularly traveled to Britain to acquire pedigree
puppies to take home and sell to Hollywood stars
including Marilyn Monroe's now famous poodle,
Maf Honey.

Natalie Wood with her poodle, Morning Star,
Warner Brothers, c.1956

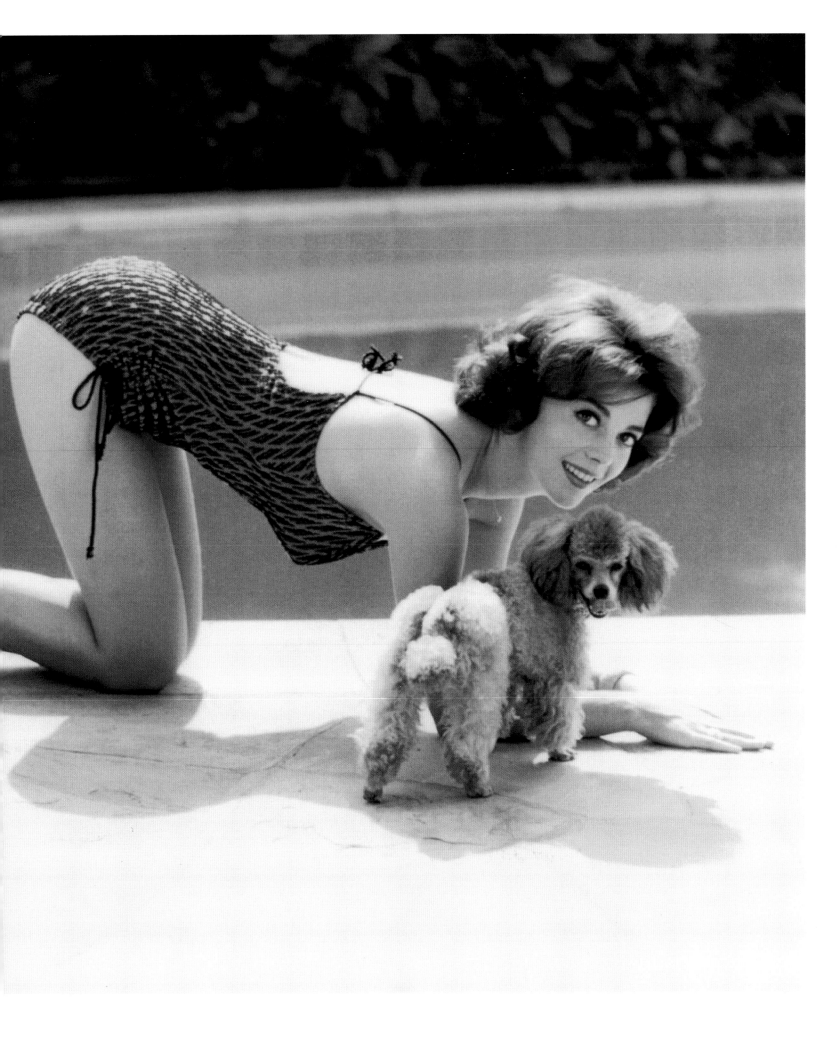

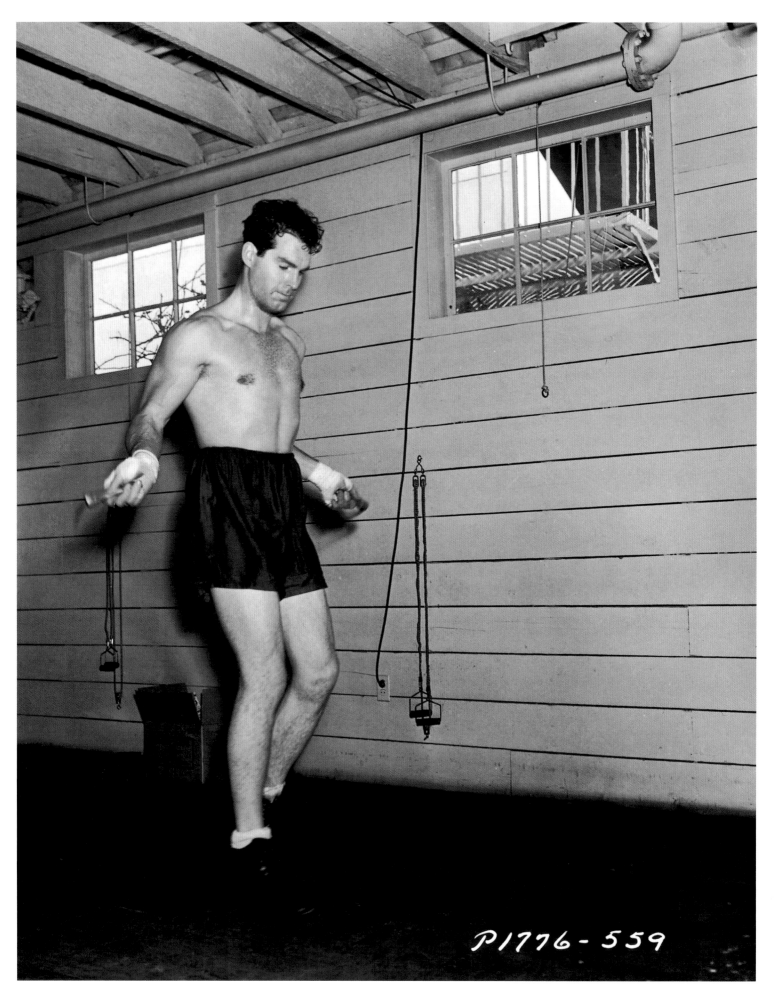

P1776-559

Fred MacMurray in training
Paramount Pictures, c.1935

140

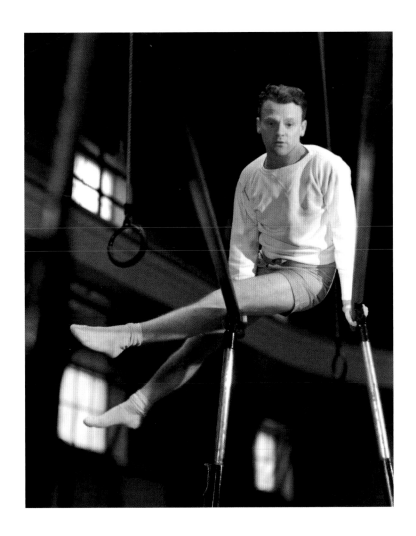

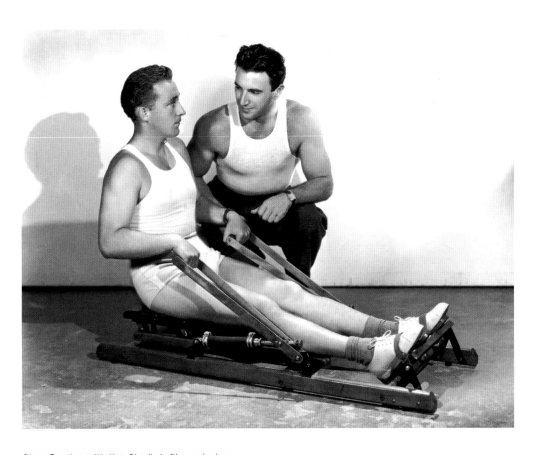

James Cagney
Warner Brothers, 1933

Bing Crosby with the Studio's fitness trainer
Paramount Pictures, 1934

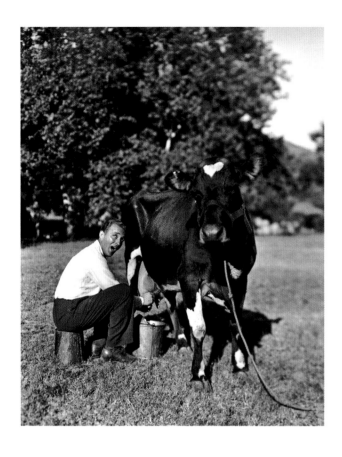

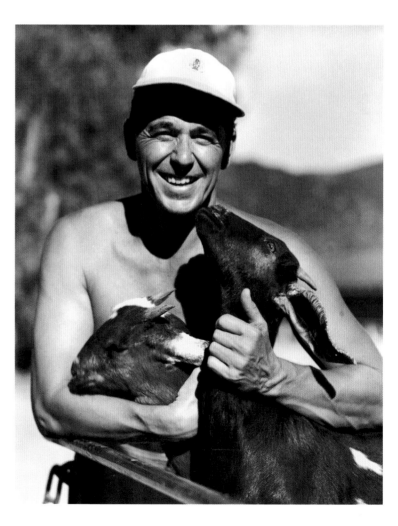

Bing Crosby doing a publicity gag shot during
the filming of *Pennies from Heaven*
Columbia, 1936

Ronald Reagan at home in Pacific Palisades
Warner Brothers, c.1954

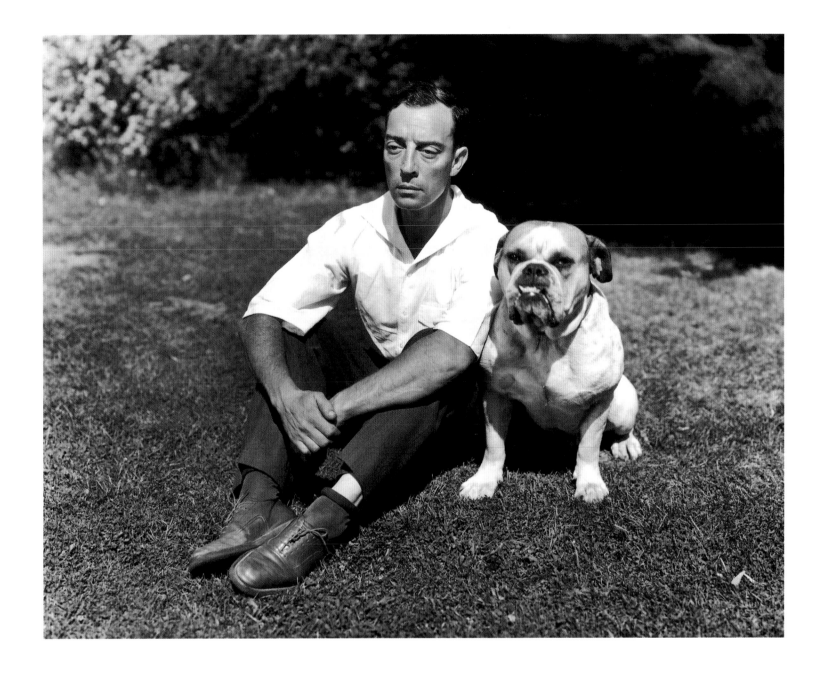

Buster Keaton with a canine chum
MGM, c.1928

Cyd Charisse in a party mood
MGM, 1953
Photograph by Clarence Sinclair Bull

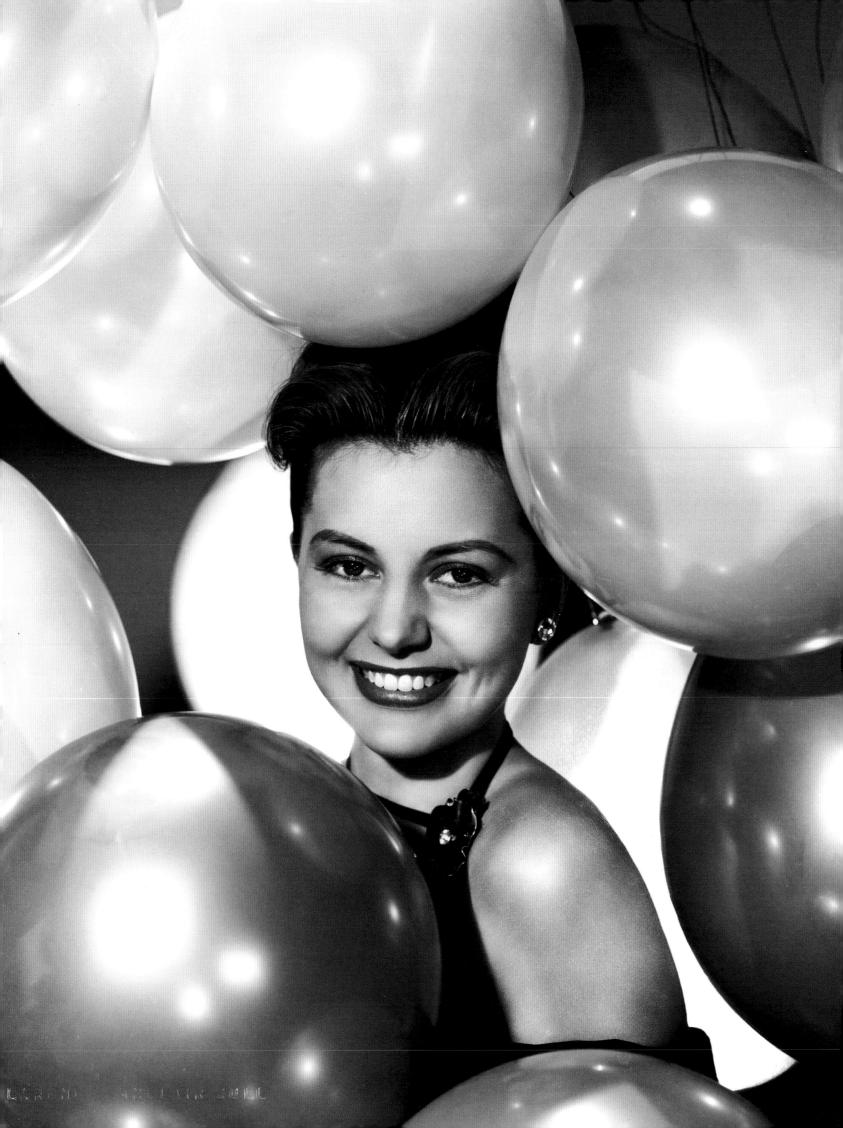

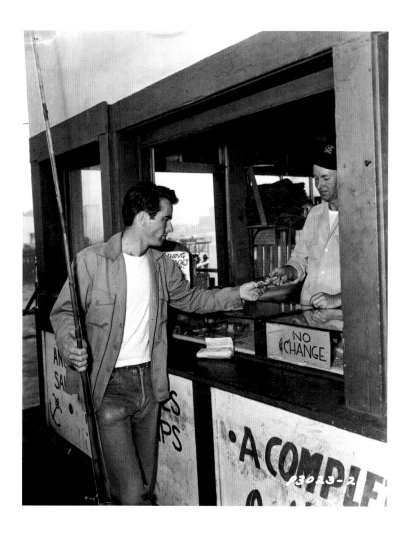

Montgomery Clift
MGM, c.1950

Clark Gable planning a hunting expedition
MGM, 1933

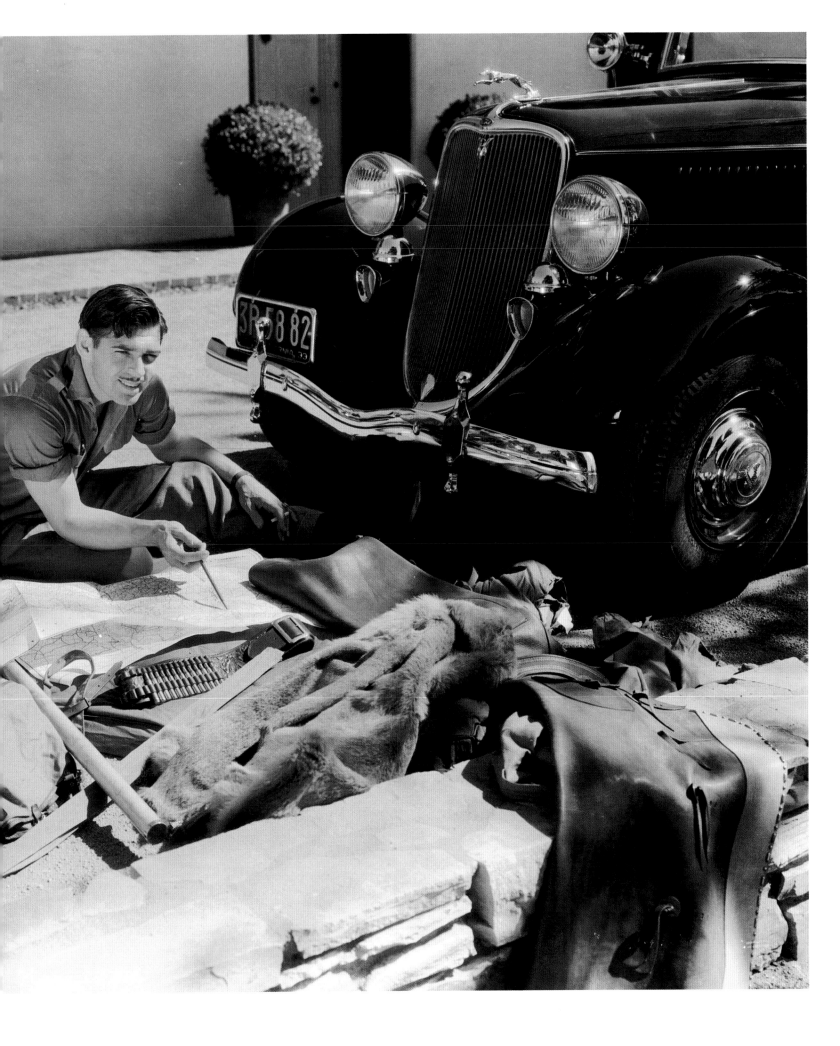

147

Gary Cooper, bound for the USA, boarding the
Majestic boat train at Waterloo Station, London
Paramount Pictures, 1931

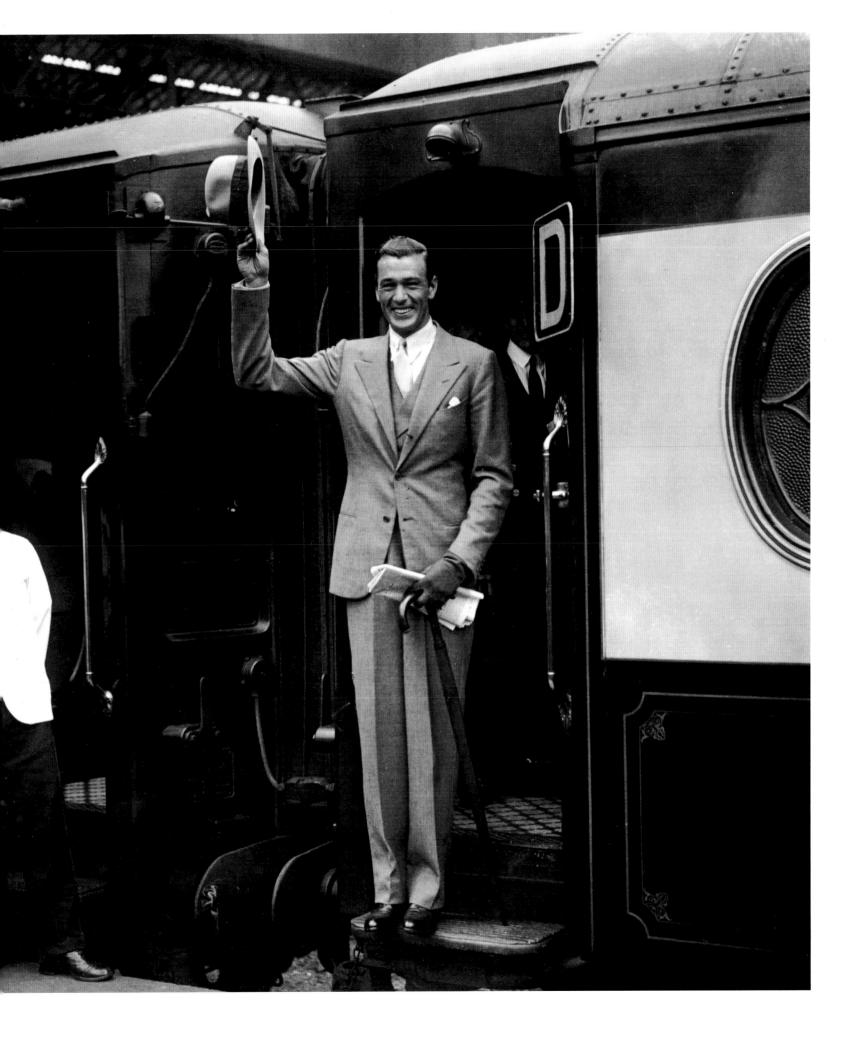

When Hunter, one of Hollywood's top beefcake stars, was persistently pursued by tabloid magazines trying to "out" him as gay, Warner Brothers, to combat them, made sure he was seen escorting beautiful actresses, such as their very own Natalie Wood, to premieres and parties.

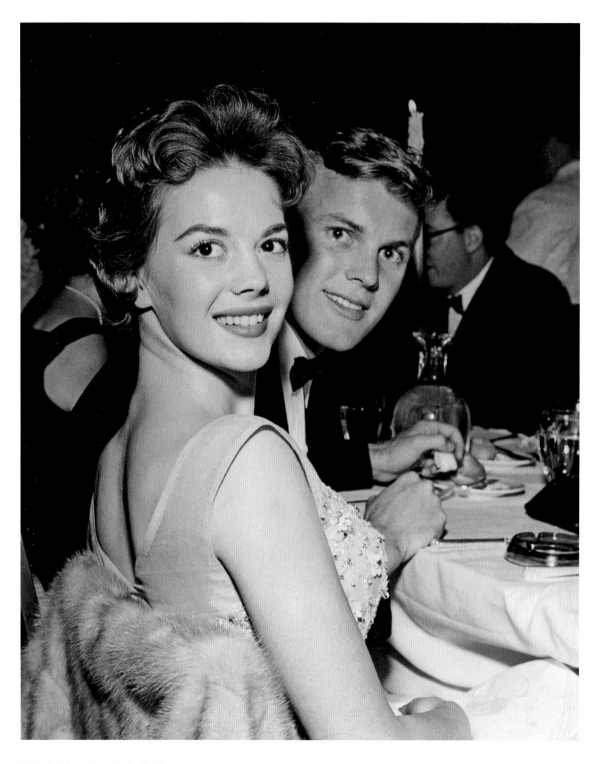

Natalie Wood and Tab Hunter
Warner Brothers, c.1955

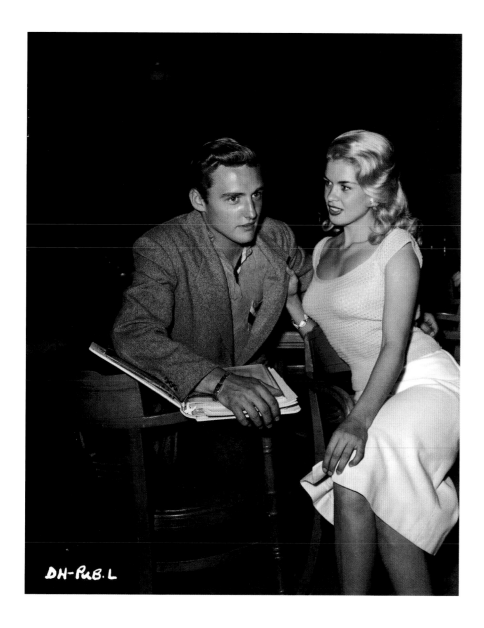

"Photo opportunity" shots were a staple of the film studio publicist's repertoire. What better way was there to get hearts beating than for Warner Brothers to pose two of their hot young actors like Hopper and Mansfield together; or for Paramount to promote the handsome, young, and as yet unknown hunk, Sterling Hayden by linking him with established Paramount star, Veronica Lake.

Dennis Hopper and Jayne Mansfield,
Warner Brothers stars
Warner Brothers, 1954

Veronica Lake with Sterling Hayden
at a Hollywood dinner
Paramount Pictures, c.1941

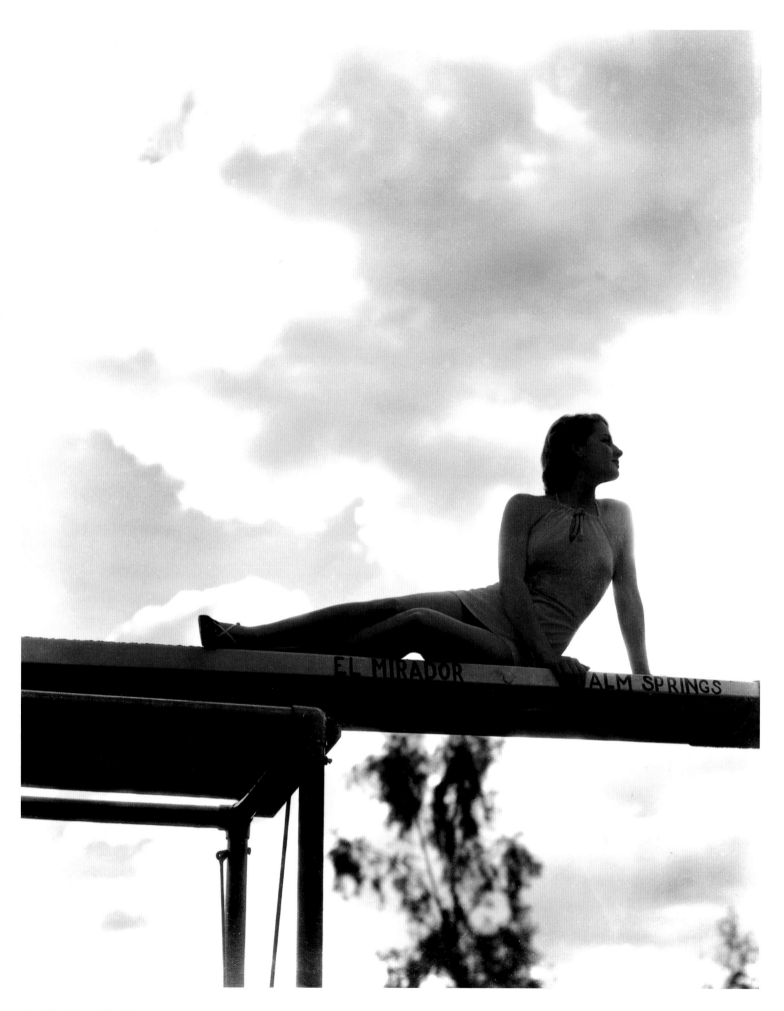

Ann Sheridan at the El Mirador Hotel, Palm Springs, California
Warner Brothers, c.1936

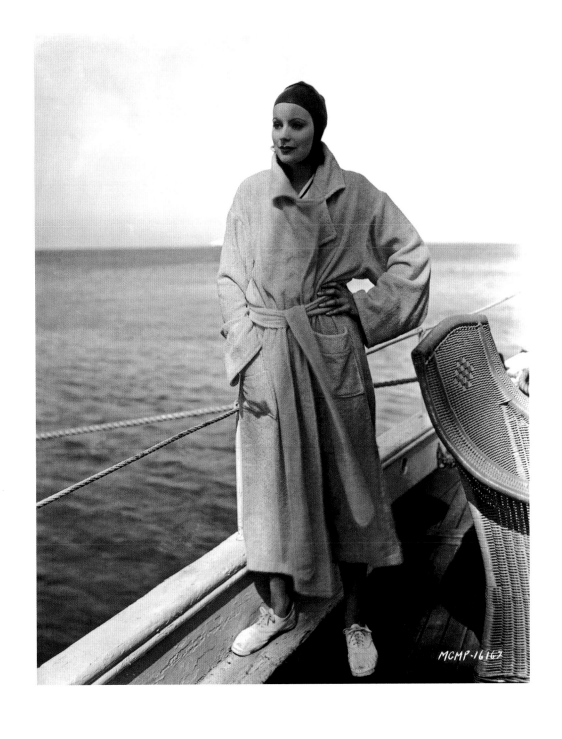

Greta Garbo on a yacht off Catalina Island, California,
the location for scenes in *The Single Standard*
MGM, 1929

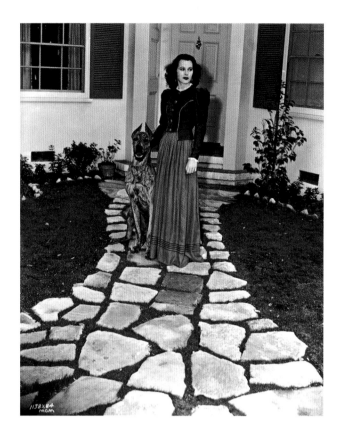

Hedy Lamarr at home with a hound
MGM, c.1943

Marilyn Monroe posing for a photo session to be
used in the poster art for *How To Marry A Millionaire*
20th Century Fox, 1953

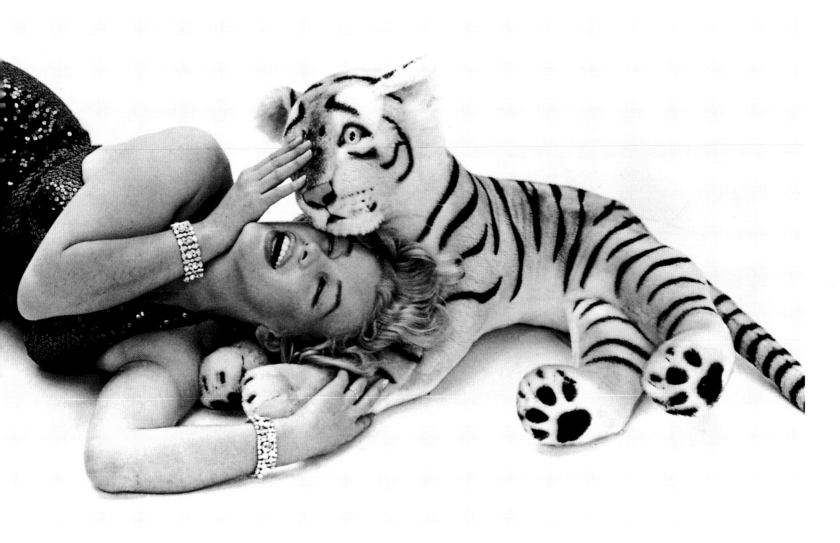

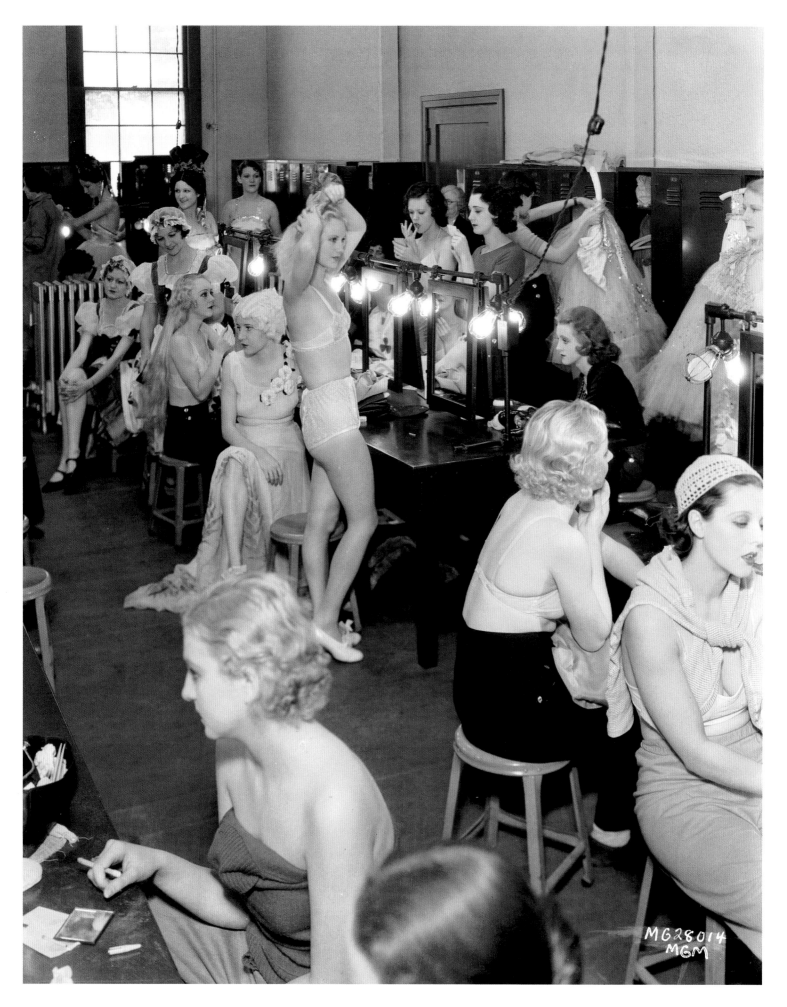

Chorus girls crowd into the dressing room as they prepare
for the day's shoot of the musical *Dancing Lady*, starring
ex-chorus girl Joan Crawford
MGM, 1932

W.C. Fields
Paramount Pictures, c.1935

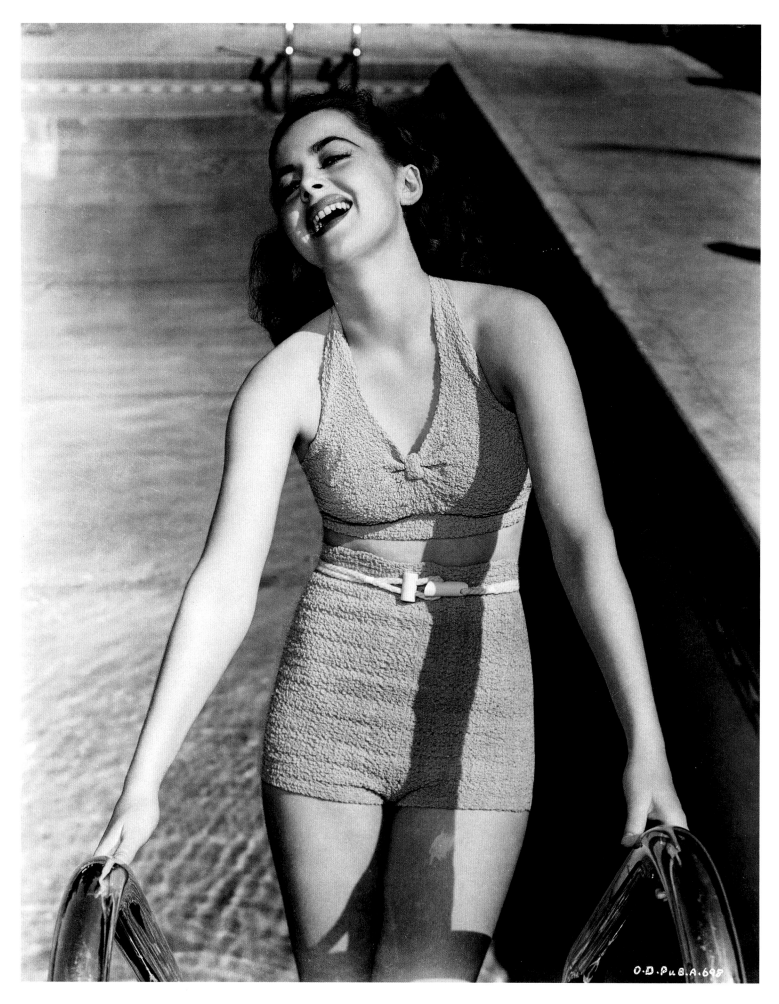

Olivia de Havilland
Warner Brothers, 1938

Fred Astaire
RKO, c.1935

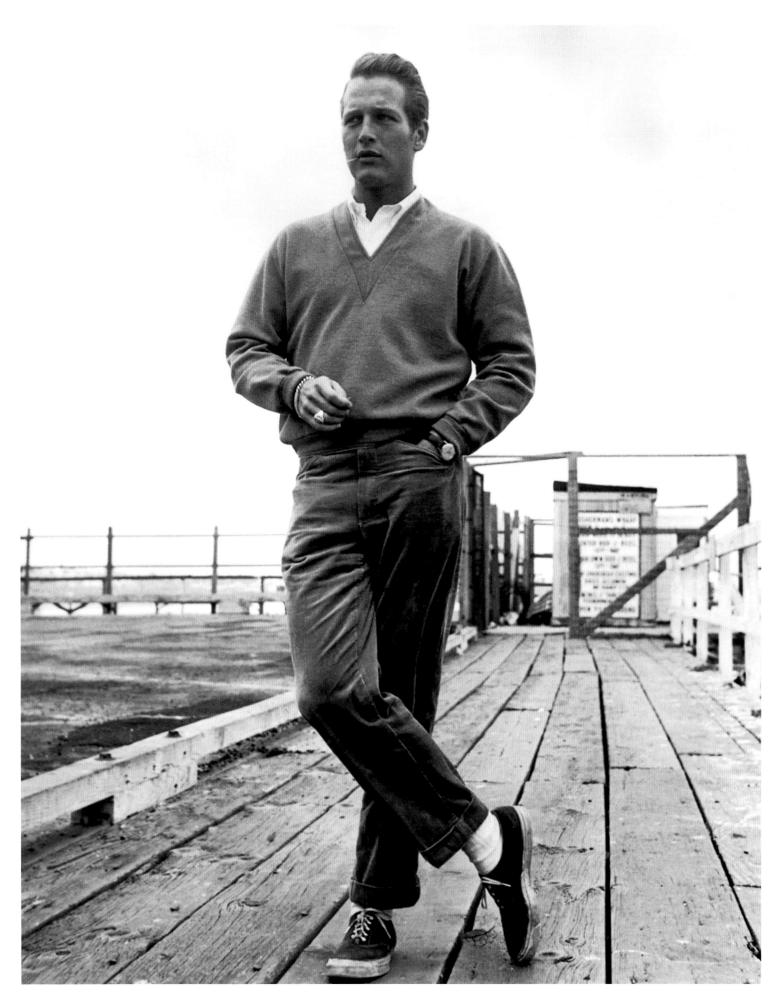

Paul Newman
MGM, c.1956

Robert Mitchum
United Artists, c.1956

P2631-117

Alan Ladd and William Bendix signing photos
for the extras while on location for *China*
Paramount Pictures, 1943

Stan Laurel, Buster Keaton, Oliver Hardy
and Jimmy Durante playing around
MGM, c.1931

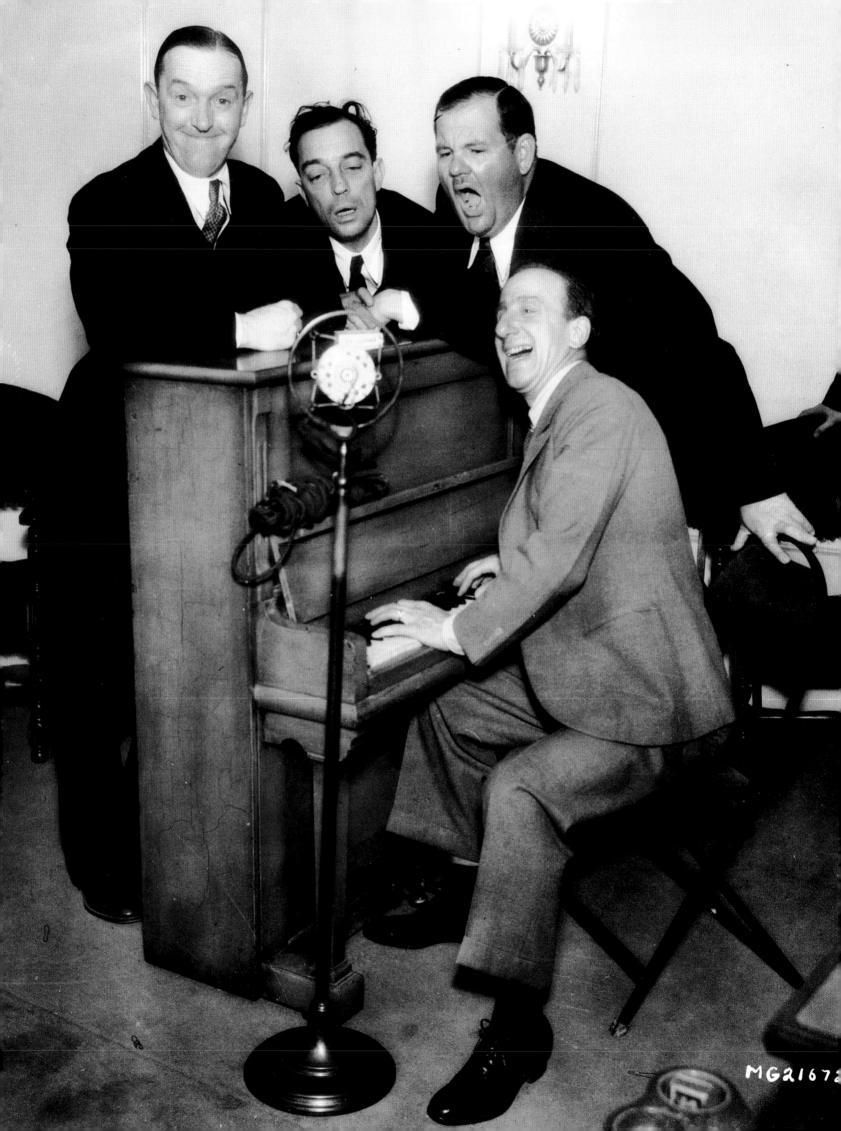

MG21672

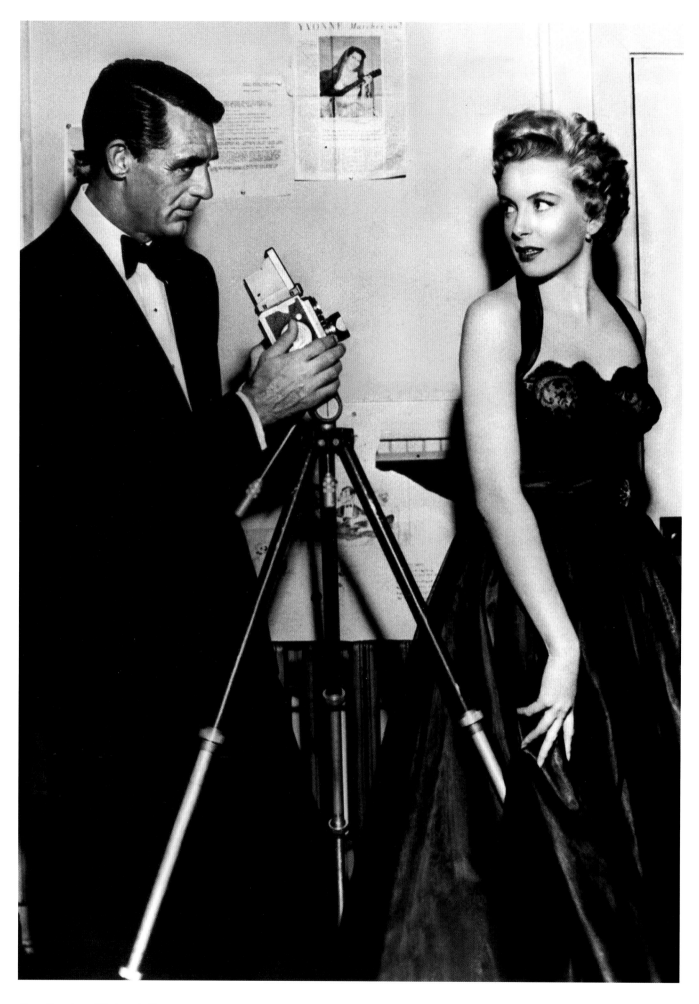

Cary Grant and Deborah Kerr
during the filming of *Dream Wife*
MGM, 1953

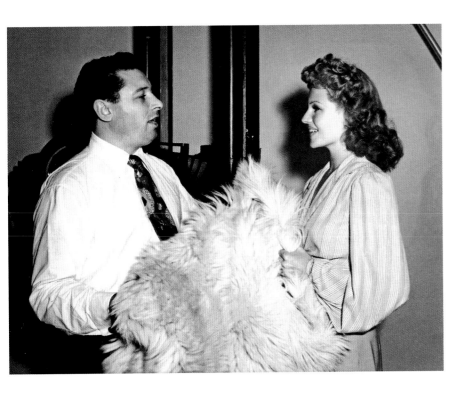

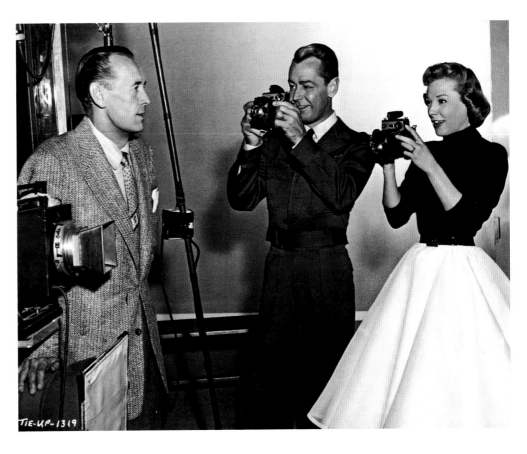

Photographer George Hurrell
and Rita Hayworth preparing
for a photo session together
Columbia, c.1946

June Allyson and Alan Ladd with
photographer Bert Six during the
filming of *The McConnell Story*
Warner Brothers, 1955

Audrey Hepburn with her dog, Mr. Famous
Paramount Pictures, c.1961

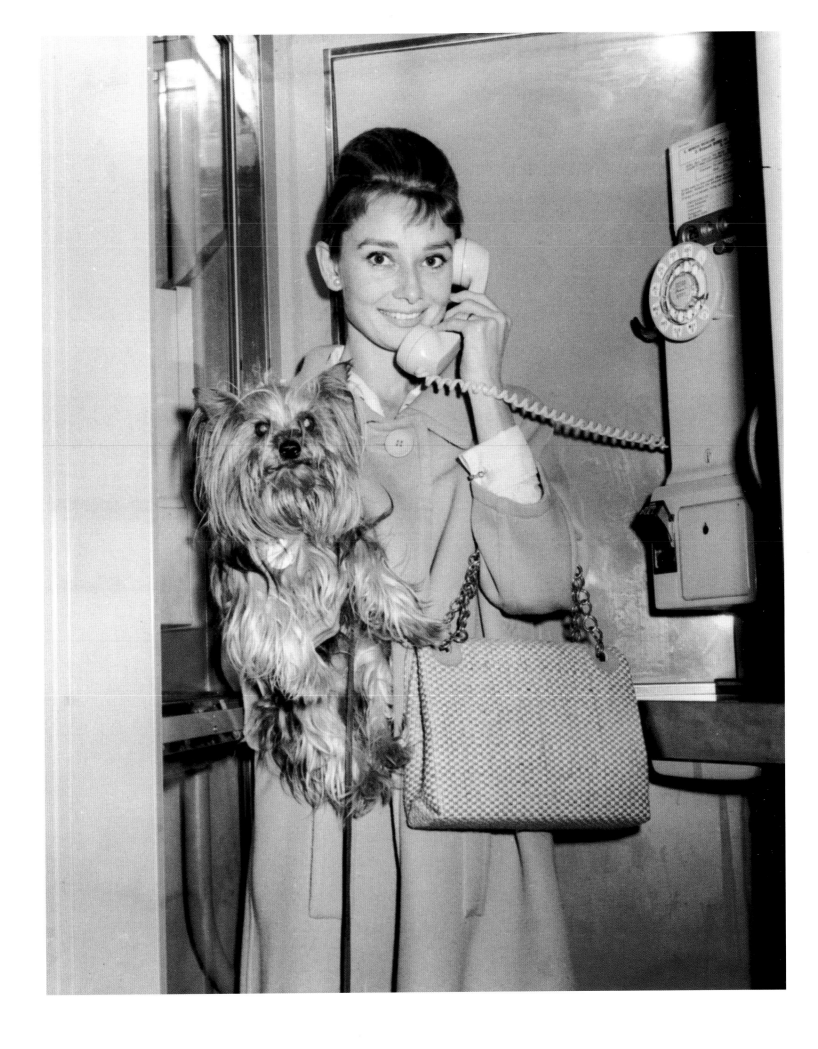

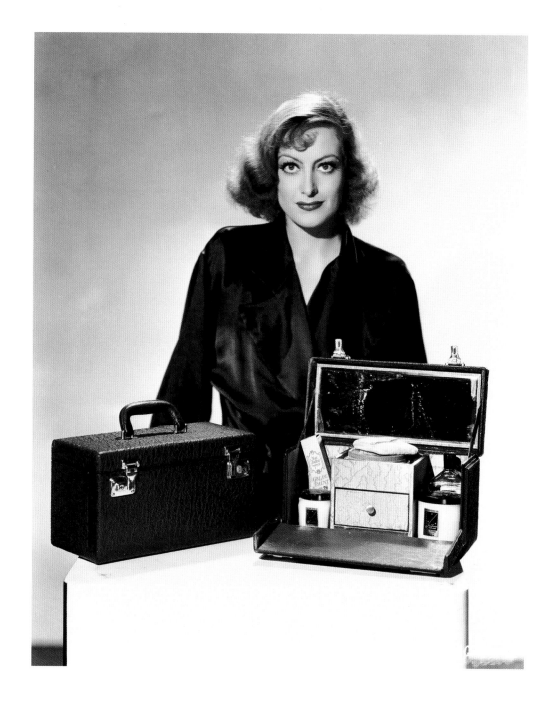

Brand promotional tie-ins go right back to the 1930s, when Studio stars were contractually obligated to promote cars, perfumes, make-up, fashion, alcohol, soft drinks and cigarettes. In return, the brands being promoted were bound to place advertisements to coincide with the star's next film release.

Joan Crawford promoting Max Factor make-up
MGM, 1933
Photograph by Clarence Sinclair Bull

Rita Hayworth advertising perfume
Columbia, c.1941

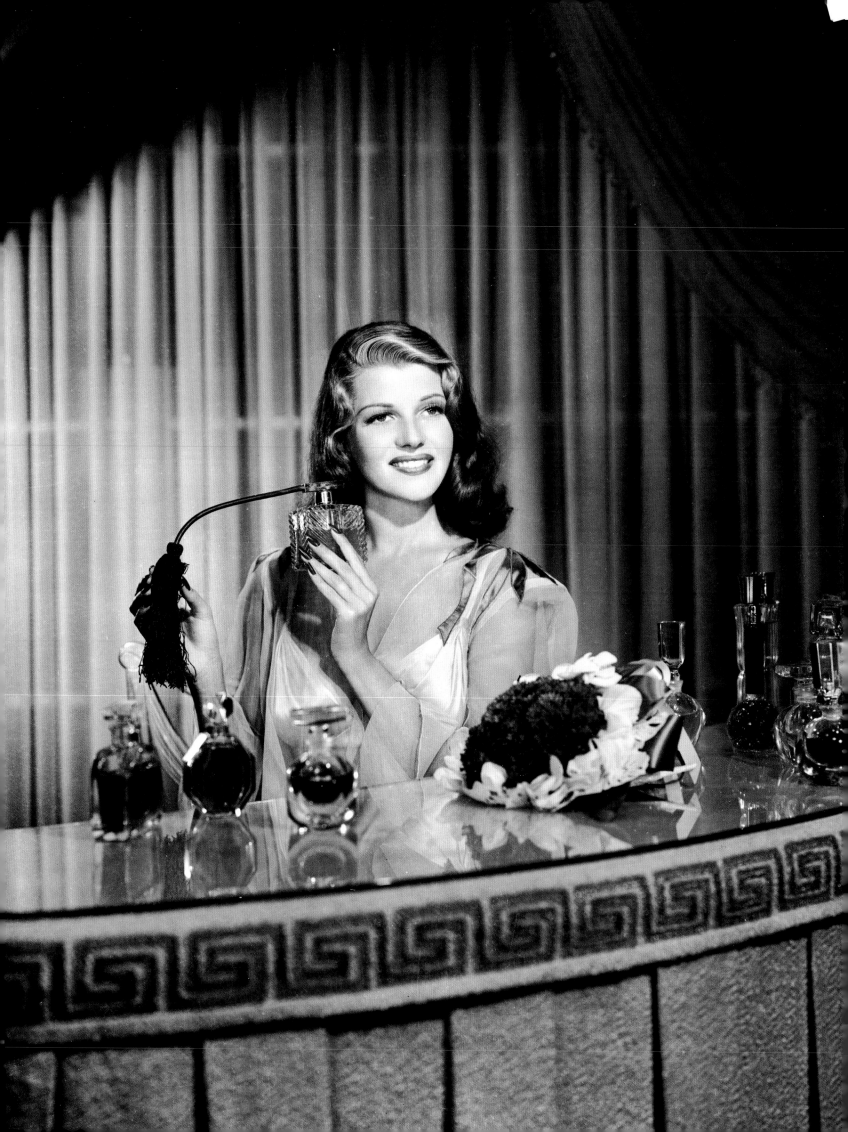

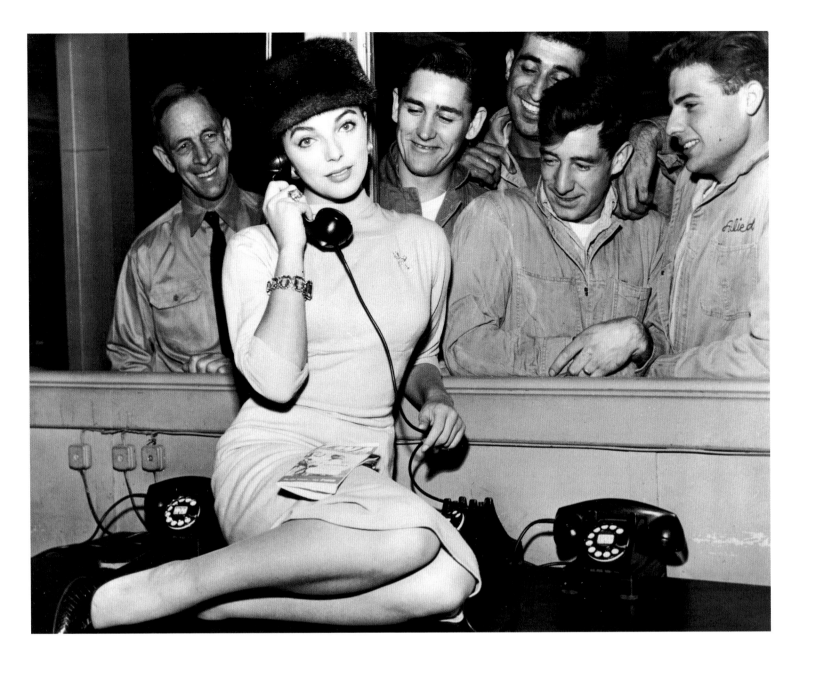

Joan Collins at Idlewild Airport, New York,
after completing *Island in the Sun*
20th Century Fox, 1957

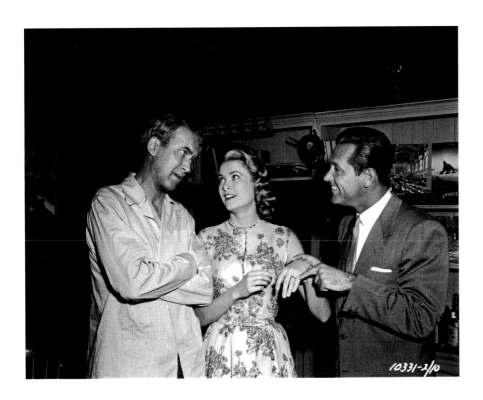

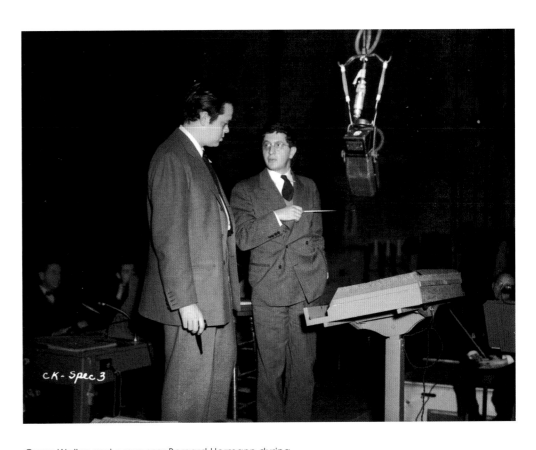

William Holden visiting James Stewart
and Grace Kelly on set, *Rear Window*
Paramount Pictures, 1954

Orson Welles and composer Bernard Hermann during
the recording of his musical score for *Citizen Kane*
RKO, 1941

Cary Grant on the Studio back lot, Los Angeles
Paramount Pictures, 1932

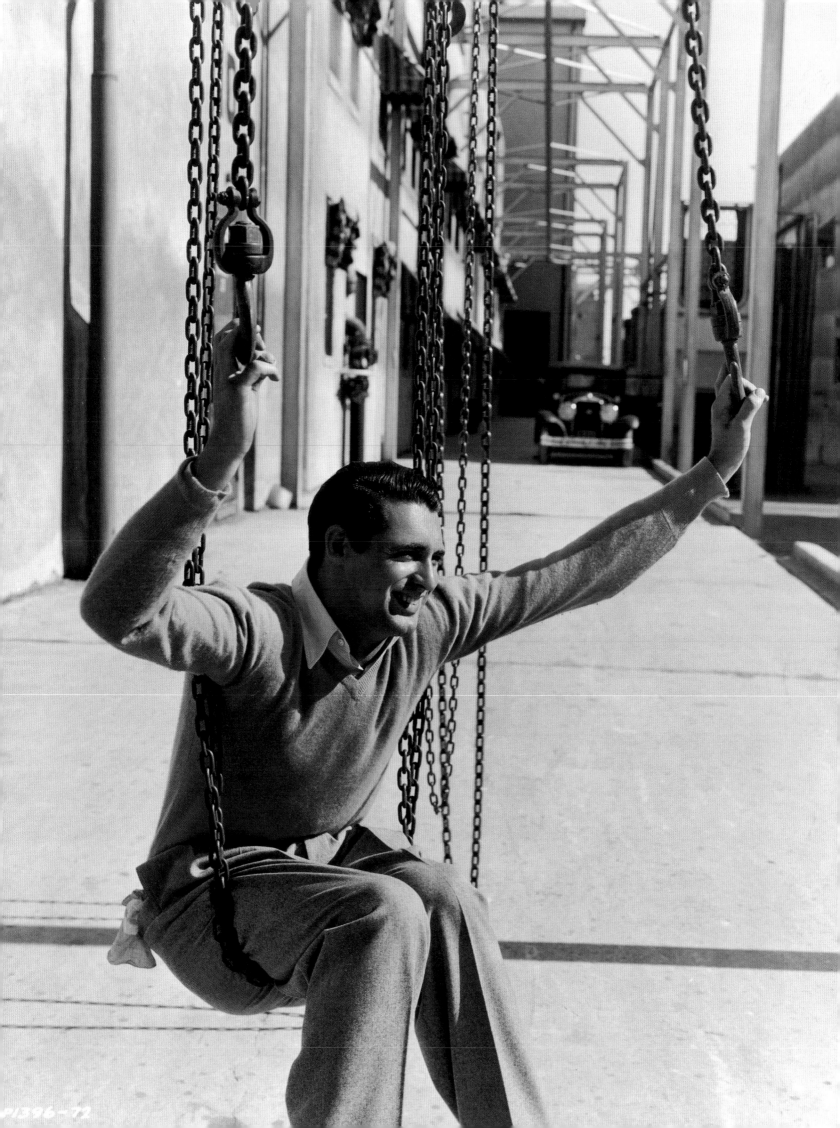

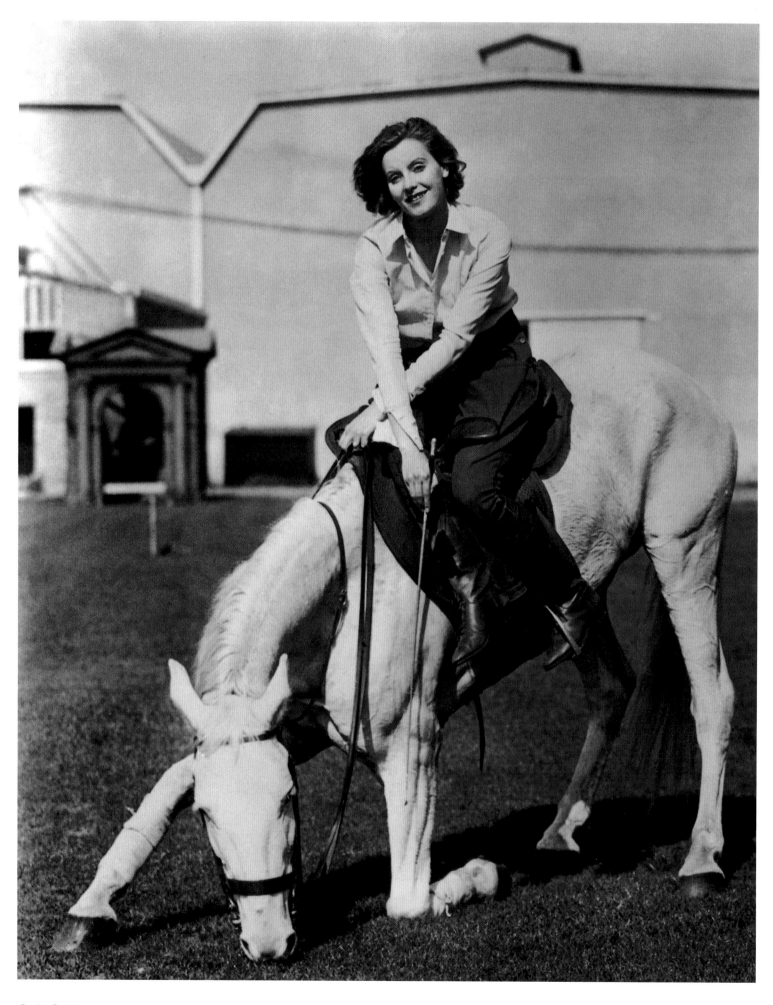

Greta Garbo
MGM, 1926
Photograph by Don Gillum

Greta Garbo
MGM, 1925

After 1927 and her huge success in *Flesh and the Devil*, Garbo never appeared again in these kinds of publicity shots. This refusal was unprecedented at the time. Garbo was the only Studio star who used her box office power in this way.

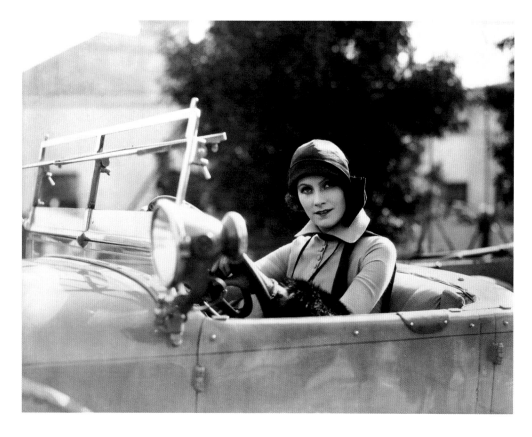

Greta Garbo
MGM, 1925

Greta Garbo with USC track
coach, Dean Cromwell
MGM, 1926
Photograph by Don Gillum

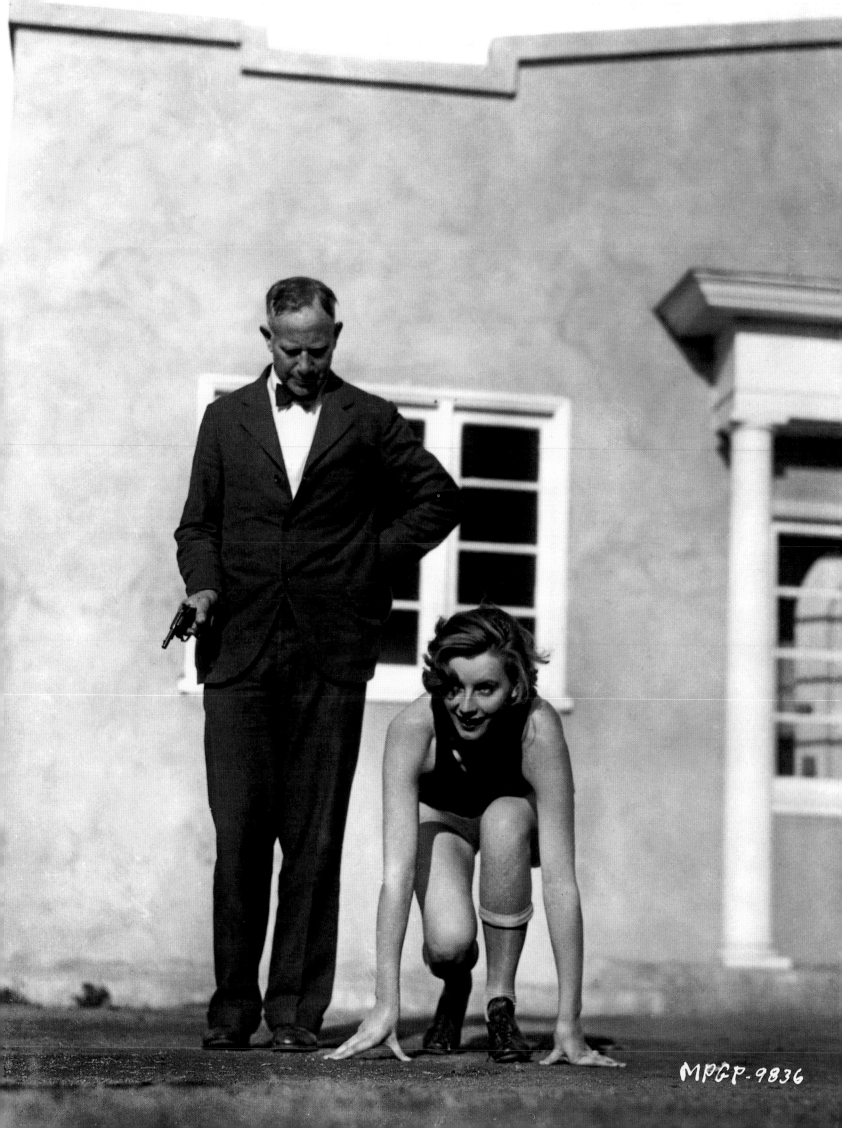

MPGP-9836

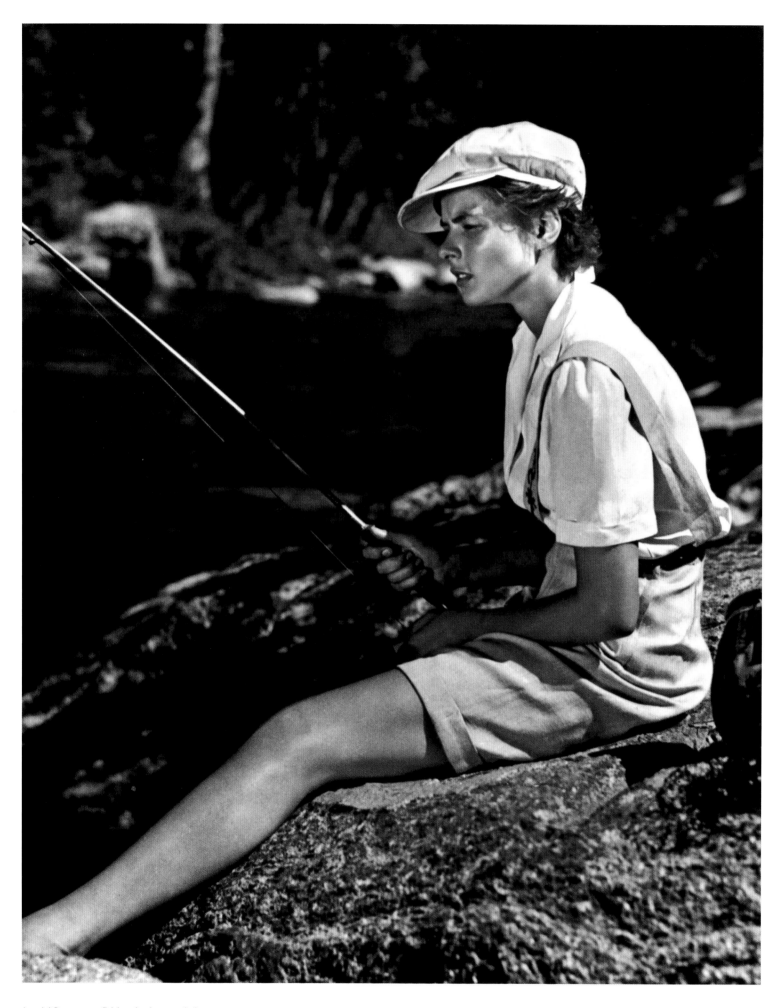

Ingrid Bergman fishing between takes
of *For Whom the Bell Tolls*
Paramount Pictures, 1942

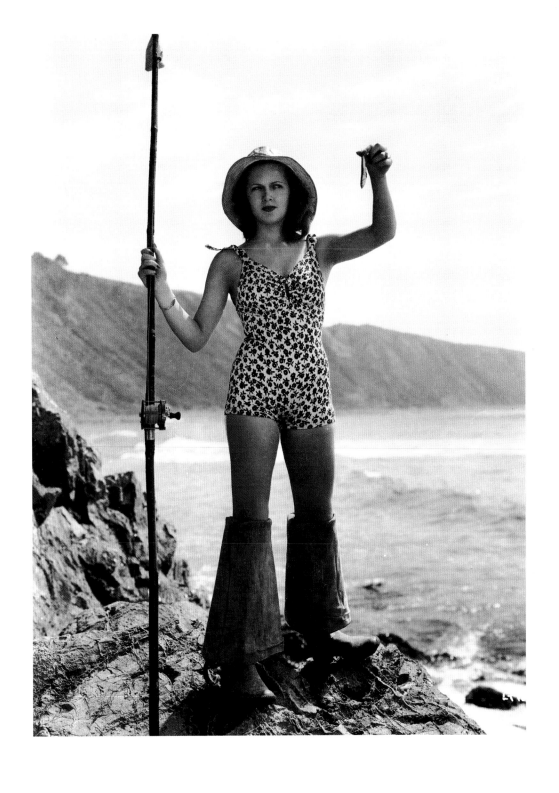

Lana Turner
Warner Brothers, c.1937

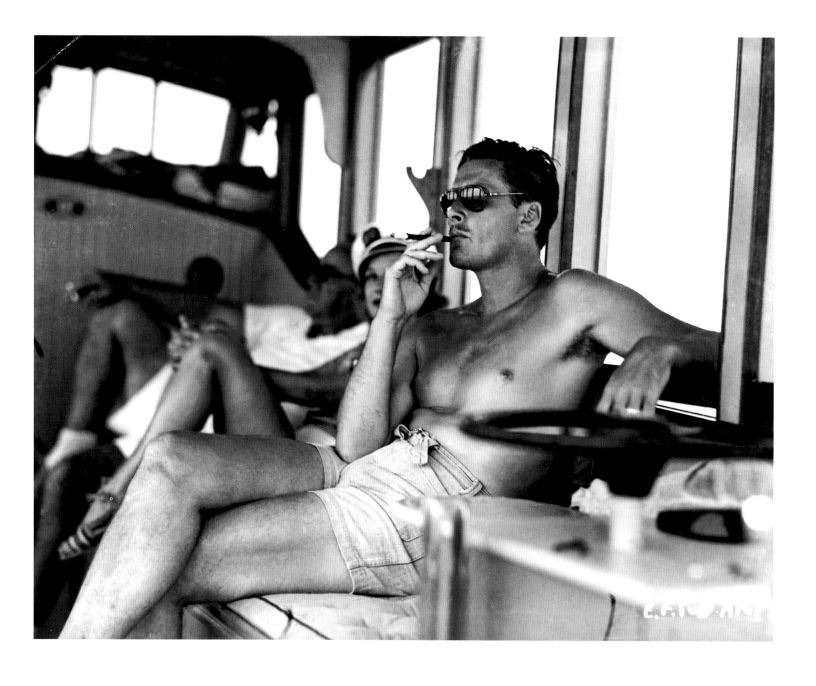

Errol Flynn boating with his first wife,
French actress Lili Damita
Warner Brothers, c.1940

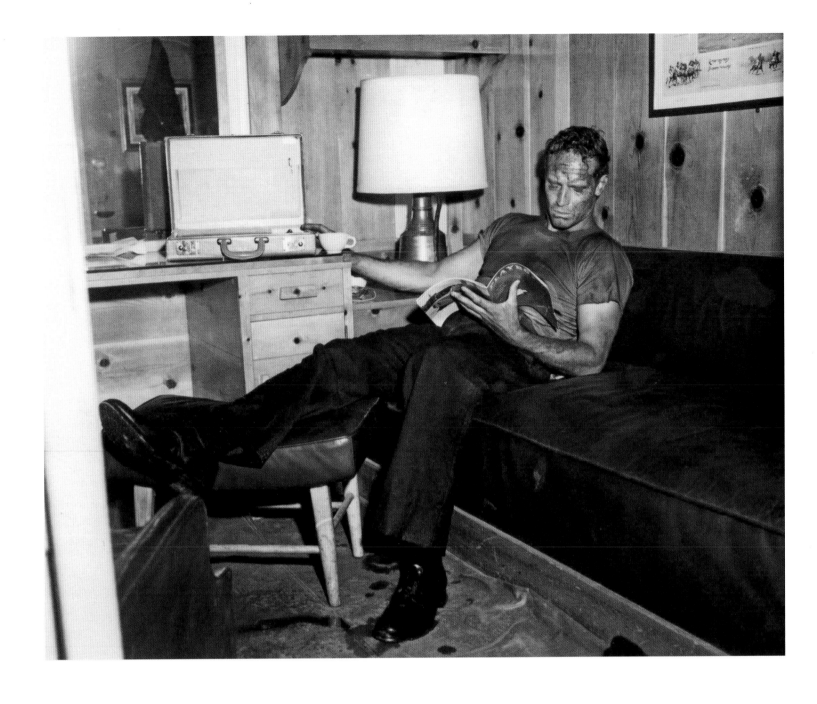

Charlton Heston in his trailer off set,
The Wreck of the Mary Deare
MGM, 1959

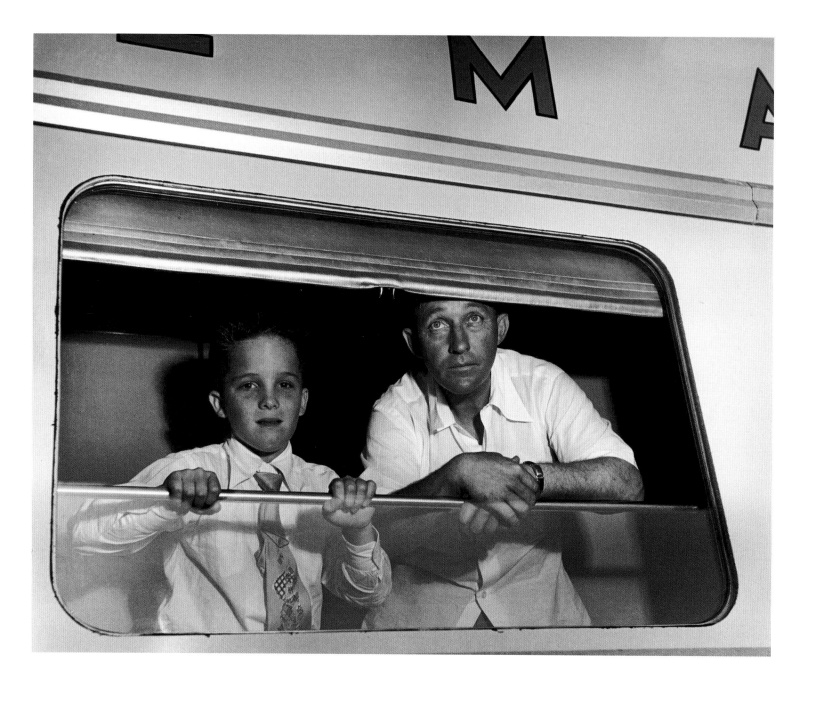

Bing Crosby and his son, Lindsay, aged twelve, aboard the
Santa Fe train which carried them to their Nevada ranch
Paramount Pictures, 1949
Photograph by Bert Parry

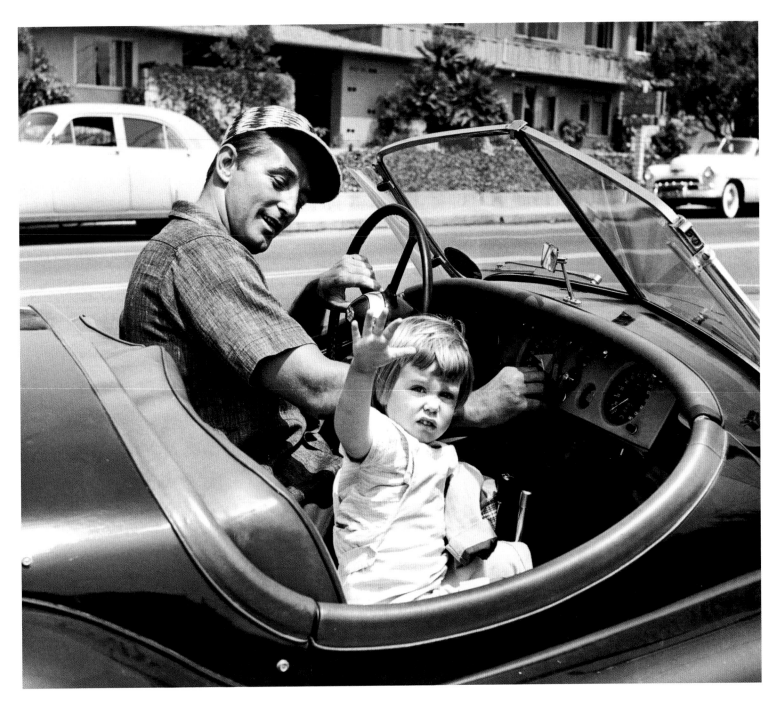

Robert Mitchum with his daughter, Trini
United Artists, c.1956

Alan Ladd with the car that reflects his status
as one of Hollywood's leading cowboys
Paramount Pictures, c.1942

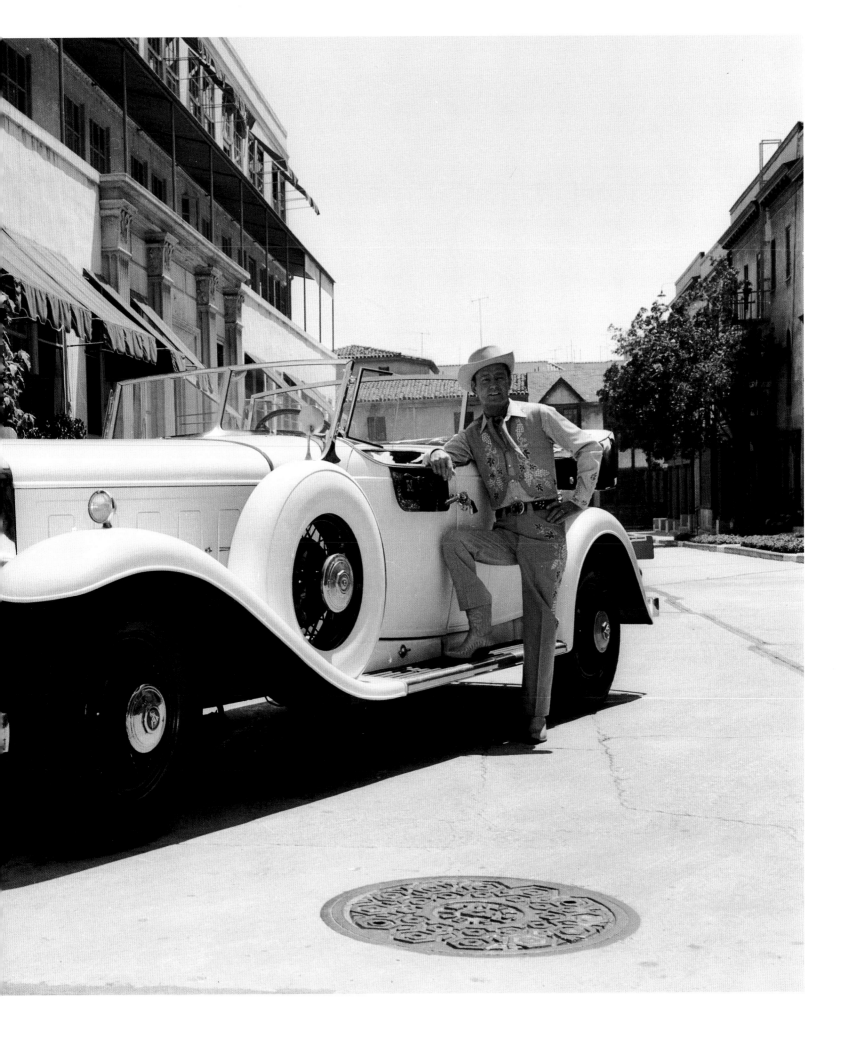

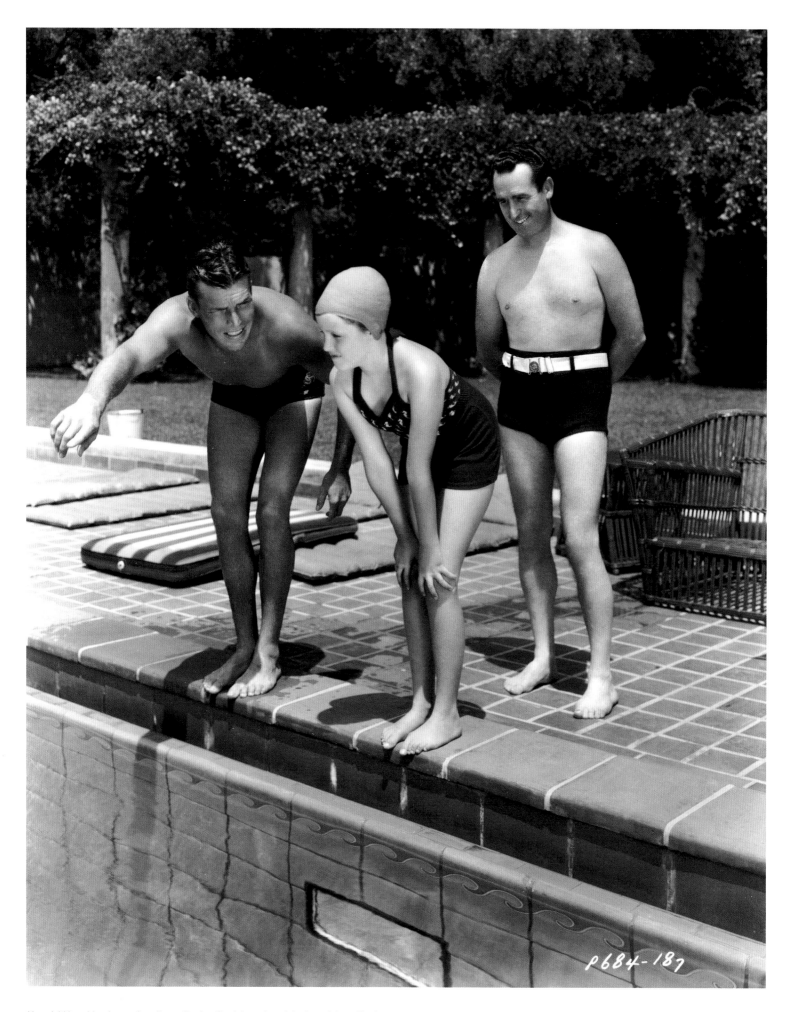

Harold Lloyd looks on fondly as Buster Crabbe gives his daughter, Gloria, a swimming lesson at his Beverly Hills estate. Buster won a Gold Medal for swimming at the 1932 Olympics before becoming a film star
Paramount Pictures, c.1935

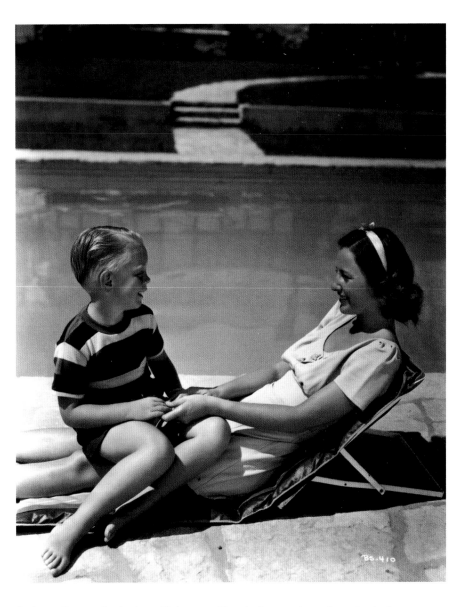

Rita Hayworth and her daughter,
Rebecca Welles
Columbia, 1946
Photograph by Robert Coburn Snr

Barbara Stanwyck relaxing with her son, Dion Anthony, whom she adopted
with her first husband, Frank Fay. Their stormy marriage finally ended after a
drunken brawl, during which Fay tossed Dion into the swimming pool.
Columbia, 1938

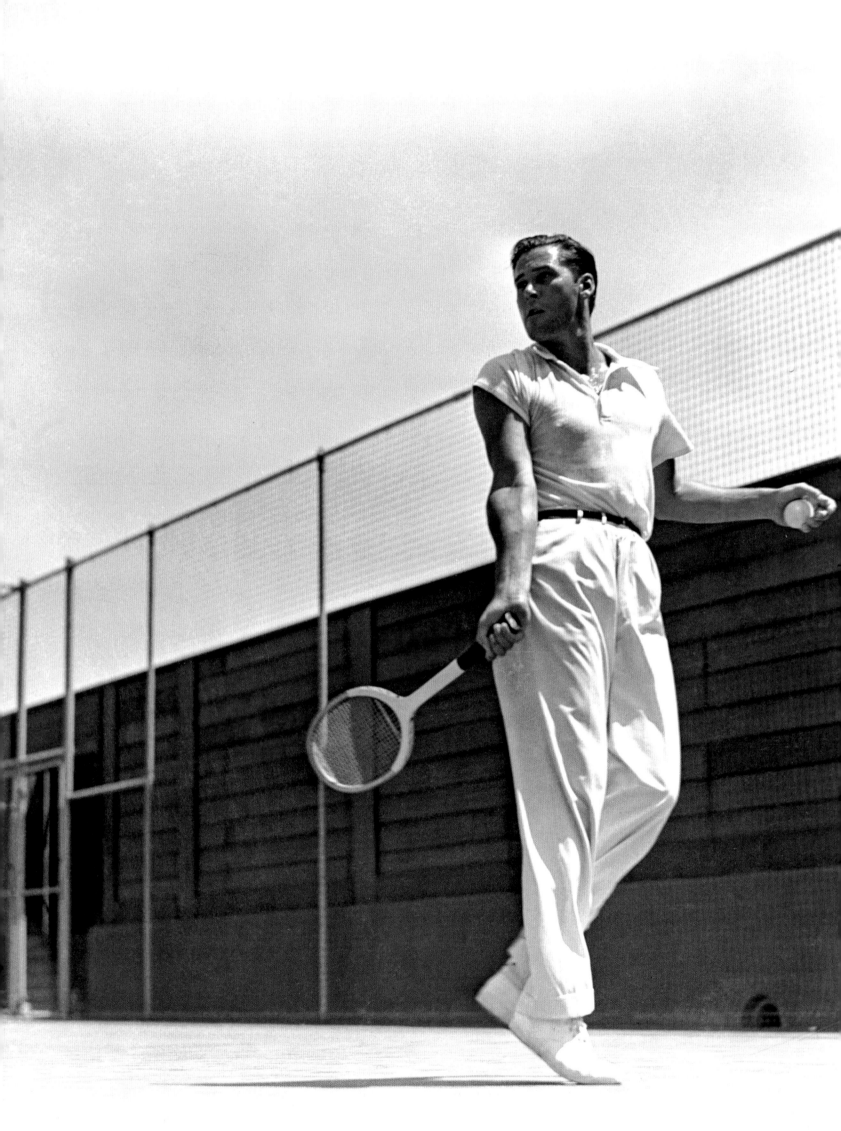

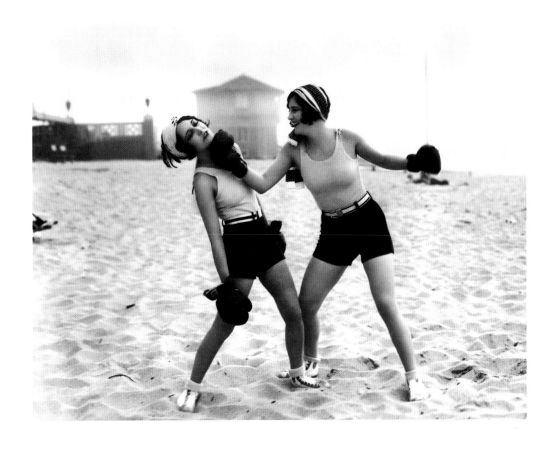

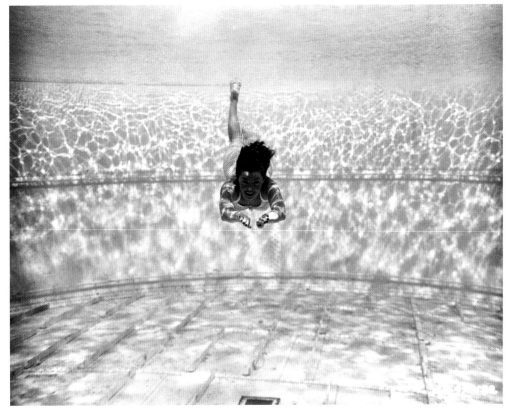

Errol Flynn
Warner Brothers, 1935

Starlets, Dorothy Sebastian and
Joan Crawford, larking about on
Santa Monica Beach, California
MGM, 1928
Photograph by Don Gillum

Esther Williams in her pool
MGM, 1942
Photograph by Eric Carpenter

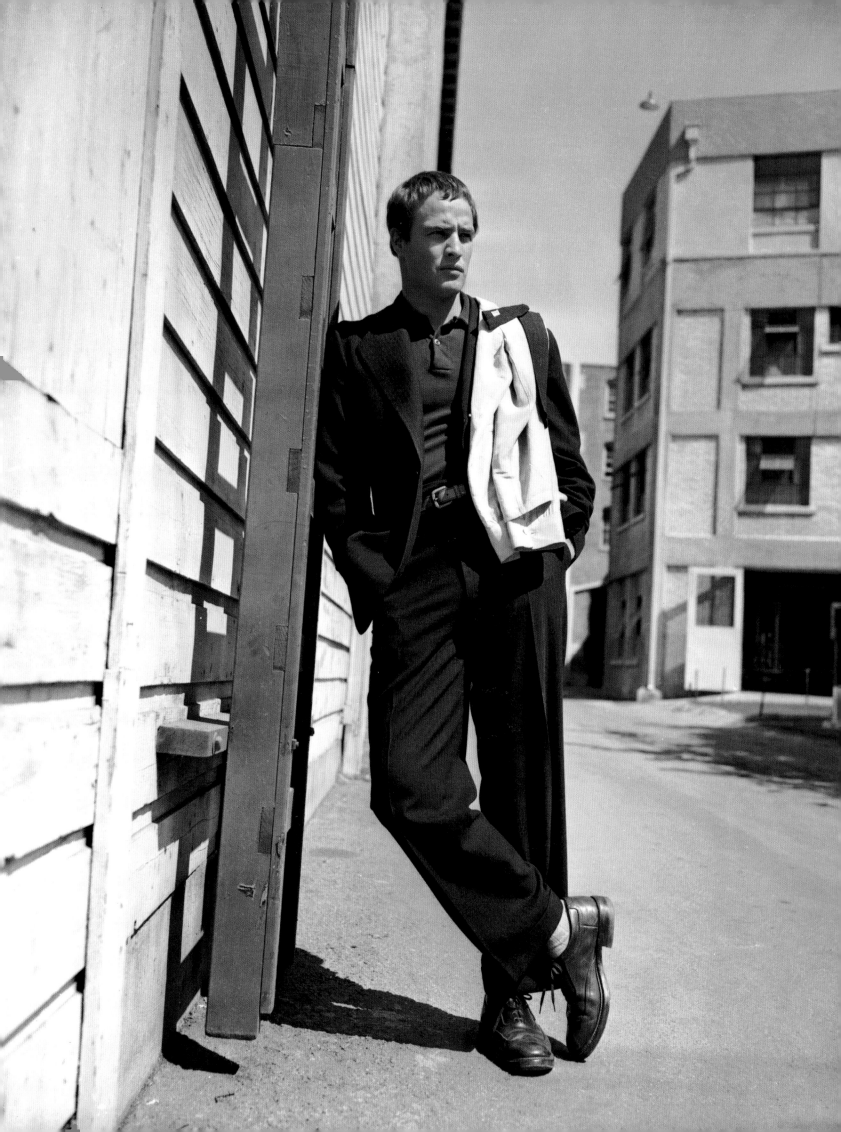

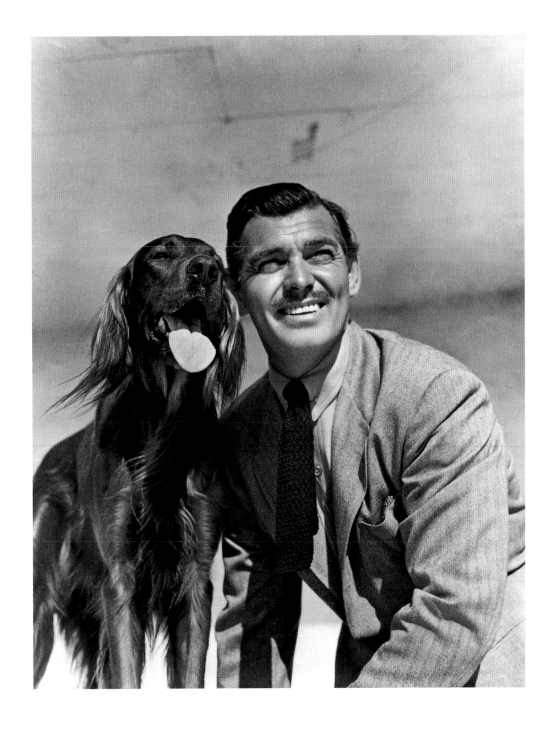

Marlon Brando taking a break on
the Studio back lot during the
filming of *A Streetcar Named Desire*
Warner Brothers, 1951

Clark Gable
MGM, c.1945
Photograph by Eric Carpenter

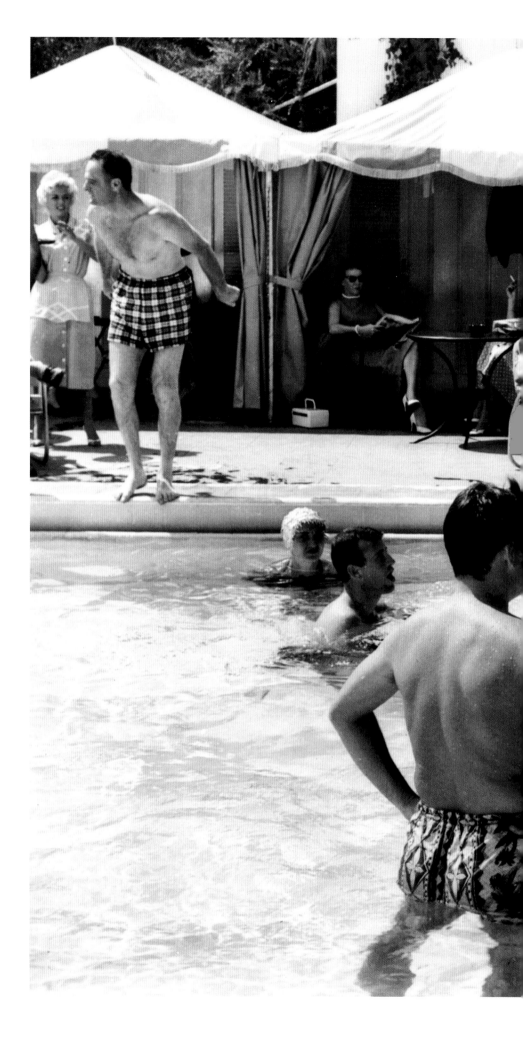

Lauren Bacall and Gregory Peck
on set, *Designing Woman*
MGM, 1956

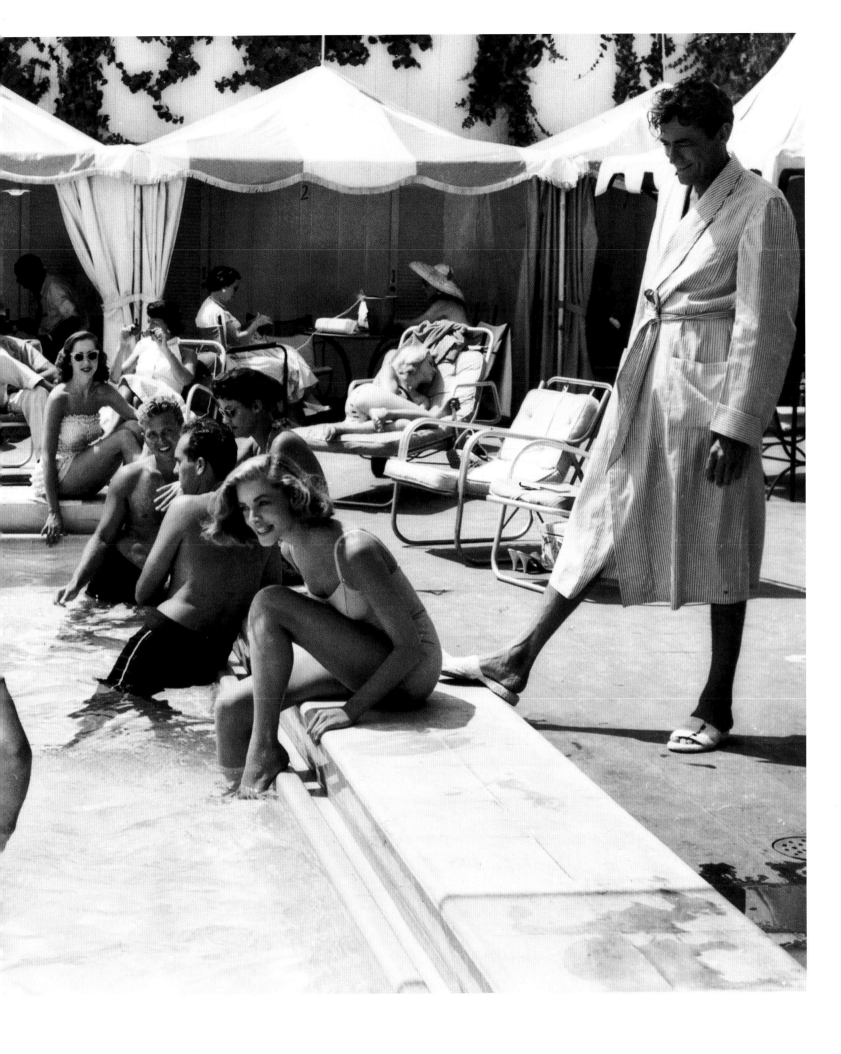

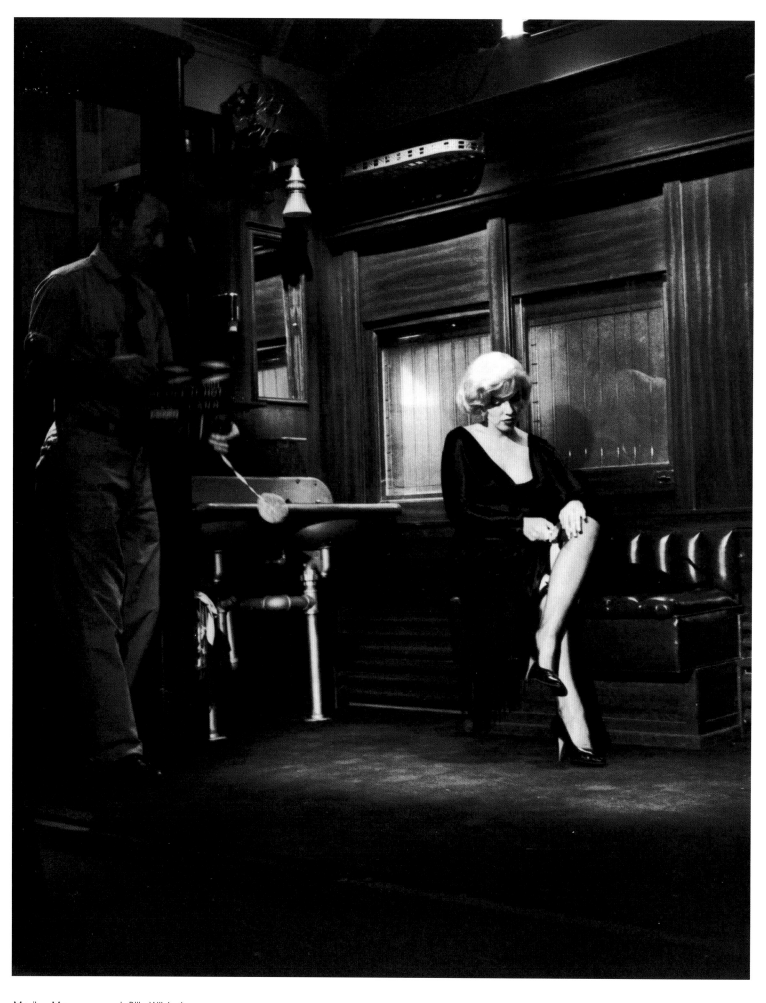

Marilyn Monroe on set, Billy Wilder's
Some Like It Hot (1959)
United Artists, 1958

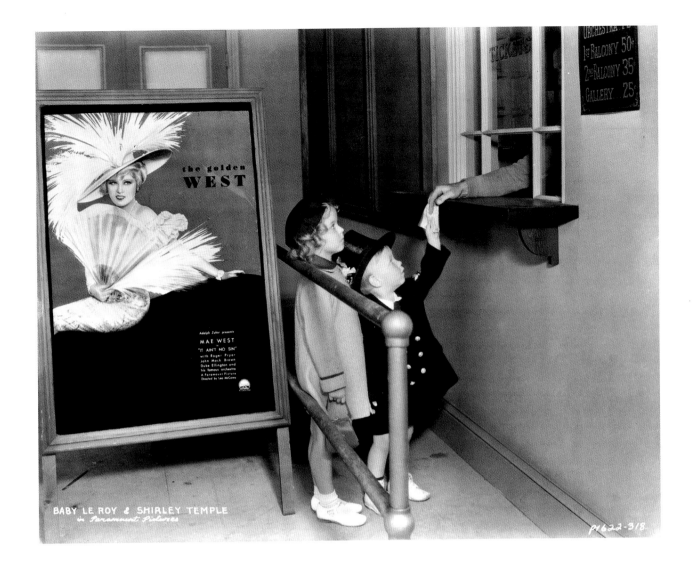

In this carefully composed publicity shot, Temple and LeRoy are seen buying tickets for a Mae West film which, ironically, they would have been too young to see. The poster refers to Mae's aura and not the film's title; originally this was *It Ain't No Sin*, but by the time of its release, this had been changed to *Belle of the Nineties*.

Shirley Temple and Baby LeRoy
Paramount Pictures, 1934

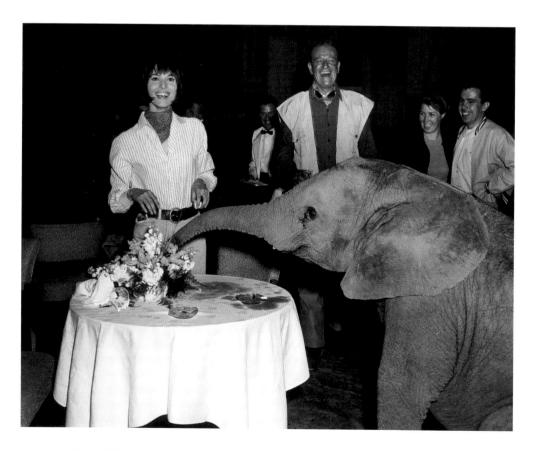

Co-stars of *Hatari!*, Elsa Martinelli and John Wayne with Tembo the elephant
celebrating their return from the African shoot for the film
Paramount Pictures, 1962

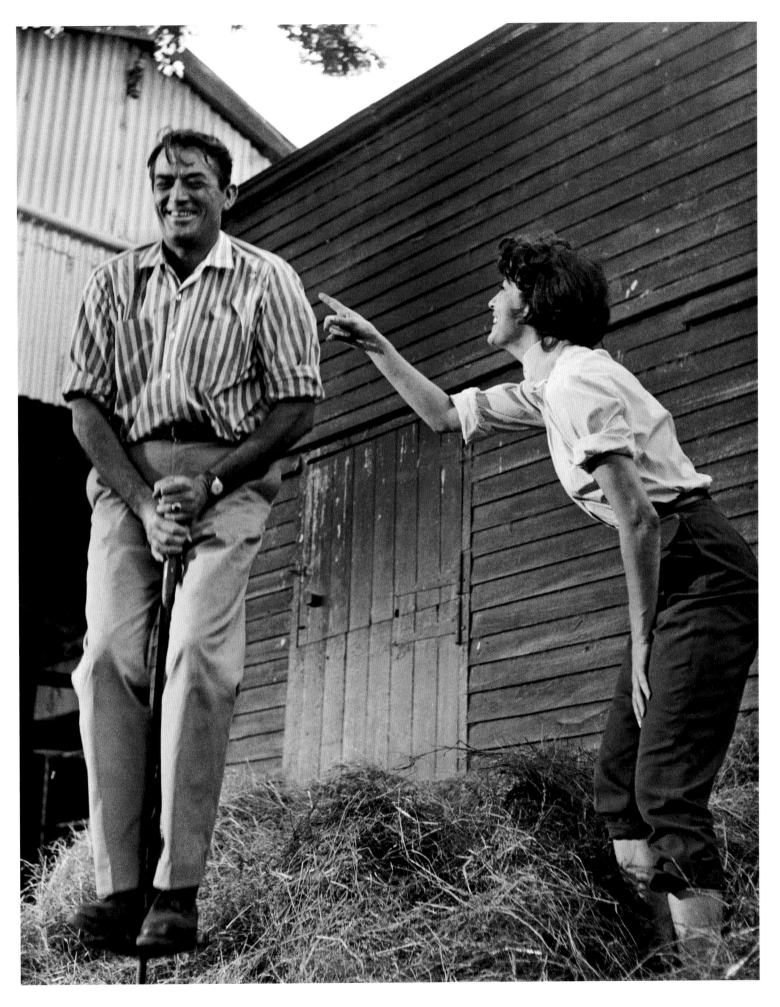

Gregory Peck showing Ava Gardner his pogo stick, off set, *On The Beach*
United Artists, 1959

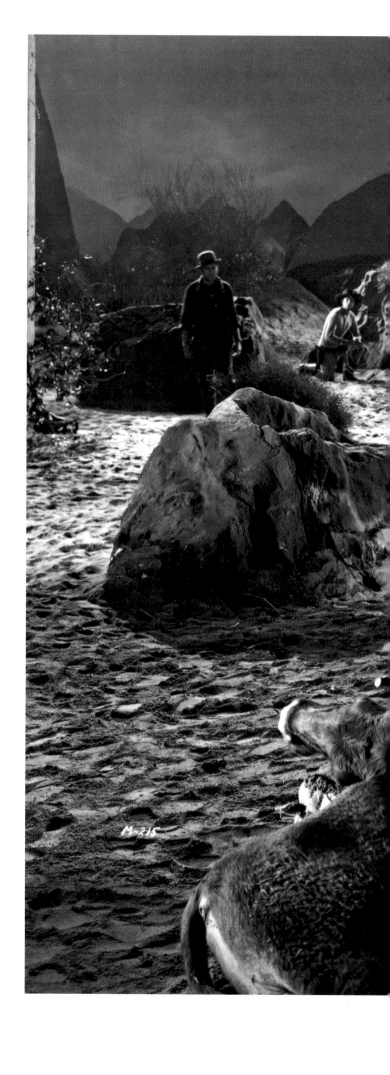

Montgomery Clift and John Wayne on set, *Red River*
United Artists, 1948

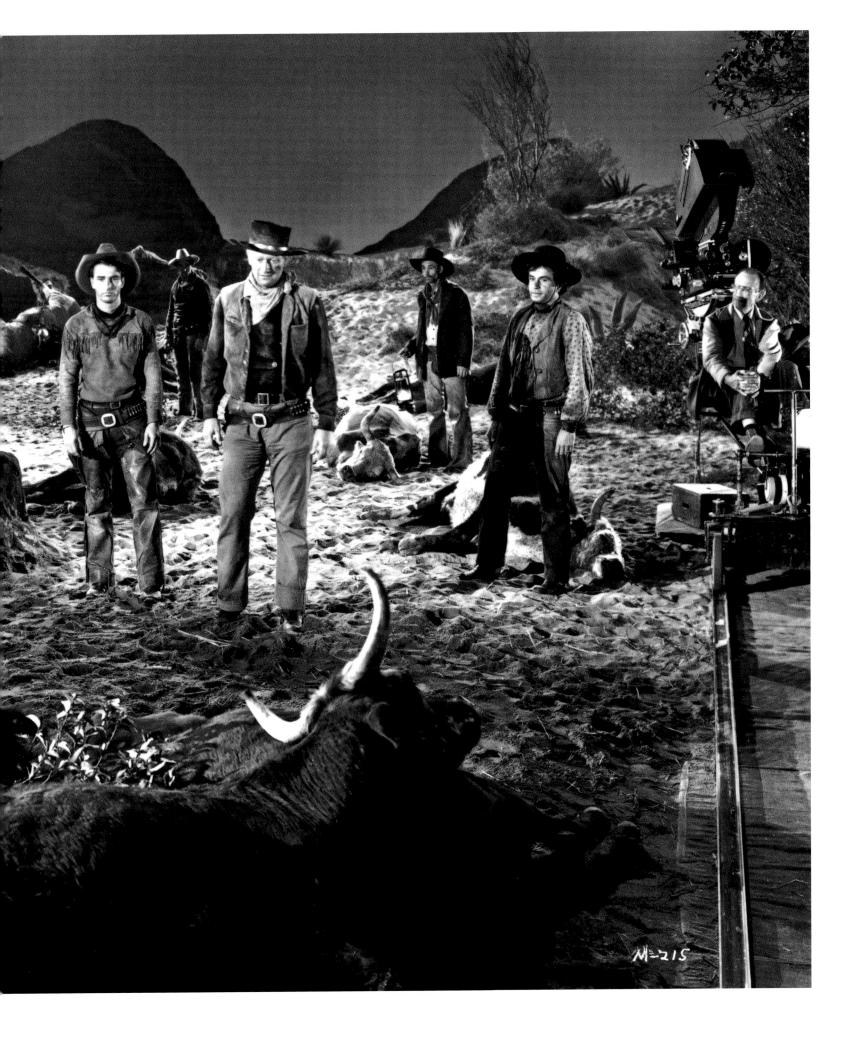

M-215

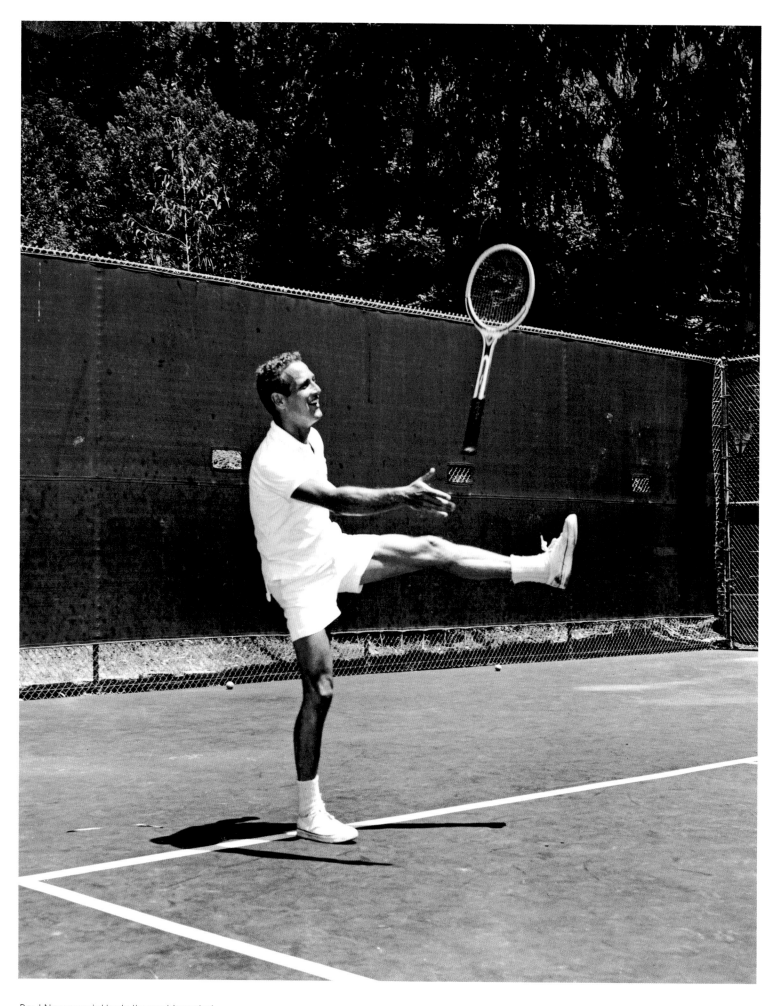

Paul Newman jokingly throws his racket
in the air during a game of tennis
MGM, c.1958

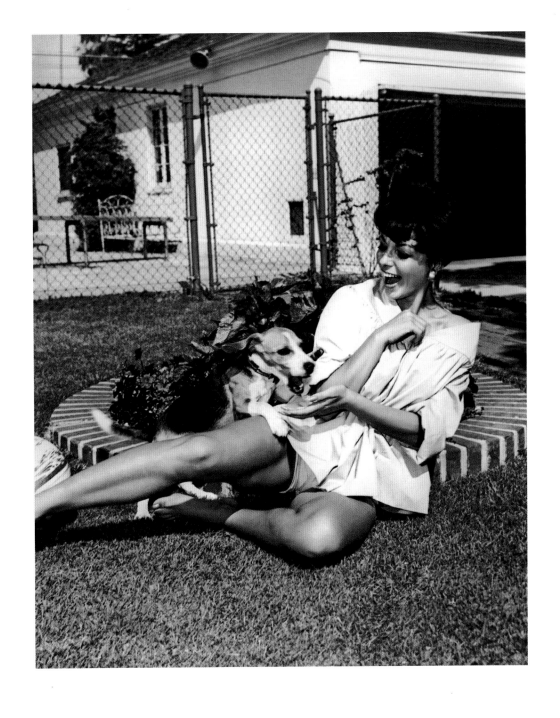

Joan Collins
20th Century Fox, c.1960

James Dean playing around with Elizabeth Taylor,
on set, *Giant*
Warner Brothers, 1956

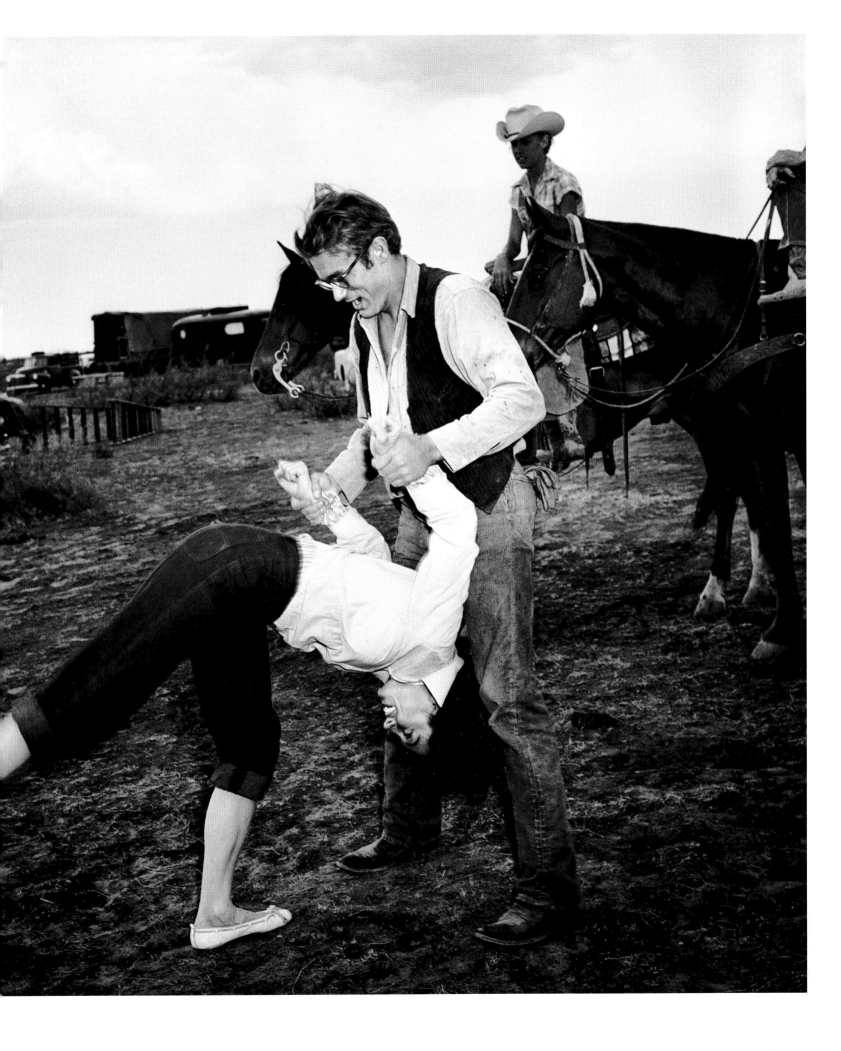

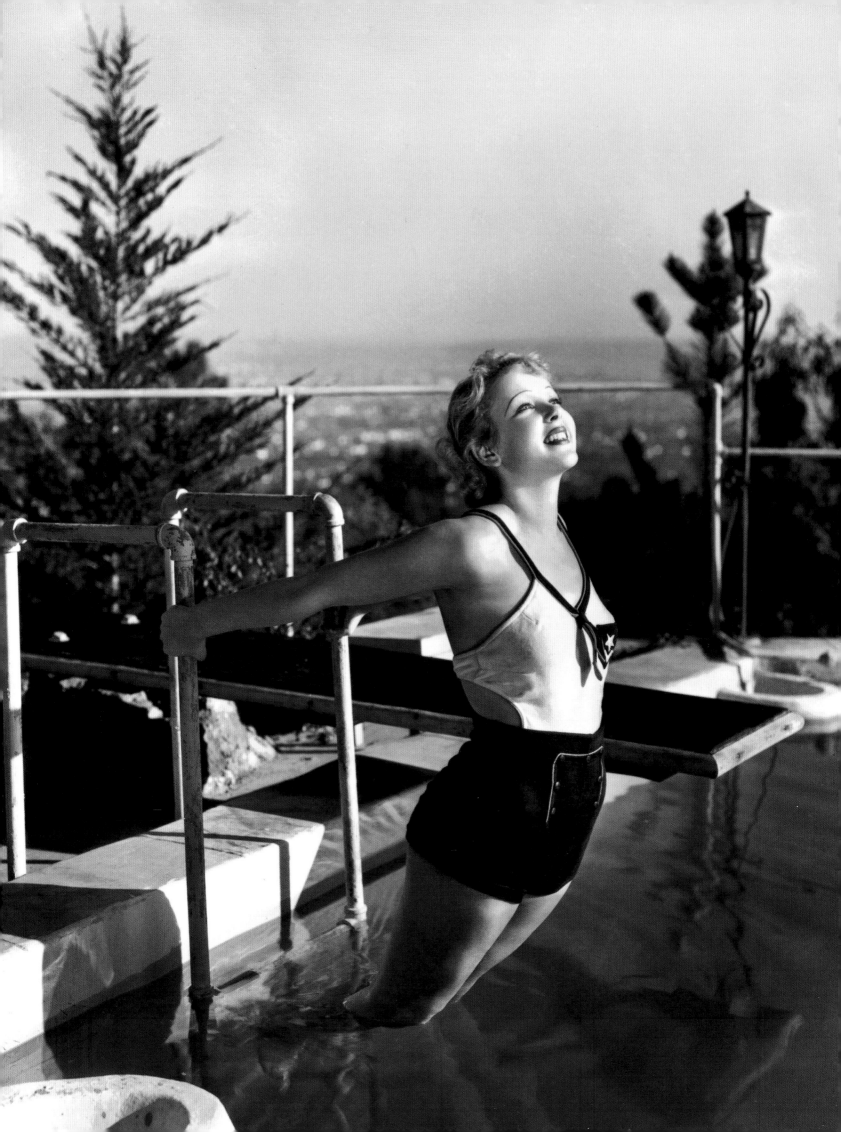

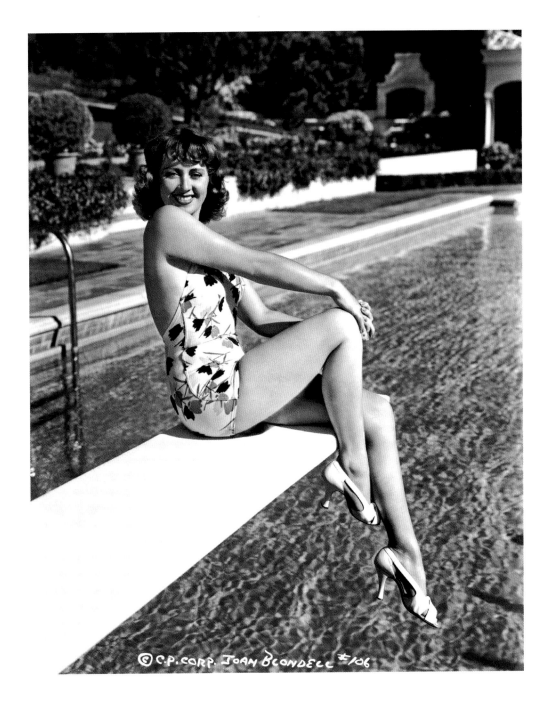

Ida Lupino
Paramount Pictures, c.1934

Joan Blondell
Columbia, 1939

Humphrey Bogart on the Studio back lot
Warner Brothers, c.1942

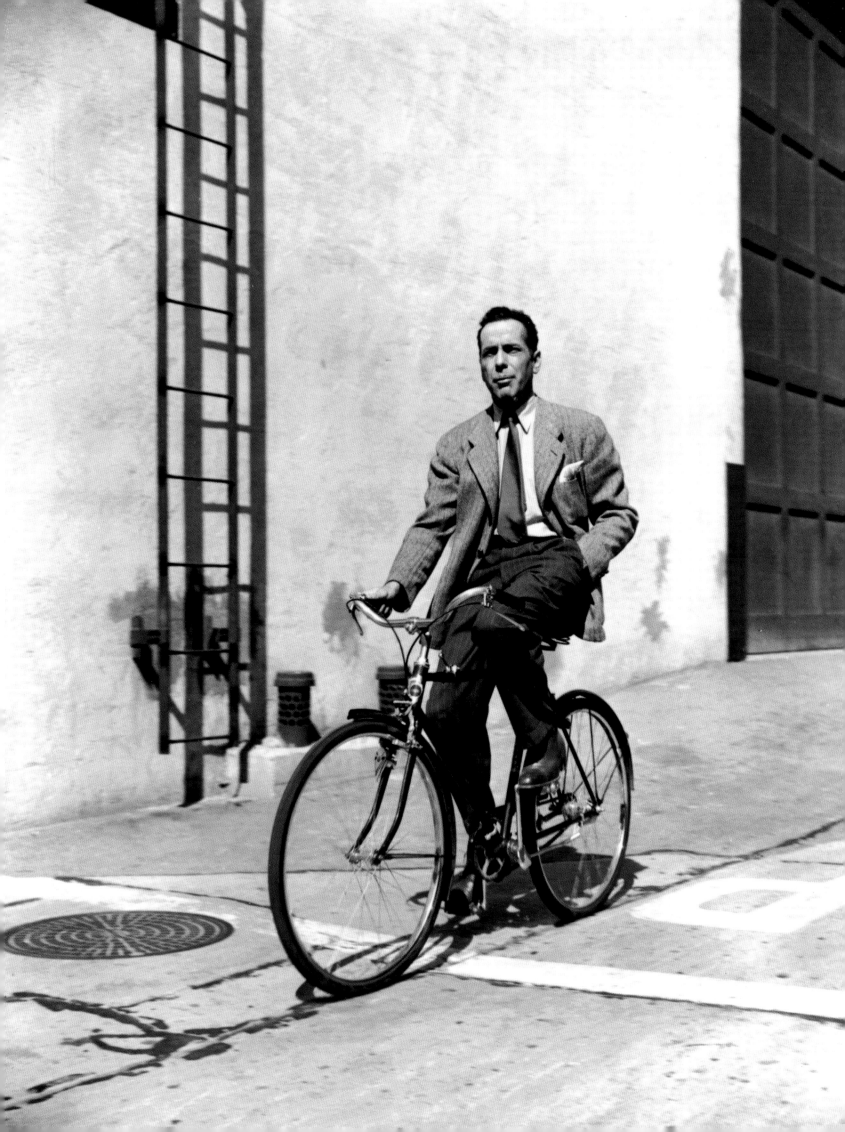

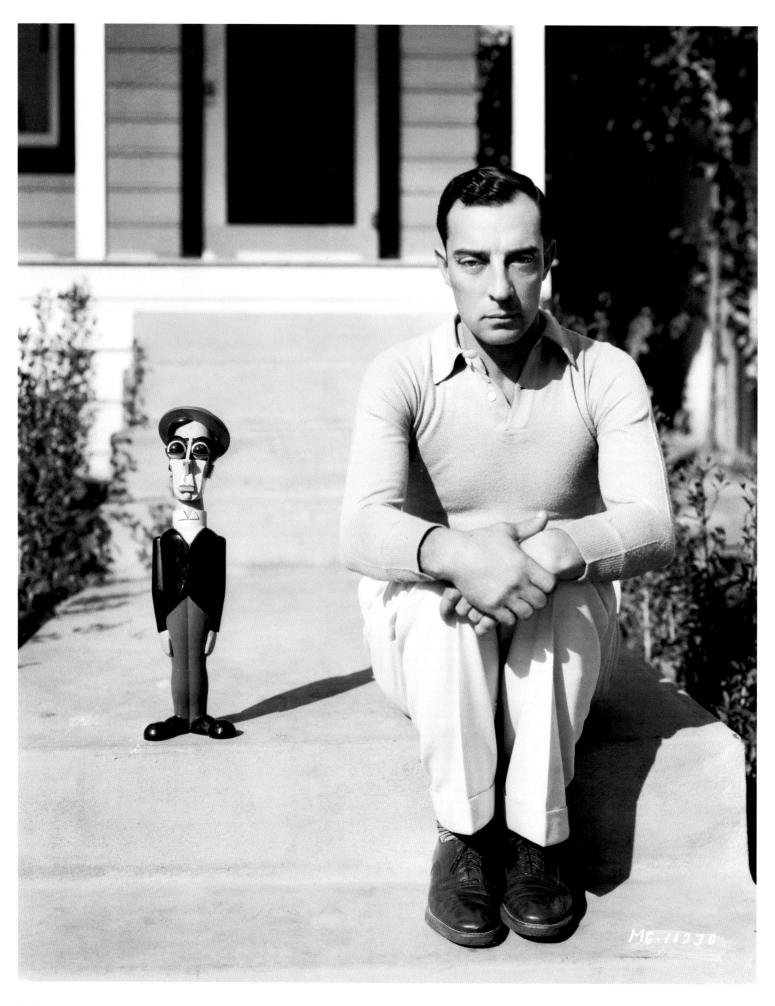

Buster Keaton, known as "The Great Stone Face" sits
beside an equally deadpan miniature model of himself
MGM, 1930

Sylvia Sidney
Paramount Pictures, c.1930

Clara Bow with her "dog"
Paramount Pictures, c.1926
Photograph by Don English

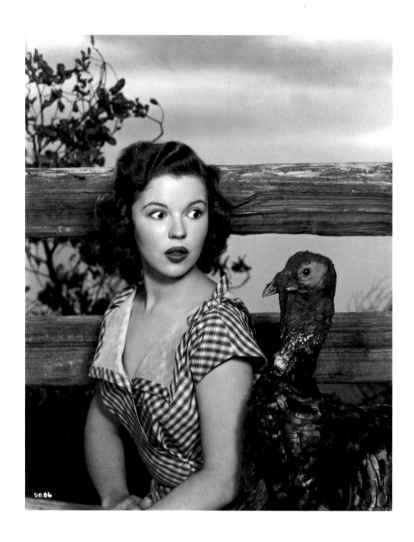

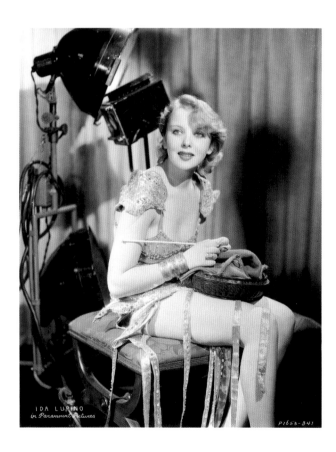

Ida Lupino, on set for *Anything Goes*, knitting
a turkey for Thanksgiving Day celebrations
Paramount Pictures, 1936

Shirley Temple being surprised by
the Thanksgiving Day turkey
Warner Brothers, c.1947

Arlene Dahl showing off the
Thanksgiving Day turkey
MGM, c.1949

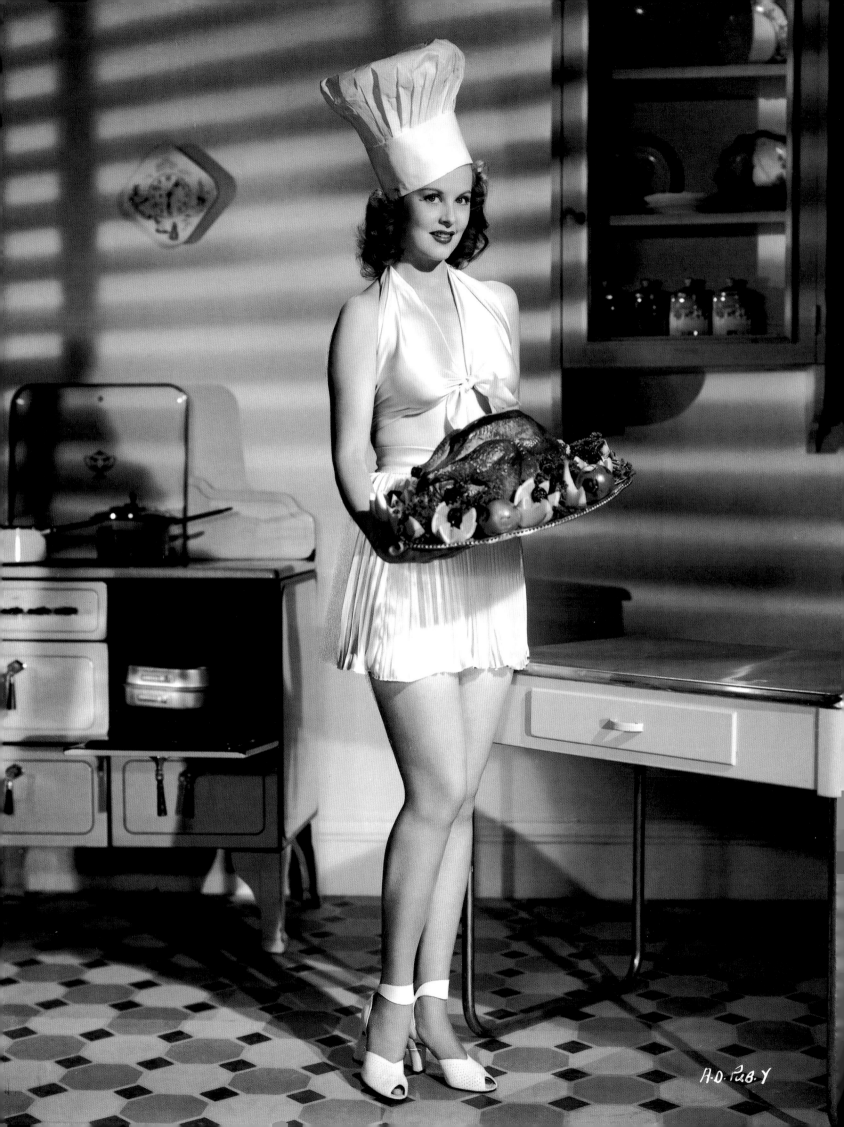

A·D·Pub·Y

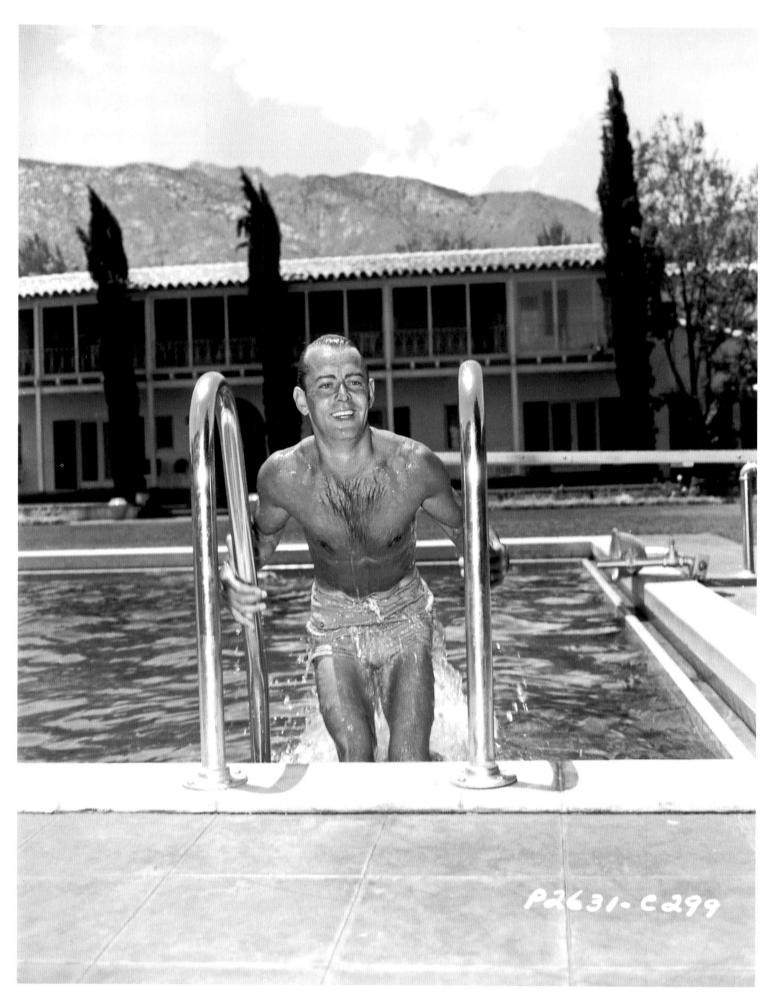

P2631-C299

Alan Ladd
Paramount Pictures, 1945

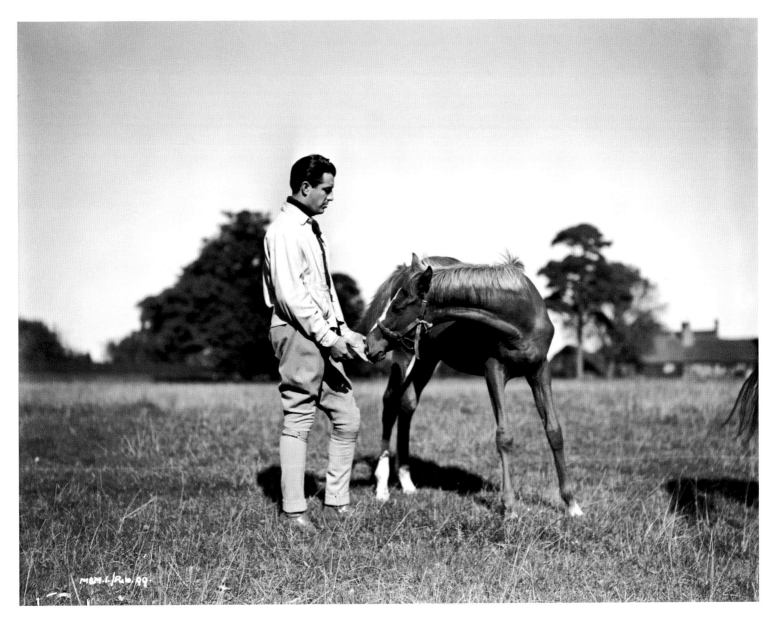

Robert Taylor
MGM, c.1939

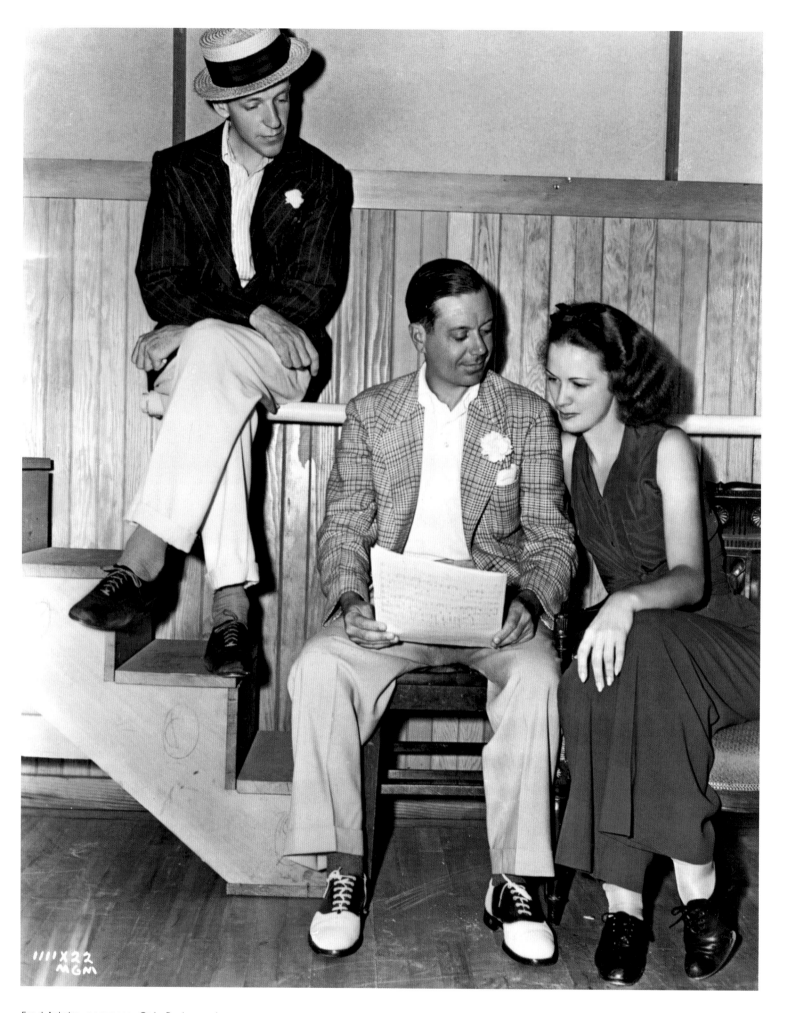

Fred Astaire, composer Cole Porter and
Eleanor Powell on set, *Broadway Melody*
MGM, 1940

214

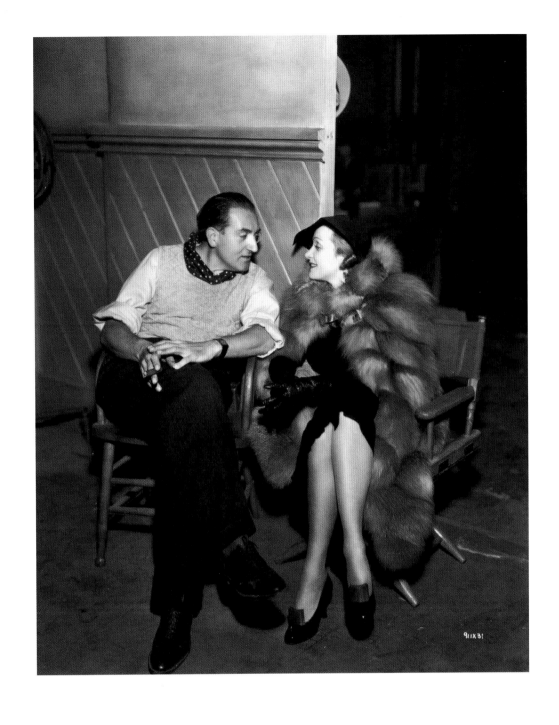

Marlene Dietrich visiting director Fritz Lang on set, *Fury*
MGM, 1936

The transition from child to adult star was rarely an easy one and many never made it. Taylor, Rooney and Garland did, although not without having faced adversity at times, an experience which left its stamp firmly on them.

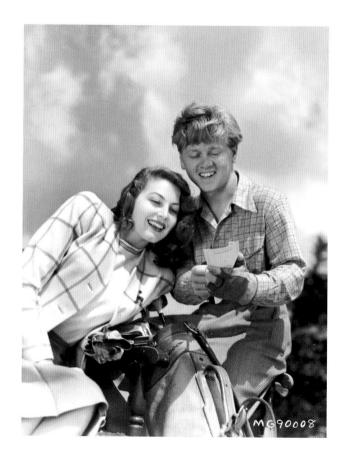

Newlyweds Mickey Rooney and Ava Gardner
MGM, 1942
Photograph by Eric Carpenter

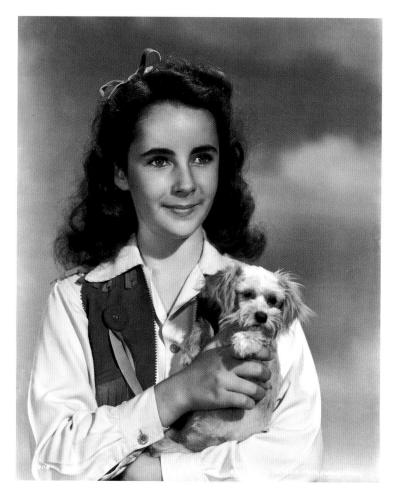

Elizabeth Taylor. She was only twelve years old at this time and just about to star in *National Velvet*
MGM, 1944
Photograph by Clarence Sinclair Bull

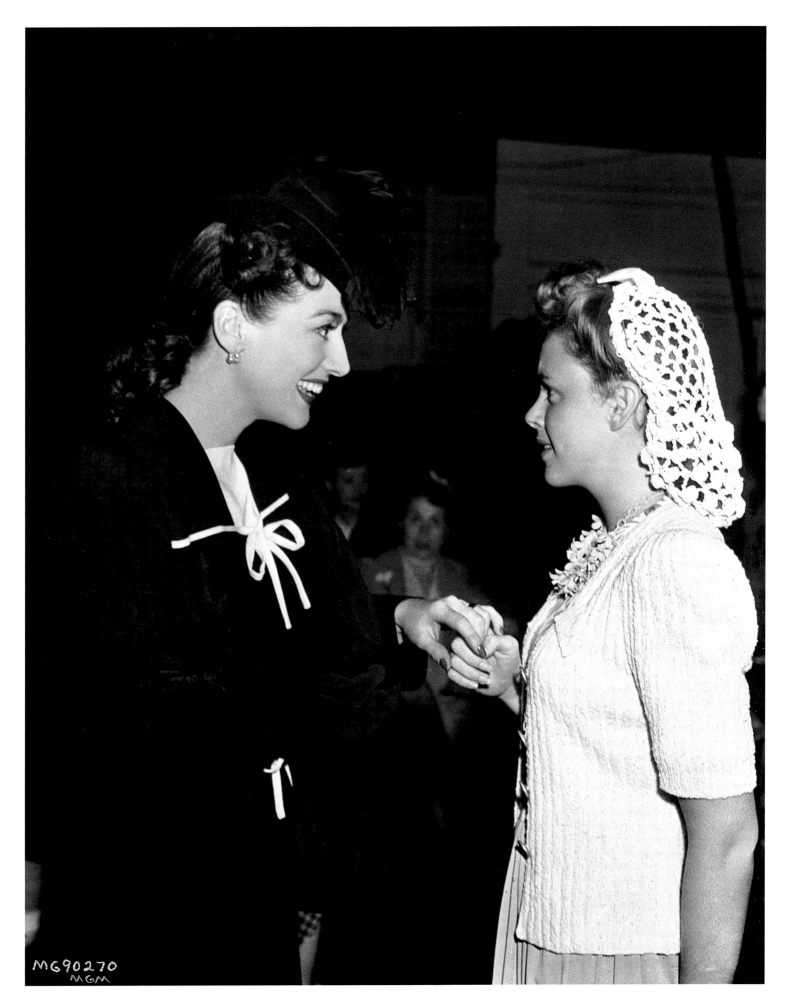

MG90270
MGM

Joan Crawford visits Judy Garland on set, *For Me and My Gal*. Joan was
shortly to be let go by MGM after 18 years at the Studio. Judy was its new
star and both actresses would probably reflect on this "passing of the flame"
from one star to another. Judy would herself be dropped by MGM in 1950.
MGM, 1942

Jean Harlow
MGM, 1934
Photograph by Virgil Apger

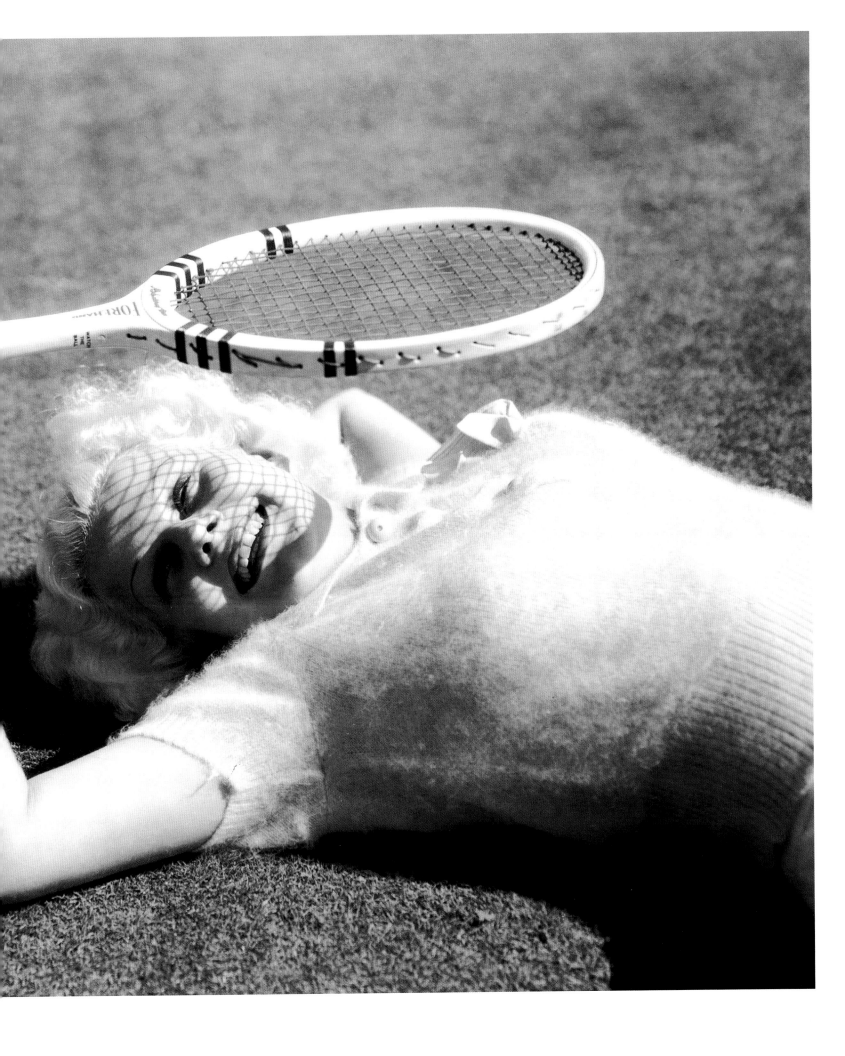

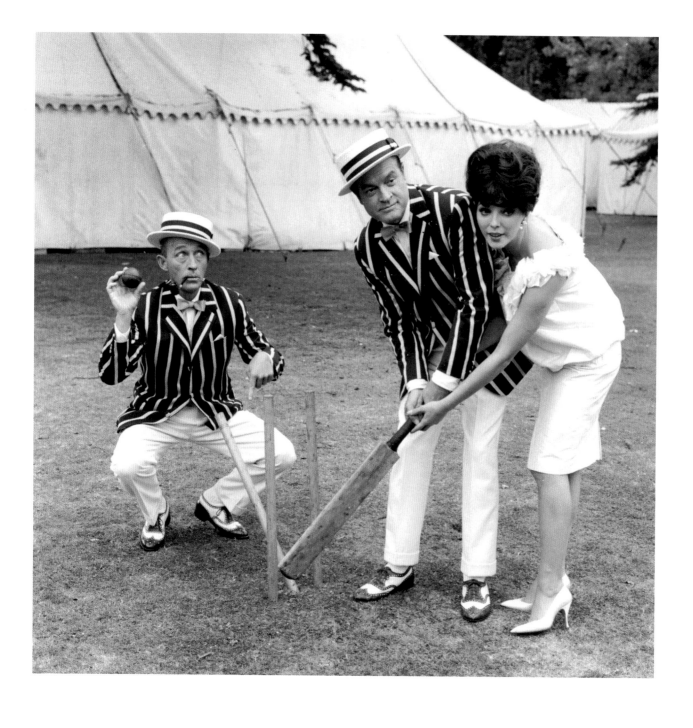

Bing Crosby, Bob Hope and Joan Collins on set for *The Road*
To Hong Kong on the first day of filming at Shepperton Studios
United Artists, 1961
Photograph by Frank Martin

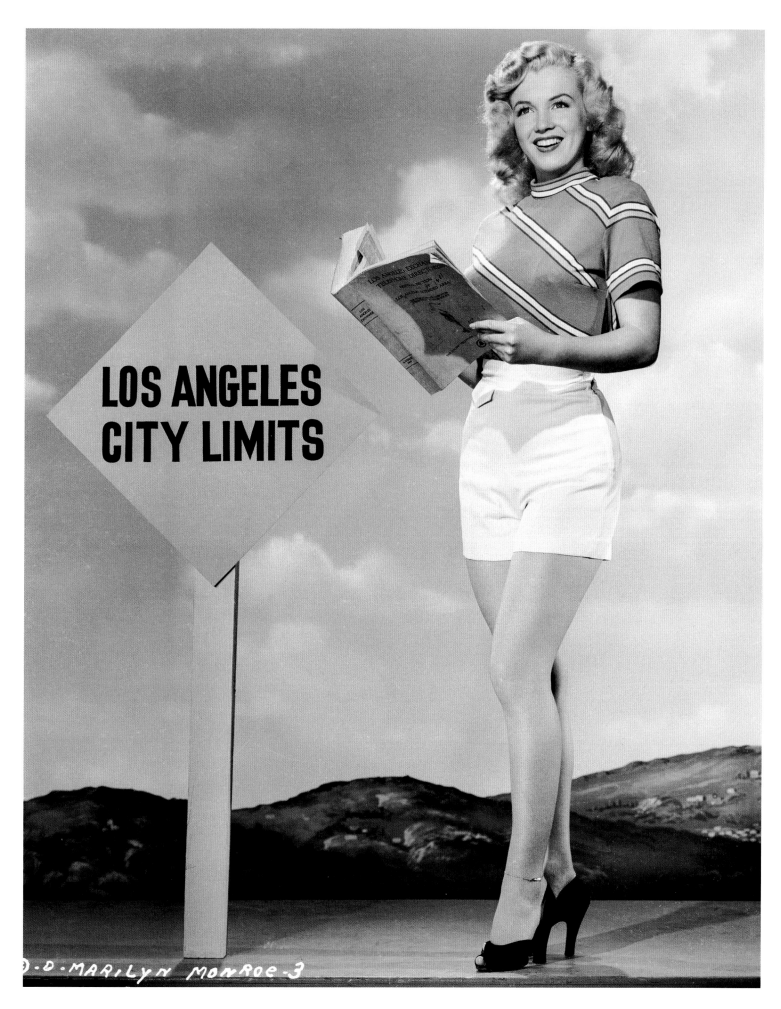

LOS ANGELES
CITY LIMITS

Eager young starlet Marilyn Monroe reading a Los Angeles
telephone directory as she crosses the City Limits sign
Columbia, 1948

MG-15705

Dolores del Rio at home with her second husband,
the Hollywood art director Cedric Gibbons
MGM, 1931
Photograph by Clarence Sinclair Bull

Boris Karloff
Universal, c.1935

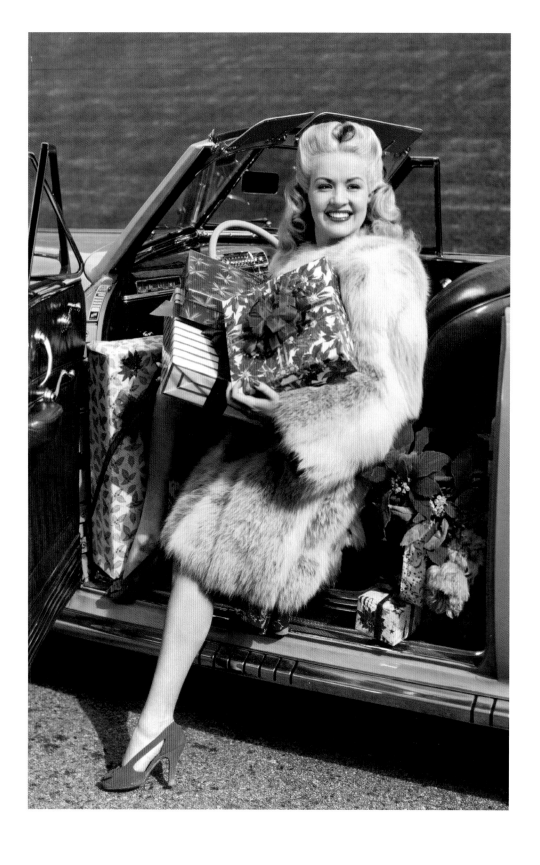

Betty Grable laden with Christmas presents
20th Century Fox, 1940
Photograph by Frank Powolny

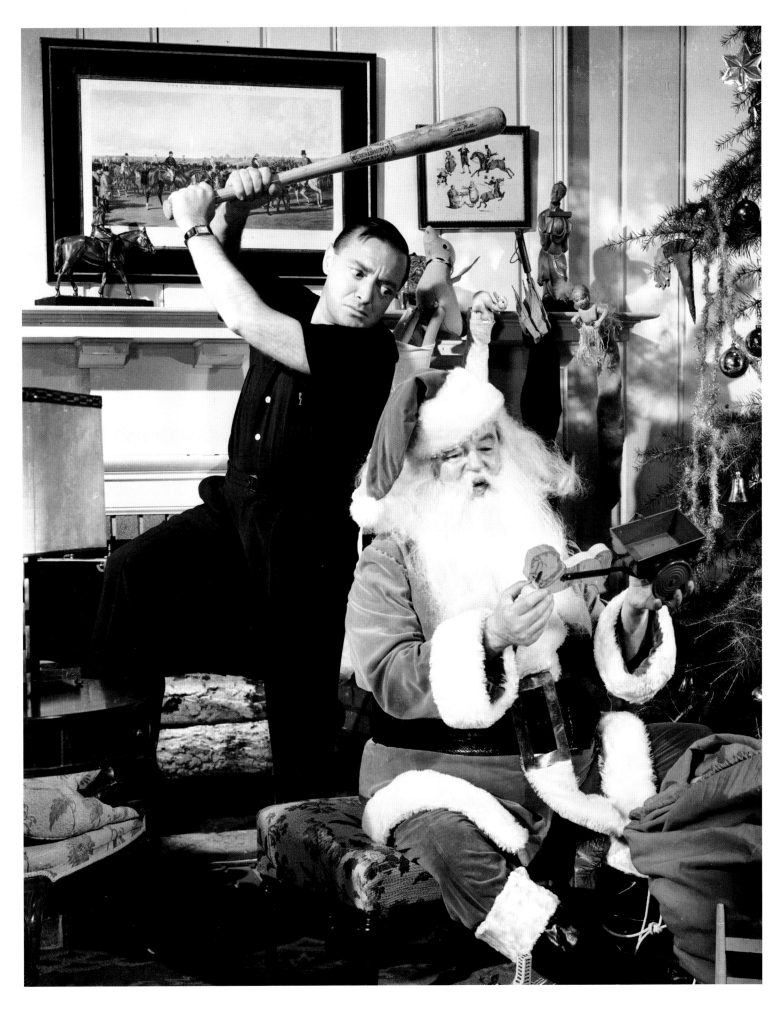

Peter Lorre as the malignant Christmas spirit with Santa,
Sydney Greenstreet. They made eight films together between
1941-1946, including *The Maltese Falcon* and *Casablanca*
Warner Brothers, 1942

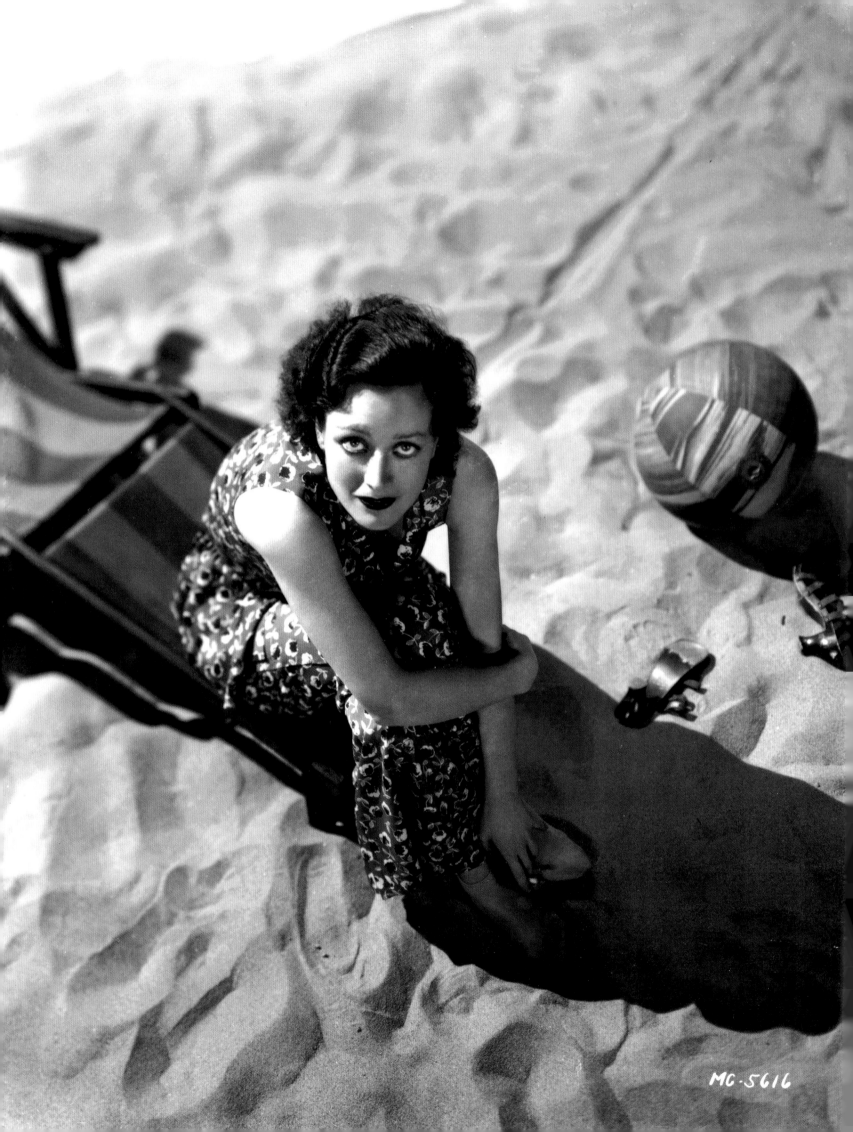

Joan Crawford on Santa Monica Beach, California
MGM, 1930
Photograph by George Hurrell

Dennis Hopper
Warner Brothers, c.1955

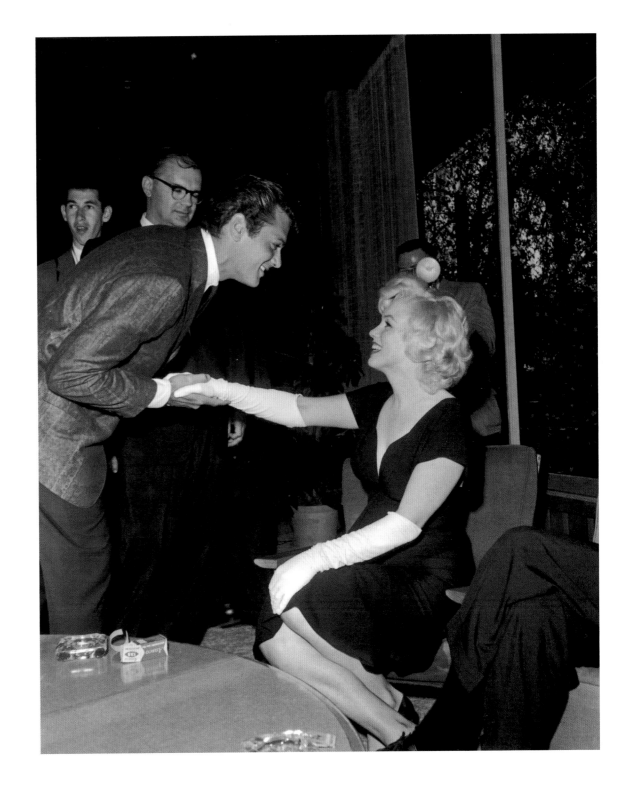

Tony Curtis and Marilyn Monroe at a press
conference for *Some Like It Hot*
20th Century Fox, 1959

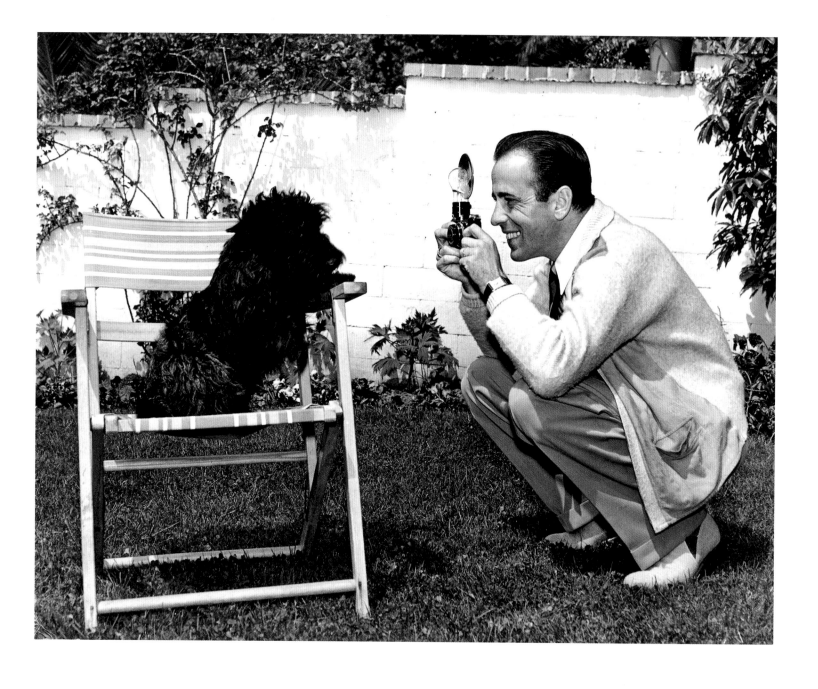

Humphrey Bogart at home taking
a snap of his dog, Sluggy
Warner Brothers, c.1941

Lauren Bacall
Warner Brothers, 1944
Photograph by John Engstead

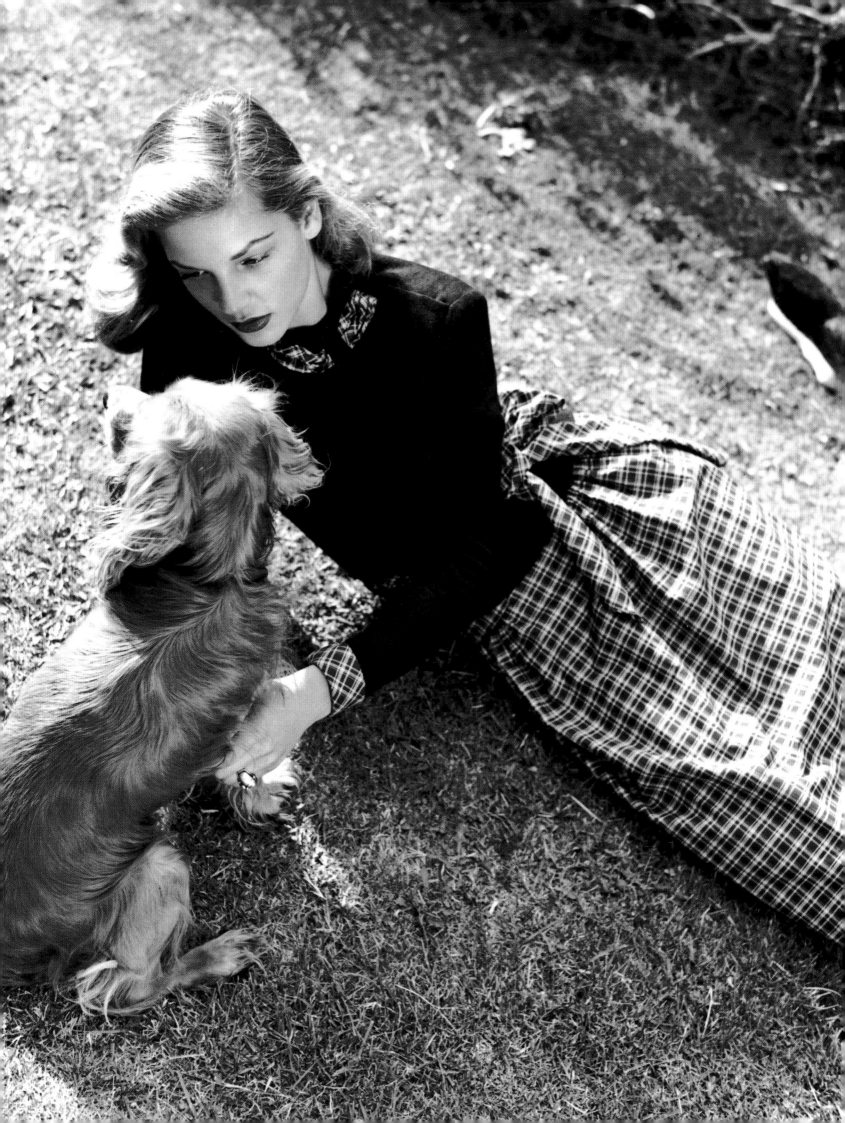

MGM first recorded Leo the Lion (whose real name was Jackie) roaring for their official opening movie title logo in 1928. Jackie was used as the MGM logo for all of their films from 1928 to 1956 and was the first lion to appear in a Technicolor film in 1932.

Leo the Lion
MGM, 1928

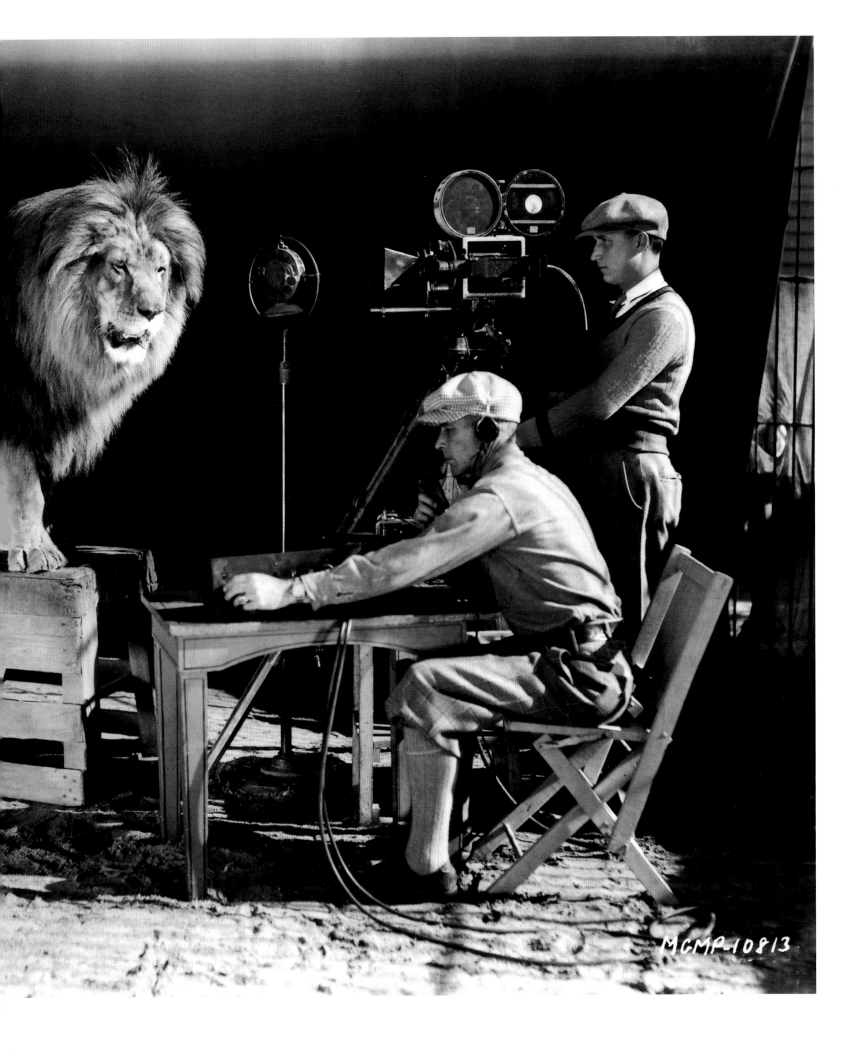

MGMP-10813

233

P2228-N546

Barbara Stanwyck in costume as the scheming
Phyllis Dietrichson on the set of the film noir classic
Double Indemnity, directed by Billy Wilder
Paramount Pictures, 1944

Bette Davis having her hair adjusted
between takes of *Satan Met a Lady*
Warner Brothers, 1936
Photograph by Bert Longworth

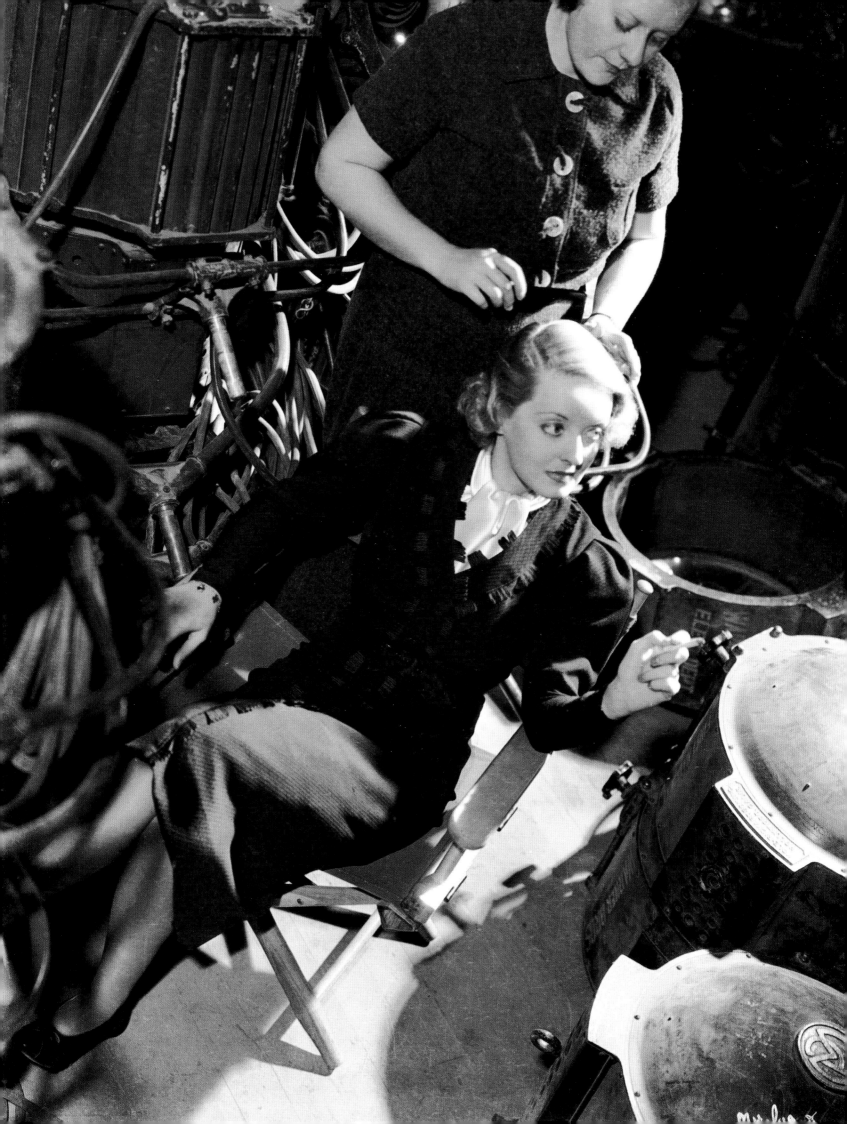

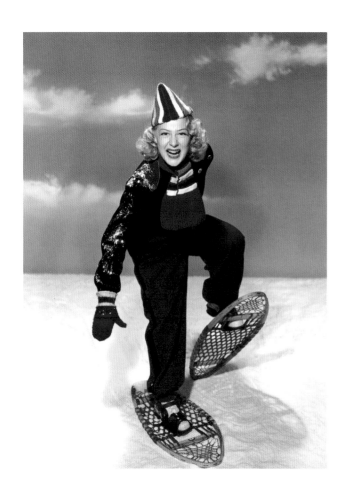

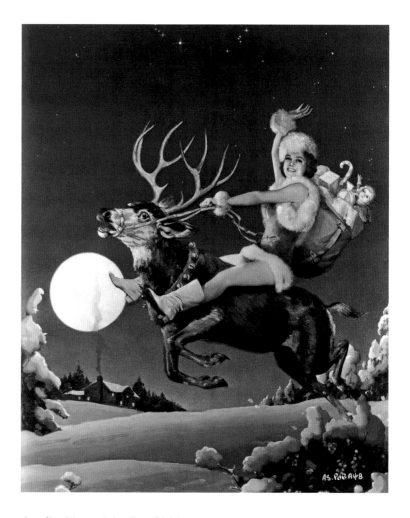

Betty Hutton promoting herself as an "outdoor girl"
in the Studio Gallery with its artificial snow and sky
Paramount Pictures, 1944

Ann Sheridan celebrating Christmas
Paramount Pictures, c.1935

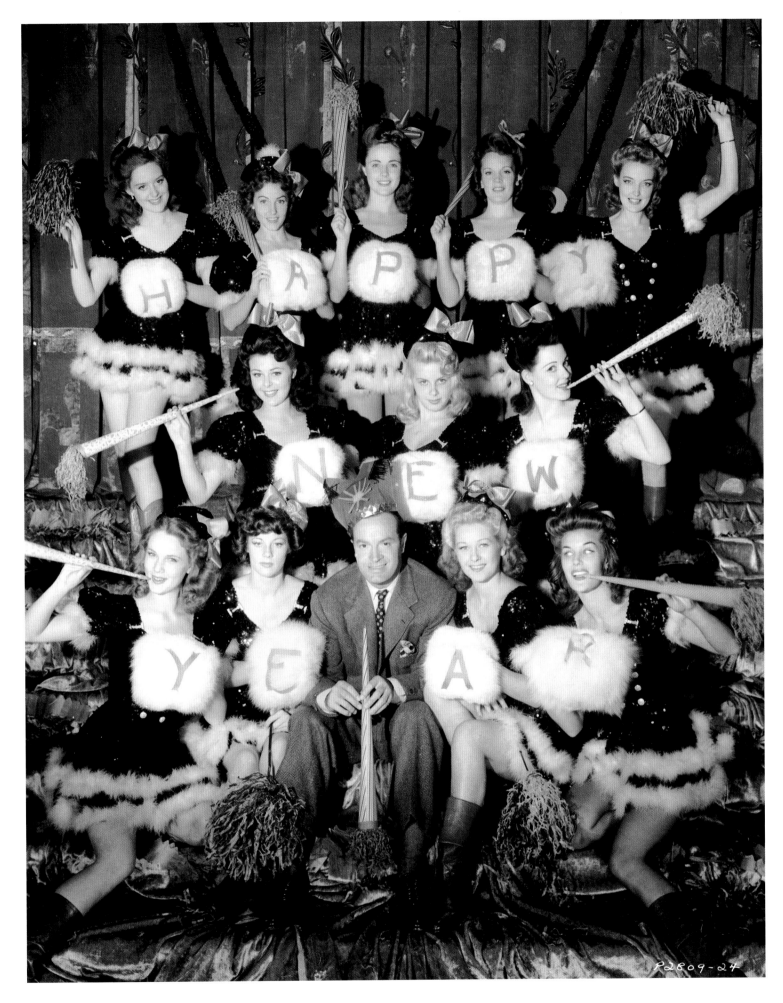

Bob Hope welcoming in the New Year with the Louisiana
Belles who were to appear with him in *Louisiana Purchase*
Paramount Pictures, 1942

Index of Stars in Photos

Image Credits

pp. 1, 44, 65, 117, 149, 150, 170, 200, 203, 220, 230 Courtesy Getty Images
p. 196 Courtesy Flash Projects, London
All other images in the book are from The John Kobal Foundation Archive

Prints of most of the images in the book can be purchased from The John Kobal
Foundation. All enquiries should be sent via email to admin@johnkobal.org or can
be made by visiting the website www.johnkobal.org

Acknowledgements

Many thanks to the following without whom the book would not
have turned out as wonderfully as it has done: Joan Collins for her
terrific foreword to the book; Percy Gibson for his helpful backup;
Robert Dance for his lucid and entertaining essay spotlighting the
context of these photos and for his ongoing support of the John
Kobal Foundation and its work; Gareth Abbott and Steve Parker,
our editor and designer, who worked very closely with us from the
beginning and were central to devising the book, selecting the
images and designing it – their enthusiasm and determination to
get it just right have made producing this book a pleasure; Rachel
Perry, Administrator of the Foundation, our right arm throughout –
she good naturedly took on board all of our many frantic requests
and calmly dealt with them; Sarah Macdonald and her team at
Getty Images who did splendid work digging out the mountain of
negatives we needed for the book. We would also like to thank
the team at ACC. Finally, John Kobal. Without his insight and
perspicacity, this archive would not have existed and books like
this would have never seen the light of day.

FSC MIX
Paper from
responsible sources
FSC® C104723

Front Cover:
Humphrey Bogart on the Studio back lot
Warner Brothers, c.1942

Back Cover:
Jayne Mansfield on top of a large scale
model of Uncle Sam's hat to celebrate
the Fourth of July, US Independence Day
20th Century Fox, 1955